P9-DEB-679

The Art of
Oil Painting

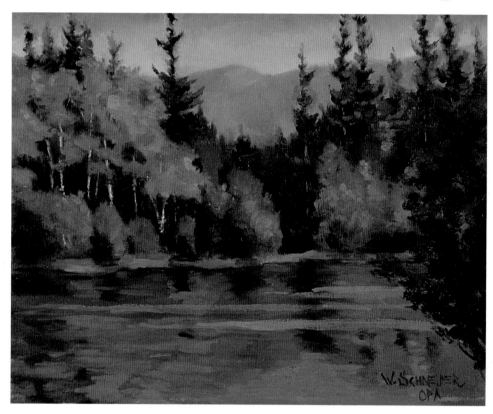

© 2003 Walter Foster Publishing, Inc. All rights reserved.
Artwork on front cover and pages 1, 3, 4, and 16–29 © 2003
Robert Moore. Artwork on pages 30–37 © 2003 John Loughlin.
Artwork on title page and pages 38-45 © 2003 Michael
Obermeyer. Artwork on back cover and pages 46–59 © 2003
Anita Hampton. Artwork on half-title page and pages 60–67
© 2003 William Schneider. Artwork on pages 68–93 © 2003
Tom Swimm. Artwork on table of contents and pages 94–103
© 2003 Caroline Zimmermann. Artwork on pages 104–111
© 2003 Kevin Short.

This book has been produced to aid the aspiring artist.
Reproduction of the work for study or finished art is
permissible. Any art produced or photomechanically
reproduced from this publication for commercial purposes is
forbidden without written consent from the publisher, Walter
Foster Publishing, Inc.

The Art of
Oil Painting

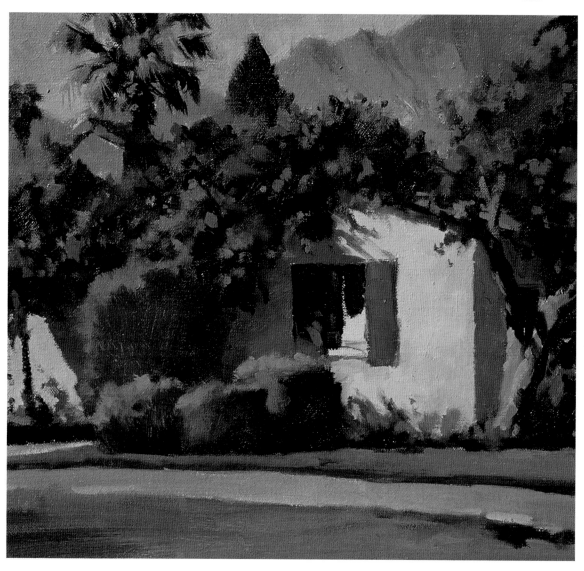

WALTER FOSTER PUBLISHING, INC.

3 Wrigley, Suite A
Irvine, California 92618
www.walterfoster.com

CONTENTS

INTRODUCTION TO OIL PAINTING

The rich, versatile art of oil painting has captivated artists for centuries and continues to be a favorite artistic medium. Oil is a very adaptable medium that lends itself to many painting styles—from the precision of photorealism to the freedom of expressionism. The projects in this book are a collection of lessons from some of the finest and most popular oil painting books published by Walter Foster Publishing. Each artist shares personal techniques and insights for mastering the medium. And because all these fine artists have developed their own special approach to painting, there are countless lessons to be learned from their individual and distinct perspectives. Learn from these artists' wide range of experiences and styles as you follow them through a diverse presentation of subject matter and instruction. Above all, have fun painting in oil!

TOOLS AND MATERIALS

There are so many items to choose from in art supply stores, it's easy to get carried away and want to bring home one of everything! However you only need a few materials to get started. A good rule of thumb is to always buy the best products you can afford. And think of your purchase as an investment—if you take good care of your brushes, paints, and palette, they can last a long time, and your paintings will stay vibrant for generations. The basic items you'll need are described here, but for more information, you can refer to *Oil Painting Materials and Their Uses* by William F. Powell in Walter Foster's Artist's Library series.

BUYING OIL PAINTS

There are several different grades of paint available, including students' grade and artists' grade. Even though artists' grade paints are a little more expensive, they contain better-quality pigment and fewer additives. The colors are more intense and will stay true longer.

Basic Palette

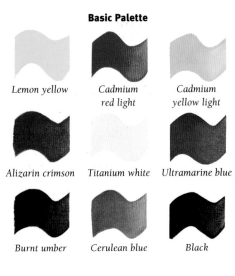

Lemon yellow	*Cadmium red light*	*Cadmium yellow light*
Alizarin crimson	*Titanium white*	*Ultramarine blue*
Burnt umber	*Cerulean blue*	*Black*

CHOOSING A PALETTE OF COLORS

The nine colors shown above are a good basic palette (including a warm and cool version of each of the primary colors). Each artist featured in this book has some unique colors in his or her palette, so these lessons will give you an opportunity to try out some other colors. Keep in mind that there is always more than one way to mix a color—once you understand the basics of color theory, you can get a better feel for the art of mixing color. (For more on color, please see pages 8-9.)

Selecting Supports

The surface on which you paint is called the "support"—generally canvas or wood. You can stretch canvas yourself, but it's simpler to purchase prestretched, preprimed canvas (stapled to a frame) or canvas board (canvas glued to cardboard). If you choose to work with wood or any other porous material, you must apply a primer first to seal the surface so the oil paints will adhere to the support (instead of soaking through).

PURCHASING AND CARING FOR BRUSHES

Oil painting brushes vary greatly in size, shape, and texture. There is no universal standard for brush sizes, so they vary slightly among manufacturers. Some brushes are sized by number, and others are sized by inches or fractions of inches. Just get the brushes that are appropriate for the size of your paintings and are comfortable for you to work with. The six brushes pictured below are a good starting set; you can always add to your collection later. Brushes are also categorized by the material of their bristles; keep in mind that natural-hair brushes are best for oil painting. Cleaning and caring for your brushes is essential—always rinse them out well with turpentine and store them bristle side up or flat (never bristle side down).

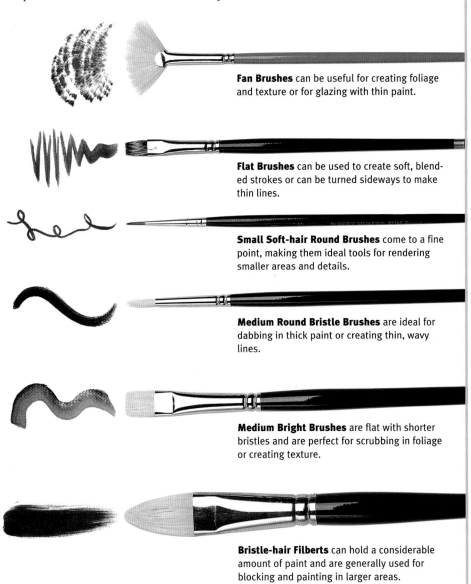

Fan Brushes can be useful for creating foliage and texture or for glazing with thin paint.

Flat Brushes can be used to create soft, blended strokes or can be turned sideways to make thin lines.

Small Soft-hair Round Brushes come to a fine point, making them ideal tools for rendering smaller areas and details.

Medium Round Bristle Brushes are ideal for dabbing in thick paint or creating thin, wavy lines.

Medium Bright Brushes are flat with shorter bristles and are perfect for scrubbing in foliage or creating texture.

Bristle-hair Filberts can hold a considerable amount of paint and are generally used for blocking and painting in larger areas.

UTILIZING ADDITIVES

Mediums and thinners are used to modify the consistency of your paint. Many different types of oil painting mediums are available—some thin out the paint (linseed oil) and others speed drying time (copal). Still others alter the finish or texture of the paint. Some artists mix a small quantity of turpentine with their medium to thin the paint. You'll want to purchase some type of oil medium, since you'll need something to moisten the paint when it gets dry and stiff and to thin it for glazing and underpaintings. Turpentine or mineral spirits can be used to clean your brushes and for initial washes or underpainting, but you won't want to use them as mediums. They break down the paint, whereas the oil mediums you add actually help preserve the paint.

PICKING A PALETTE

Whatever type of mixing palette you choose—glass, wood, plastic, or paper—make sure it's easy to clean and large enough for mixing your colors. Glass is a great surface for mixing paints and is very durable. Palette paper is disposable, so cleanup is simple, and you can always purchase an airtight plastic box (or paint seal) to keep your leftover paint fresh between painting sessions.

INCLUDING THE EXTRAS

Paper towels or lint-free rags are invaluable; you will use them to clean your tools and brushes, and they can also be used as painting tools to scrub in washes or soften edges. Some type of paint box is also useful to hold all your materials, and you may want charcoal or a pencil for sketching. In addition to the basic tools, you may also want to acquire a silk sea sponge and an old toothbrush to render special effects. Even though you may not use these additional items for every oil painting you work on, it's a good idea to keep them on hand in case you need them.

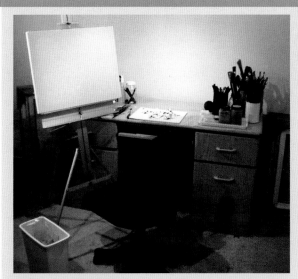

Setting up a Work Station
How you set up your workspace will depend on whether you are right- or left-handed. It's a good idea to keep your supplies in the same place, so that each time you sit down to paint, you don't have to waste time searching for anything. If natural light is unavailable, make sure you have sufficient artificial lighting, and above all else, make sure you're comfortable!

Selecting an Easel
The easel you choose will depend on where you plan to paint. You can purchase a studio or tabletop easel for painting indoors, or you can buy a portable easel if you are going to paint outdoors.

Cleaning Brushes
Purchasing a jar that contains a screen or coil can save some time and mess. As you rub the brush against the coil, it loosens the paint from the bristles and separates the sediment from the solvent. Once the paint has been removed, you can use brush soap and warm (never hot) water to remove any residual paint. Then reshape the bristles of the brush with your fingers and lay it out to dry.

Using Painting and Palette Knives
Palette knives can be used either to mix paint on your palette or as a tool for applying paint to your support. Painting knives usually have a smaller, diamond-shaped head, while palette (mixing) knives usually have a longer, more rectangular blade. Some knives have raised handles, which help you avoid getting wet paint on your hand as you work.

Adding Mediums
In addition to the medium or thinner you choose, be sure to purchase a glass or metal cup to hold the additive. Some containers have a clip built into the bottom that attaches easily to your mixing palette.

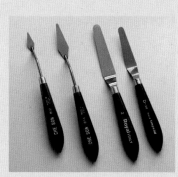

Finishing Up
Varnishes are used to protect your painting—spray-on varnish temporarily sets the paint, and brush-on varnish will permanently protect your work. See the manufacturer's instructions for application guidelines.

Checklist of Basics
At right is a list of the materials you'll need to purchase to get started painting in oils. (For specifics, refer to the suggested brushes and colors on page 6.)

- 9 basic oil colors
- 6 brushes and palette knife
- Medium (copal or linseed oil)

- Thinner (mineral spirits or turpentine)
- Containers for thinner and medium
- Palette and palette paper

- Easel
- Supports
- Paper towels

COLOR THEORY

A color wheel can be a handy visual reference for mixing colors. All the colors on the color wheel are derived from the three *primary* colors (yellow, red, and blue). The *secondary* colors (purple, green, and orange) are each a combination of two primaries, and *tertiary* colors are mixtures of a primary and a secondary (red-orange, yellow-orange, yellow-green, blue-green, blue-purple, and red-purple). *Complementary* colors are any two colors directly across from each other on the color wheel, and *analogous* colors are any three colors adjacent on the color wheel. When discussing color theory, there are several terms that are helpful to know. *Hue* refers to the color itself, such as red or yellow-green; *intensity* refers to the strength of a color, from its pure state (right out of the tube) to one that is grayed or diluted; and *value* refers to the relative lightness or darkness of a color or of black.

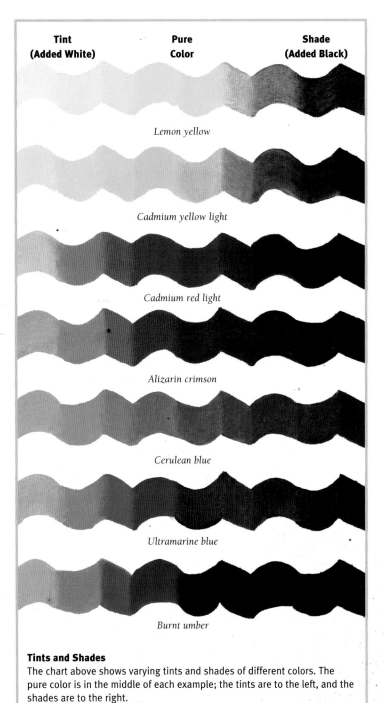

Tint (Added White)	Pure Color	Shade (Added Black)

Lemon yellow

Cadmium yellow light

Cadmium red light

Alizarin crimson

Cerulean blue

Ultramarine blue

Burnt umber

Tints and Shades
The chart above shows varying tints and shades of different colors. The pure color is in the middle of each example; the tints are to the left, and the shades are to the right.

Color Wheel *(labels around wheel:)* Cadmium yellow light · Yellow-green · Green · Blue-green · Cerulean blue · Blue-purple · Purple · Red-purple · Cadmium red light · Red-orange · Orange · Yellow-orange

Color Wheel
Knowing the fundamentals of how colors relate to and interact with one another will help you create feeling—as well as interest and unity—in your oil paintings. You can mix just about every color from the three primaries. But all primaries are not created alike, so you'll eventually want to have at least two versions of each primary, one warm (containing more red) and one cool (containing more blue). These two primary sets will give you a wide range of secondary mixes.

VALUE

The variations in value throughout a painting are the key to creating the illusion of depth and form. On the color wheel, yellow has the lightest value and purple has the darkest value. You can change the value of any color by adding white or black (see the chart at left). Adding white to a pure color results in a lighter value *tint* of that color, adding black results in a darker value *shade,* and adding gray results in a *tone.* (A painting done with tints, shades, and tones of only one color is called a *monochromatic* painting.) In a painting, the very lightest values are the highlights and the very darkest values are the shadows.

COMPLEMENTARY COLORS

As stated above, complements are any two colors directly opposite each other on the color wheel, such as red and green, yellow and purple, or blue and orange. When placed next to each other, complementary colors create visual interest, but when mixed, they neutralize (or "gray") one another. For example, to neutralize a bright red, mix in a touch of its complement: green. By mixing varying amounts of each color, you can create a wide range of neutral grays and browns. (In painting, mixing neutrals is preferable to using them straight from a tube; neutral mixtures provide fresher, realistic colors that are more like those found in nature.)

UNDERSTANDING COLOR PSYCHOLOGY

Colors on the red side of the color wheel are considered to be "warm," while colors on the blue side of the wheel are thought of as "cool." Warm colors can convey energy and excitement, whereas cool colors can evoke a calm, peaceful mood. Within all families of colors, there are both warm and cool hues. For example, a cool red (such as alizarin crimson) contains more blue, and a warm red (such as cadmium red) contains more yellow. Keep in mind that cool colors tend to recede, while warmer colors appear to "pop" forward. This is especially relevant for painting landscapes, as you can use the contrast between warm and cool colors to help portray a sense of distance in a scene.

MIXING COLOR

Successfully mixing colors is a learned skill, and, like anything else, the more you practice, the better you will become. One of the most important things is to train your eye to really see the shapes of color in an object—the varying hues, values, tints, tones, and shades of the subject. Once you can see them, you can practice mixing them. If you're a beginner, you might want to go outside and practice mixing some of the colors you see in nature at different times of day. Notice how the colors of things seem to change as the light changes; the ability to discern the variations in color under different lighting conditions is one of the keys to successful color mixing.

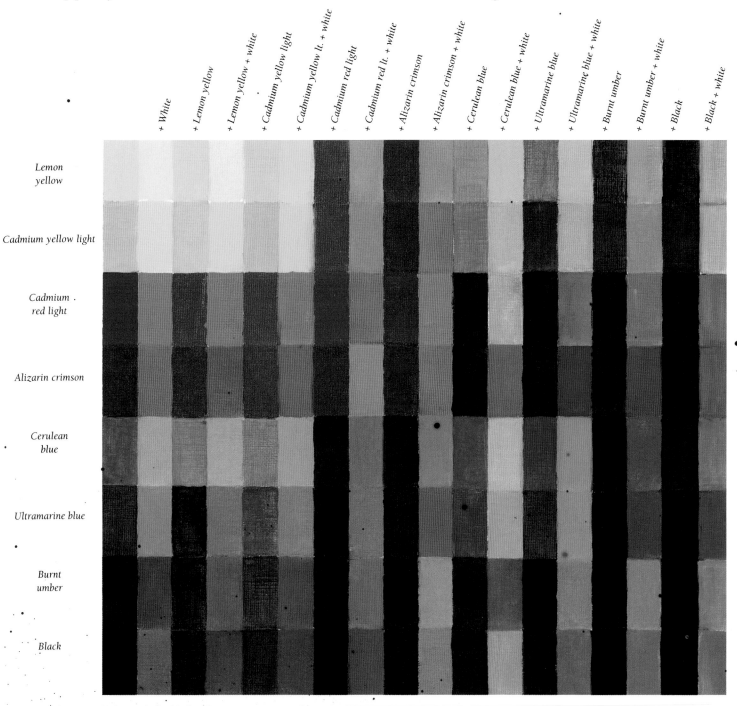

Using a Limited Palette
You don't need to purchase dozens of tubes of paint to be able to mix a vast array of hues. Instead you can use a limited number of paints and mix the other colors you need. The chart above shows just some of the colors that can be made using the nine colors found in the basic palette listed on page 6. You may want to create your own chart using the colors from your palette; this is an excellent exercise in learning to mix color.

DRAWING TECHNIQUES

Drawing is an art in itself. It is also a very important part of painting—even oil painting. You'll often need a light guideline of the shape and form of the subject to start an organized oil painting. (An unorganized form of painting would be the free flow of color in nonrepresentational masses.) Your drawings don't need to be tight and precise as far as geometric perspective goes, but they should be within the boundaries of these rules for a realistic portrayal of the subject.

Drawing is actually simple; just sketch the shapes and the masses you see. Sketch loosely and freely—if you discover something wrong with the shapes, you can refer to the rules of perspective to make corrections.

Practice is the only way to improve your drawing and to polish your hand-eye relationships. It's a good idea to sketch everything you see and keep all your drawings in a sketchbook so you can see the improvement.

In oil painting, there are several approaches to sketching. Some artists use charcoal to sketch directly on the canvas, some "draw" their composition on the support with a brush and paint, and others transfer their sketch to canvas using transfer paper or a projector.

Following are a few exercises to introduce the basic elements of drawing in perspective. Begin with the one-point exercise.

ONE-POINT PERSPECTIVE

In one-point perspective, the face of a box is the closest part to the viewer, and it is parallel to the horizon line (eye level). The bottom, top, and sides of the face are parallel to the picture plane.

A. Draw a horizontal line and label it "eye level" or "horizon line." Draw a box below this line.

B. Now draw a light guideline from the top right corner to a spot on the horizon line. Place a dot there and label it VP (vanishing point). All side lines will go to the same VP.

C. Next, draw a line from the other corner as shown; then draw a horizontal line to establish the back of the box.

D. Finally darken all lines as shown, and you will have drawn a perfect box in one-point perspective. This box may become a book, a chest, a building, etc.

TWO-POINT PERSPECTIVE

In two-point perspective, the corner of the box is closest to the viewer, and two VPs are needed. Nothing is parallel to the horizon line in this view. The vertical lines are parallel to the sides of the picture plane.

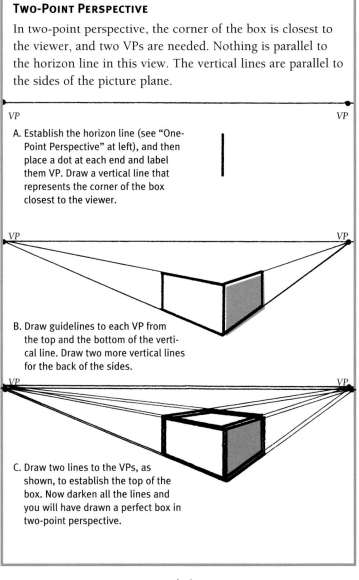

A. Establish the horizon line (see "One-Point Perspective" at left), and then place a dot at each end and label them VP. Draw a vertical line that represents the corner of the box closest to the viewer.

B. Draw guidelines to each VP from the top and the bottom of the vertical line. Draw two more vertical lines for the back of the sides.

C. Draw two lines to the VPs, as shown, to establish the top of the box. Now darken all the lines and you will have drawn a perfect box in two-point perspective.

FINDING THE PROPER PEAK AND ANGLE OF A ROOF

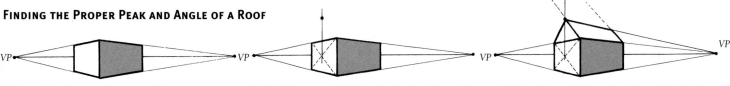

A. Draw a box in two-point perspective

B. Find the center of the face by drawing diagonal lines from corner to corner; then draw a vertical line upward through the center. Make a dot for the roof height.

C. Using the vanishing point, draw a line for the angle of the roof ridge; then draw the back of the roof. The angled roof lines will meet at a third VP somewhere in the sky.

BASIC SHAPES

There are four basic shapes you should know: the cube, the cone, the cylinder, and the sphere. Each of these shapes can be an excellent guide for beginning a complex drawing or painting. Below are some examples of these shapes in simple use.

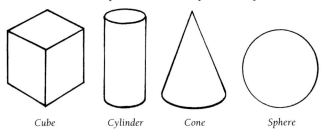

Cube Cylinder Cone Sphere

ELLIPSES

An *ellipse* is a circle viewed at an angle. Looking across the face of a circle, it is foreshortened, and we see an ellipse. The axis of the ellipse is constant, and it is represented as a straight centerline through the longest part of the ellipse. The height is constant to the height of the circle. Here is the sequence we might see in a spinning coin.

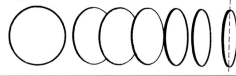

FORESHORTENING

As defined in Webster's dictionary, to foreshorten is "to represent the lines (of an object) as shorter than they actually are in order to give the illusion of proper relative size, in accordance with the principles of perspective." Here are a few examples of foreshortening to practice.

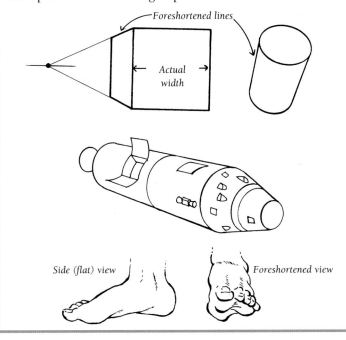

Foreshortened lines

Actual width

Side (flat) view *Foreshortened view*

CREATING DEPTH WITH SHADING

To create the illusion of depth when the shapes are viewed straight on, shading must be added. Shading creates different values and gives the illusion of depth and form. The examples below show a cylinder, a cone, and a sphere in both the line stage and with shading for depth.

Line

Shaded

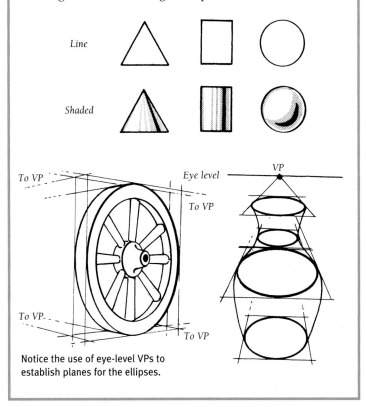

Notice the use of eye-level VPs to establish planes for the ellipses.

CAST SHADOWS

When there is only one light source (such as the sun), all shadows in the picture are cast by that single source. All shadows read from the same vanishing point. This point is placed directly under the light source, whether on the horizon line or more forward in the picture. The shadows follow the plane on which the object is sitting. Shadows also follow the contour of the plane on which they are cast.

Light rays travel in straight lines. When they strike an object, the object blocks the rays from continuing and creates a shadow relating to the shape of the blocking object. Here is a simple example of the way to plot the correct shape and length of a shadow for the shape and the height of the light.

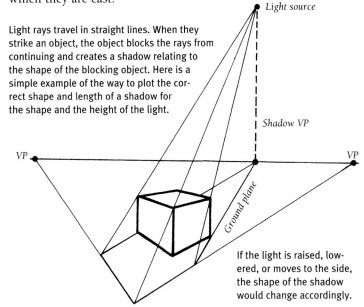

Light source

Shadow VP

VP *VP*

Ground plane

If the light is raised, lowered, or moves to the side, the shape of the shadow would change accordingly.

PAINTING TECHNIQUES

You can paint with a variety of tools and techniques, and there are many different ways to approach a blank support. Some artists begin by *toning* the support, or covering it with a thin wash of color. This underpainting provides a base to build colors on, and it is sometimes even allowed to show through in places in the final painting. Using a toned support can help you avoid ending up with "holes" in the final piece that somehow didn't get painted. Generally a toned background is a fairly neutral color; warm colors work well for earth-toned subjects, and blue or another cool hue suits most other subjects. Another approach to oil painting is to build up gradual layers of paint by applying successive glazes (very thin mixtures of diluted pigment). The paint is thinned with medium and then applied with a soft brush over an area that's already dry. Other artists prefer to apply thick applications of paint directly to the support, sometimes blending and reworking the painting as they go. No matter how you begin, it's the final application of the color that will determine the feel of your painting.

Knife Work
To create thick texture, load the edge of a painting knife with color and place the side of the blade on the support. Then draw it down, letting the paint "pull" off the knife. You can also use this effect to blend colors directly on your support.

Impasto
To punctuate highlights or add texture, apply very thick layers of paint to the support (called "impasto"). This texturizing technique creates thick ridges of paint; the dramatic brushstrokes are not blended together but remain visible.

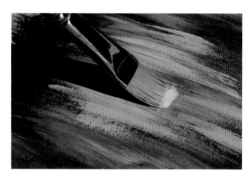

Scumble
Scumbling is an excellent technique for rendering mist or haze to help convey distance in a landscape. With a dry brush, lightly apply semi-opaque color over dry paint, allowing the underlying colors to show through.

Smear
For realistic rocks or mountains, use a palette knife to lightly smear layers of color over another color or directly onto the support. Your strokes should blend the colors slightly, but overworking the area will ruin the texture.

Scratch
To effectively render rough textures such as bark, use a palette knife and quick, vertical strokes to scratch off color. Use the side of the knife, leaving grooves and indentations of various shapes and revealing the underlying color.

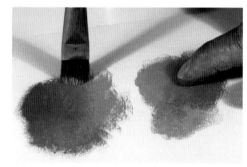

Dab
To achieve a soft, gradual blend, try dabbing color onto the support. Using vertical tapping strokes with a brush or your finger, apply or gently blend the color. You don't need to apply very much pressure; the lighter your touch is, the softer the blend will be.

Slash
Rocks and mountains have jagged, jutting planes and edges. By making angular strokes that follow the direction of the different planes, you can create realistic rocky textures. Use a bristle brush or palette knife for best results.

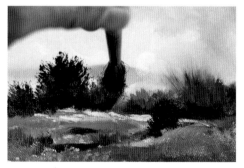

Stamp and Lift
This is a quick and easy way to create background foliage. Using a round bristle brush loaded with paint, push the brush onto the canvas, and then pull it away to stamp a bush. Stroke up with the brush as you lift to create tall grasses.

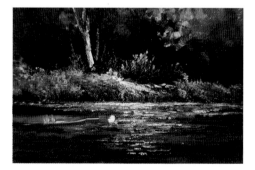

Drag
Dragging is perfect for rendering sunlight glistening on the water; pull the brush lightly across the canvas to leave patterns of broken color over another color. Use a "hit and miss" technique so that the highlights appear to "dance" across the water.

WORKING WITH PAINTING TOOLS

The energy of your strokes will translate directly to your painting. The way you hold your tool, how much paint you load on it, the direction you turn it, and the way you manipulate it will all determine the effect of your stroke. For example, you may use thick paint and broad, angular slashes to render the sharp edges of a cliff, or you may create soft, light, dabbing strokes with thin paint to create foliage. The type of brush you use also has an effect; bristle brushes are stiff and generally hold a generous amount of paint. Bristle brushes are excellent for covering large areas or for scrubbing in underpaintings. Soft-hair brushes (such as sables) are well suited to soft blends and glazes, and they can also be used to create fine lines and intricate details. The more you work with your tools, the more familiar you will become with the effects you can achieve with them. The examples here illustrate some of the techniques you can use to render realistic textures and subjects with oil paint.

EXPERIMENTING WITH SPECIAL TECHNIQUES

Although a brush is a standard tool for artists, there are many other tools you can use to create special effects in oil painting. A palette knife, a rag, a sponge, and even your finger can be used to create texture and highlights in a painting. Special techniques in oil can help you accomplish a variety of exciting variations with your paints, including realistic textures for rocks and sand, complex patterns for starry skies or tangled foliage, and even natural-looking objects like clouds and trees. Experiment with them all to discover the many ways in which you can enhance your paintings.

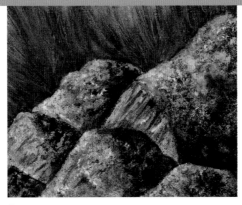

Sponge
A sponge is a simple texturizing tool. You can use a natural silk sea sponge (readily available at most art and craft stores) or even a piece of a clean kitchen sponge. Here different colors are sponged on in layers, creating the appearance and texture of stone.

Stipple
For reflections or highlights, use a stiff bristle brush and hold it very straight, bristle side down. Then dab on the color quickly, creating a series of small dots.

Wipe Away
To create subtle highlights, wipe paint off the support with a paper towel or blot it with tissue or newspaper. To wipe off paint to lighten the color or to "erase" mistakes, use a rag moistened with thinner or solvent.

Spatter
Spattered paint produces tiny dots that can provide a realistic appearance for rocks or sand. To spatter, load a brush with paint and tap your finger against the handle to let the color loose. (You can also use an old toothbrush to create the same effect.)

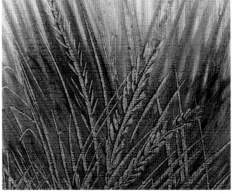

Scrape
Use the tip of a palette knife to scrape color away. This can create an interesting texture or represent grasses.

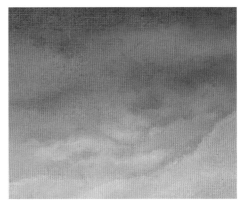

Soft Blend
For a soft blend, lay in the base colors, and lightly stroke the brush back and forth to pull the colors together. Make sure that you don't overwork the area; overblending can muddy up the color and erase the contrasts in value.

Blending Large Areas
A hake brush is handy for blending large areas, such as backgrounds and skies. While the area you want to blend is still wet, use a clean, dry hake to lightly stroke back and forth over the color for a smooth, even blend. These soft brushes often leave stray hairs on your canvas, so be sure to remove them before the paint dries. And never clean your hake in thinner until you're sure you're done blending for the rest of the painting session; these brushes take a long time to dry.

PAINTING TECHNIQUES (CONTINUED)

Drybrush
This woodgrain effect was created with a drybrush technique. Load a dry brush with thick paint (no paint thinner) and lightly drag it across the canvas to create broken, textured strokes.

Dark over Light
This example and the one at right show the same colors on different backgrounds. Colors appear darker on the light background because there is more contrast.

Light over Dark
Here the same colors used on the left are painted on a darker background. Notice that these colors appear lighter than those in the previous example.

Thick Paint
To make this loose blend, load the paint onto the brush and apply it fairly thickly, continuously changing color mixtures and stroke directions.

Sawtooth Blend—Step One
For a smooth, even blend, paint two colors next to each other; then use a flat brush to pull the two color together in a zigzag motion.

Sawtooth Blend—Step Two
After making the sawtooth pattern, move the brush horizontally back and forth to blend the colors evenly. Use this blending technique for large areas.

Foliage
To create the appearance of bushes and foliage, load a flat brush with paint and gently push it repeatedly in an upward motion. Paint the darker values first; then add the lighter colors.

Puddles
Puddles in a road or pathway are excellent landscape elements. Use the warm highlights on the sand to contrast with the cool tones in the water.

Clouds
To paint realistic cloud forms, allow some of the background sky color to mix into the shadow areas to create depth.

Mountains
To paint this rock formation, use a dark brown to lay in the overall masses. Mix white, yellow, and crimson to create the rough texture and add highlights.

Bark
To imitate bark texture, paint the tree trunk with dark brown. Then use white, yellow, and crimson in short, vertical strokes to add the illusion of dappled sunlight.

Details
The point of a round brush can be used to draw details such as leaves, branches, and grasses. For a bushy texture, lay the brush on its side, and use a stamping motion.

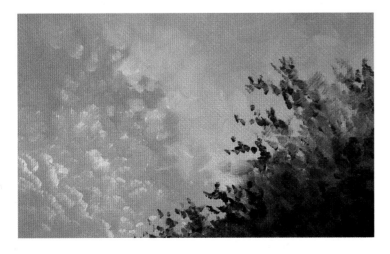

Depth
You can create the illusion of atmosphere and depth by adding sky color into the green values of the distant trees. Use loose, softened brush strokes to paint them. For the foreground trees, apply darker mixtures, establishing the general forms first. Then paint details over them, simulating leaf and foliage shapes.

Glazing
This is an example of *glazing,* or stroking ·er a dry layer of paint th a thinner layer to ild up color. Thin the int with medium, and ag a soft brush lightly ·er the area.

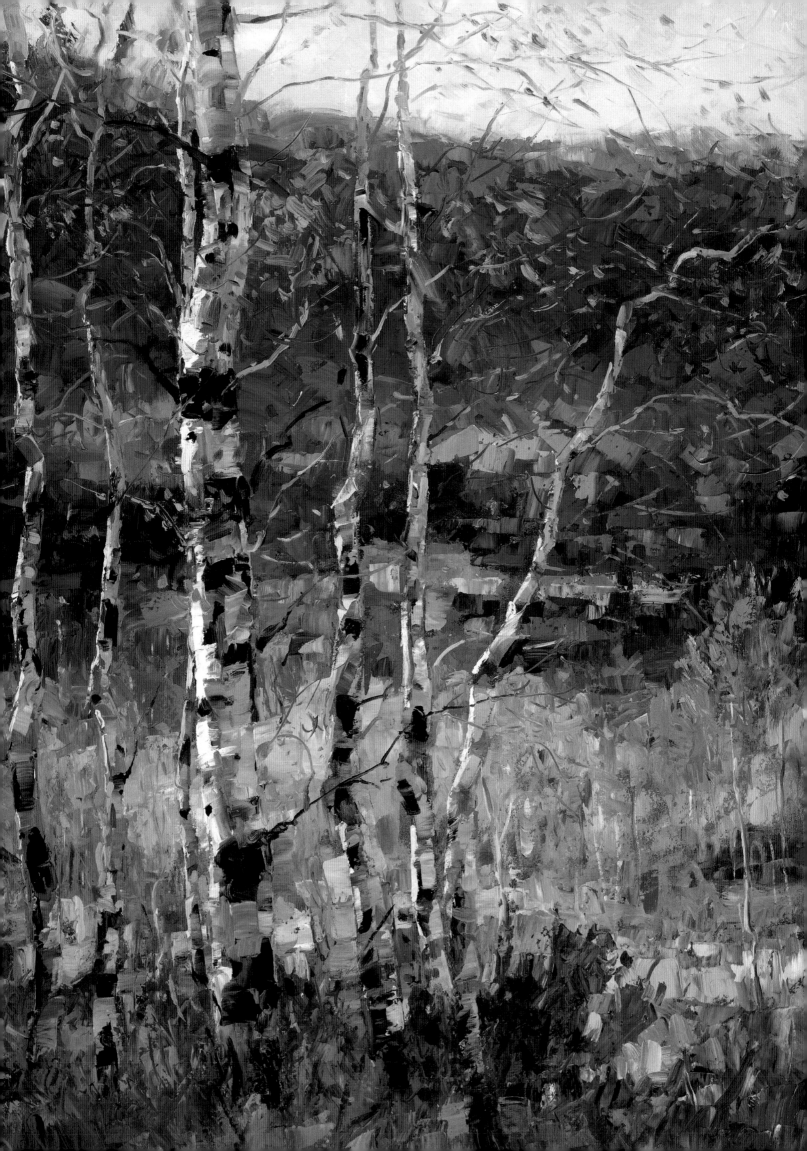

PAINTING WITH ROBERT MOORE

The colorful paintings of Robert Moore clearly communicate his deep respect and appreciation for nature. A one-time aspiring lawyer, he earned a Bachelor of Science degree from Eastern Oregon State College. His increasing desire to pursue fine art brought him a full scholarship to the Art Center College of Design in Pasadena, California, where he majored in illustration and graduated with honors. Much of his initial study included color theory classes that transformed his color blindness into a positive and distinctive element in his work and teaching. Living along the Snake River in Idaho with his wife and children, Robert is surrounded by the same scenic beauty that first captivated him as a child. Using vivid colors and high-key values, he prefers to work on location to best capture the immediate impression of each subject. Robert teaches workshops twice a year out of his studio/gallery in Declo, Idaho.

CREATING LIVELY FLORAL STILL LIFES

Most folks want to paint flowers because they're taken by the freshness and brilliance of the colors. To capture their short-lived beauty on canvas almost seems to defeat time. Oil paint is an ideal medium for creating flowers' colors, whether delicate or vibrant. It is also excellent for depicting the varied textures of soft petals and crisp foliage. Myself, I like the compositional challenge of painting bouquets and setting up imaginative still lifes.

APPROACHING YOUR WORK

A word of caution about spending a lot of time in the planning stage: Sometimes the best compositions are the accidental ones—coffee cups on the kitchen table with a jar of posies. Don't strive for the perfect setup or the perfect painting. Even if you admire the work of another artist, you don't want to paint exact copies. A painting is an expression of your own individuality, so paint for yourself and not for the approval of others. Think about what you are painting—the beauty of the flowers—and don't worry about how the painting will turn out. It will be just fine.

FINDING BALANCE

When I am setting up a still life, I try not to overcrowd the flowers in the vase; I let them droop and sprawl. If the arrangement is tall, I'll put something at the sides for balance (fruit, a dropped blossom, or favorite crockery) so it's not too vertical. I move the vase around so my viewpoint is interesting, not necessarily straight on, but perhaps looking down or looking up at the arrangement.

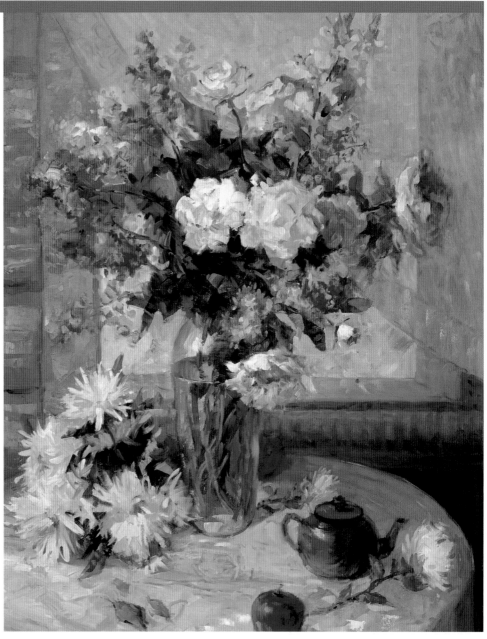

Adding Movement
I chose a view looking down at the setup so there would be plenty of movement (from the teapot up to the bouquet and down again to the flowers on the table). Note all the different flower positions; no two are angled exactly the same.

Painting the "Puzzle Pieces" of Glass
A glass container will distort the shapes of objects behind it and in it. So don't think of it as a glass vase with flower stems in it. Instead think of it in terms of shapes, colors, values, and intensity. Look for the highlights and darks that give clues to the shape—how the rim or the curved bowl catches the light, or how the elliptical base is a darker curve on one side. It's like a jigsaw puzzle where the individual shapes don't make sense until you cover the entire area and step back. Voilà—glass!

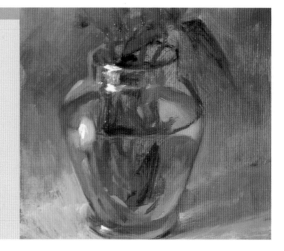

Starting Lean
When I painted these leaves, I started with a "lean" layer of relatively thin paint to establish a good base color.

Building up Fat
I used my palette knife to build up "fat" color with strokes of very thick paint, being sure to leave hard ridges at the edges for extra dimension.

Noting the Negative Spaces
When painting pale flowers, I find it helpful to paint the dark shapes surrounding them. If I accurately render the "negative" shapes, the flowers seem to emerge—a positive result!

ADDING COLOR AND DIMENSION

Once I have my flowers displayed to my liking, I look for patterns, not individual petals. Otherwise, it's too easy to get bogged down in the details and lose the "whole picture." First I roughly paint in the outline of the entire shape of the arrangement. Next I block in the basic circle or oval shapes of the blossoms. I usually start with large areas of thin color, gradually building up thicker color and finer details. This process is called painting "fat over lean" (see the captions for the leaves on the opposite page). Another technique, called "impasto" (see page 12), can also be used to add ridges to the edge of a petal or leaf. I don't work thickly right away, though, because thick paint takes a long time to dry.

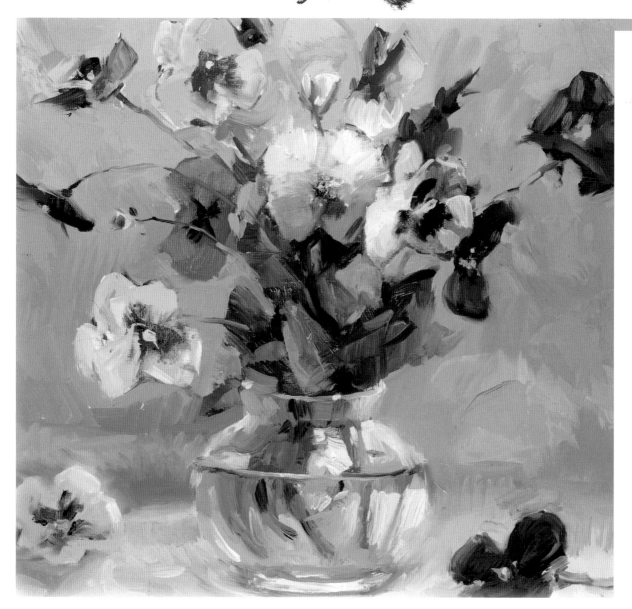

Working Quickly
I painted this *alla prima*, or all in one session, since fresh pansies don't last long. Painting this way gives a fresh and spontaneous feel.

RENDERING SEASONAL TREES

I enjoy painting trees because there are so many different types and they change dramatically with each season. Experiment painting a variety of tree shapes—spreading oaks, columnar poplars, conical firs, twisted olives, and fanlike palms. Choose one or several of your favorites and make them the focus of your painting. You will discover that oils are the perfect medium for rendering trees because the paint can be stippled impressionistically to suggest dense foliage or layered thinly to let each successive color shine through.

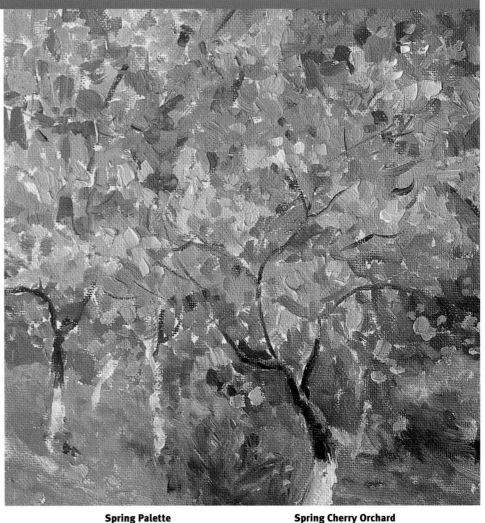

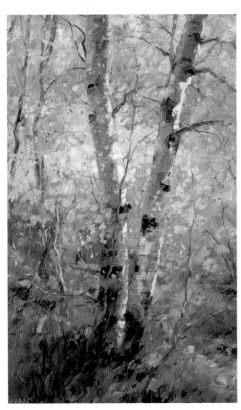

Autumn Aspens
For the fall foliage here, I used mixes of burnt sienna, cadmium yellow light, and cadmium yellow medium, with touches of violet. The warm colors are dazzling, but I think that the peeling bark is just as interesting. To paint the bark, I used a flat brush to make short, horizontal strokes that follow the curve of the trunk.

Spring Palette

Dark values: white, alizarin crimson, and violet

Middle values: white and alizarin crimson

Light values: white, violet, and alizarin crimson

Spring Cherry Orchard
When I'm painting spring trees in bloom, such as these cherry trees, my palette is predominantly pink, with mixes of alizarin crimson, violet, and white.

Autumn Palette

Dark values: burnt sienna plus specks of alizarin crimson, cadmium orange, and violet *Middle values: cadmium yellow light and cadmium yellow medium plus a speck of violet* *Light values: cadmium yellow light plus a speck of titanium white*

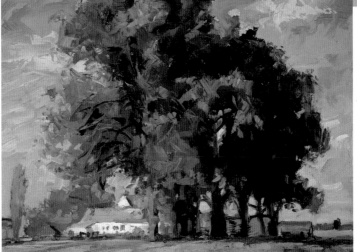

Summer Cottonwoods
The huge canopies of these trees almost hide their trunks and branches! Summer leaves are painted with a lot of greens and blues, with yellow and white for highlights.

Summer Palette

Dark values: burnt sienna, cobalt blue, viridian green, and quinacridone violet

Middle values: yellow ochre, burnt sienna, viridian green, and cadmium yellow medium

Light values: cadmium yellow light plus white and viridian green

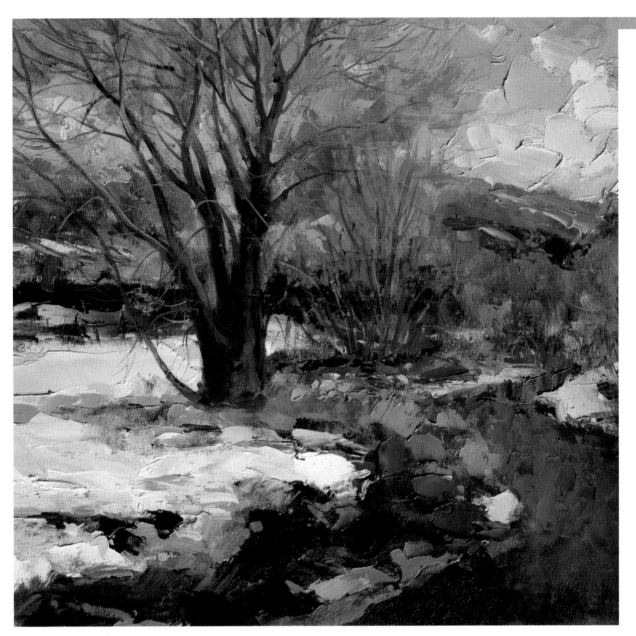

Winter Cotton Wood
The branches are not just painted with boring browns straight from the tube. To make them look realistic, I added ultramarine blue for the shadows and yellow ochre for the highlights.

Winter Palette

Light values: middle-value colors plus a speck more cadmium orange and titanium white

Middle values: burnt sienna, yellow ochre, and cadmium orange

Dark values: burnt sienna and ivory black

Painting Snow
Snow reflects the color of its surroundings—so if it's a bright, sunny day, as it was the day I painted the scene below, I add yellow in the high-lighted areas. I apply pale blue in the shallow indentations and a darker blue-gray in the deeper footprints. Since the snow surface is not flat, I vary the size, shape, and direction of my strokes to emulate the drifts.

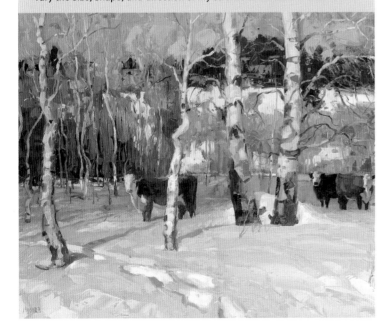

CHANGING SEASONS

Deciduous trees are wonderful subjects to paint throughout the year. The changing of colors in the fall and starkly silhouetted branches in winter are obviously striking. Flowering trees in spring and fruit-heavy trees at harvest time put on an equally flashy show. There are subtler changes too in how the pale yellow-greens of spring deepen to the blue-greens of summer.

LOOKING FOR SIMPLE SHAPES

To paint realistic trees without painting every leaf, I first look for the individual differences, and then I take out any extraneous elements. The main things to look for are the tree's size, the shape of its silhouette, its color, and its leaf density. Also notice how most trunks are not uniformly straight and how branches droop or bend. Observe how some edges are soft and blurred, while others are crisp and detailed. Too many hard edges will outline the tree and make it look flat. (Blending wet paint into a wet background is one sure way to soften your edges!) If you observe closely and follow the shape of the tree's canopy and the order of its branches, I am sure that you will have great success painting convincing trees!

Capturing Water
with Brushstrokes

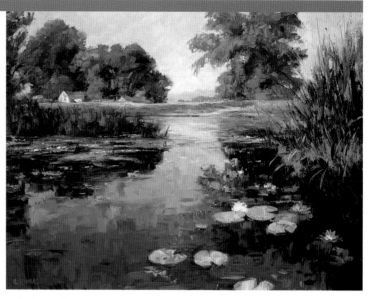

So varied in mood and form, water can be both expressive and intriguing—and oil paint is particularly well-suited for capturing its multiple personalities. By varying the size and direction of my brushstrokes and applying different thicknesses of paint, I can convey many of the fascinating qualities of water. For example, when I apply thick paint with deliberate, swirling strokes, I can create the turbulence of a fast-moving river; when I make short, choppy strokes with a bristle brush, I can depict the anger of a stormy sea; or when I smoothly blend with a soft-haired flat brush, I can mirror the serenity of an alpine lake.

Simplifying the Elements

Water reflects the colors and images of the clouds, sky, and surrounding landscape. There are also waves, shadows, and the colors of the water itself to contend with. My advice for painting water is to edit and simplify it; don't attempt to faithfully render every ripple. Another tip is to paint with a larger brush than you would usually use, because it will force you to paint in a very loose, interpretive way—just what is needed to capture the freedom and movement of water.

Painting Reflections
Moving water reflects; it does not mirror precisely. When I painted the reflections and shadows of the waterlilies, I did not exactly match the colors and shapes of the actual plants. Instead I painted the reflections with blurred edges and darker colors.

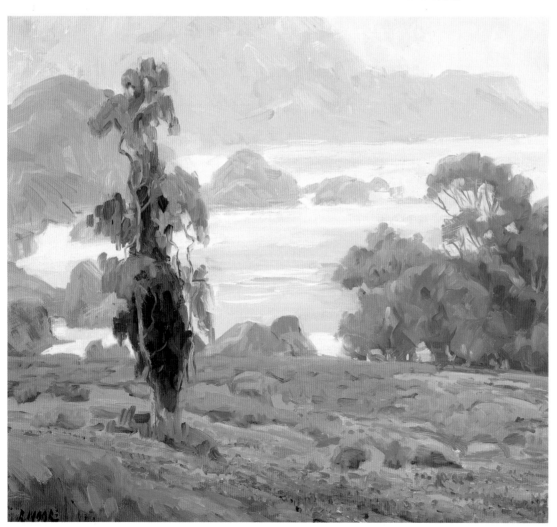

Painting Sun on Water
Using both brush and palette knife for this sample, I've portrayed rippling water using brisk strokes of white, cadmium yellow light and medium, and ultramarine blue "grayed" with cadmium red medium and cadmium yellow medium.

Creating Depth
I was fortunate the day I painted this ocean scene. A mist shrouded the details and left the trees and rocky coastline outlined—nature had simplified the shapes for me. I avoided overblending the blue and white of the water close to shore, so that the ridges of paint would appear to be waves.

BLENDING WET PAINT

Oil paint dries slowly, a quality I often try to use to my advantage when painting waterscapes. I can "push" the paint around, lightly blending together adjacent wet colors. This works especially well when depicting wave action in the distance, where the colors are muted and the water is smoother. I blend the paint less in the foreground because I want the colors and brushstrokes to remain clear and vibrant. Of course, when moving paint around, there is also the risk of churning up the underlying colors, which is something to be avoided as it makes for muddy colors.

Rendering Still Water
I wanted the cloud reflections in the lake to be the focal point of my painting, so I framed them with the curve of the shoreline and the foliage in the foreground. The viewer sees more of the dark undersides of the clouds and only a glimpse of the light tops in the water reflection. The water appears to be still and glassy, in part because the reflections of the sky and trees are undistorted.

Discovering the Colors of Water
We most often think of water as blue, but it can also be turquoise, brown, green, gray, or gold. Color comes not only from reflections but also from objects and particulates in the water itself. The mountain stream in the painting below is reddish-brown from decaying leaves. It also reflects the golds of the surrounding trees and reveals the browns of the rocky riverbed. For the shadows, I used a mixture of burnt sienna, viridian green, cobalt blue, and violet. I mixed yellow ochre, burnt sienna, viridian green, and cobalt blue for the green reflections in the water, and I used a combination of yellow ochre, burnt sienna, cadmium orange, and white for the reflections of the trees.

UNDERSTANDING LIGHT

I t is the impression of light that brings life to an oil painting. So often I find that it's not what I paint that grabs my attention but how the light falls on that object. I don't need to pack up and move to the south of France to be enraptured by light. Even ordinary objects are transformed. A stack of hay bales in the slanting afternoon light is suddenly a thing of beauty— I am seeing the world with "new" eyes.

COMPARING LIGHT DIRECTION

The direction and intensity of light influences how the form is seen and how we perceive the mood of a scene. When light is hitting the subject head-on, there are minimal shadows and colors take on a special vibrancy. Light coming from behind the subject tends to flatten forms into silhouettes and to illuminate their edges, giving a halo effect. Three-quarter and side lighting create strong shadows and bright highlights; contrasts are intense, and perspective is accentuated, making forms look very three-dimensional. I like the control I get when using a spotlight indoors; but nothing can compete with the splendor of sunrise, sunset, and the effects of natural light outdoors!

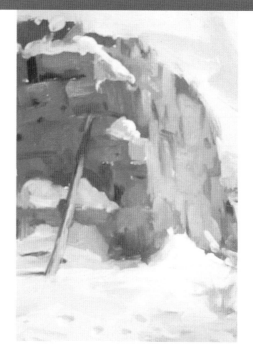

Three-quarter Lighting
This wall of hay bales has all the solidity of a building. The strong angled lighting illuminates one plane of the hay "wall," leaving the front in shadow, and creating a sense of dimension. As you can see in the sketch at right, the light source is to the right, so that's where I place the highlights on the hay and snowdrifts.

Light source

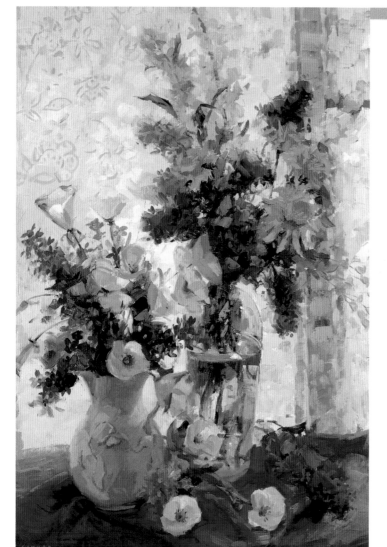

Back Lighting
Because you can't see the strong highlights when the subject is backlit, it's sometimes difficult to tell just where the light source is. The sketch at right shows that the light is coming in from the window behind the floral still life. Can you see the subtle "halo" effect around the flowers? I especially like the way the back lighting casts shadows across the foreground, giving this arrangement stature and drama.

Light source

RENDERING REFLECTED LIGHT

Light can be focused and intense or diffused and soft. It can also bounce, and when it does, it creates wonderfully luminous reflections. Reflected light can come from the sky or from a nearby light-colored object. The lighter in color and shinier an object is, the more light it will throw. Reflected light is a very important factor; when recorded in an oil painting, it enhances the overall atmosphere and form of the subject dramatically.

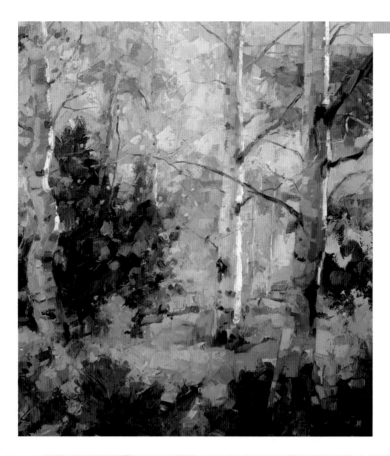

Side Lighting

The strong side lighting, illustrated in the drawing below, reaches into the shadows and allows me to show the colors of reflected light as it strikes the forms of the trees. The birch on the far right reflects the cool blue of the sky and the crooked trunk on the left shows the reflected colors of sun-lit leaves. These subtle touches really bring the subject to life.

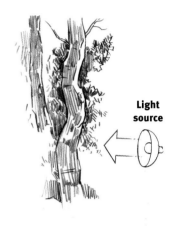

Light source

Front Lighting

A direct frontal light source (see the diagram below) illuminated the baby's blanket and created lovely highlights on the mother's face, bringing these elements to the forefront. Front lighting also eliminated virtually all cast shadows, which accentuated the colors of the various fabrics and kept the mood of this mother and child painting light and tender.

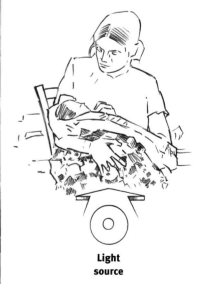

Light source

CONVEYING MOOD WITH COLOR

Colors are often thought of as happy (yellow) or sad (blue), but there's much more to it than that. Have you ever come across a painting of yellow sunflowers and, without thinking, found you just had to smile? Or perhaps you involuntarily shivered when looking at a landscape rendered in various shades of blue. These are very real examples of how color affects us. In the paintings on these two pages, I've used color to convey particular moods. Look at each work and think about how it makes you feel. I'll bet it has something to do with the colors!

TAKE ADVANTAGE OF COLOR'S MOODS

As mentioned before (see page 9), colors are considered to be either warm or cool. Warm colors evoke excitement, passion, or even danger; cool colors are calm and serene. So choose your colors to fit the mood you want to convey. You would not want to paint a sad subject in cheery colors, nor a lighthearted scene in a somber palette. Feel free to change colors to fit the mood; paint a brown cottage a bright red, for example. You can also make your colors less or more vibrant: Mix some blue into a hot red and it will appear cooler; or add yellow to green to give it warmth. Experiment and see how different colors affect you.

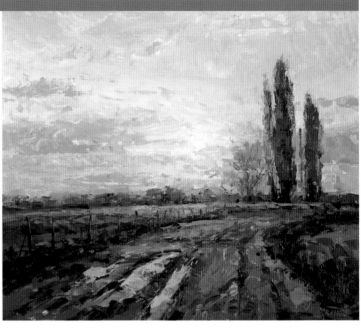

Contrasting Colors
This landscape, with its icy, rutted road catching the colors of sunset, uses a complementary color scheme (see page 8) of yellow and purple. The yellow of the sun provides the only bit of warmth in the chilly lavender expanse of the scene.

Warm Color Palette
Here I've used warm colors almost exclusively because the autumn subject matter called for them, and because the rich golds and russets make the cottonwoods glow with excitement.

Cool Color Palette
With its predominately cool shades of purple and gray against a dark violet and blue background, this still life with flowers and tea service conveys a soothing, peaceful feeling.

Using Only One Color

Painting with different values (lights, mediums, and darks) of only one color is a wonderful exercise. I especially enjoy painting people this way. Although the color palette is very limited, a monochromatic painting still conveys a definite mood; one with mainly low (dark) values creates a foreboding or mysterious effect, while one with primarily high (light) values is bright and hopeful. (See page 8 for more on value, tints, and shades.)

Establishing the Form

To create a serious mood for my painting of a Civil War soldier, I chose a monochromatic blue color scheme. I began by outlining the general shapes and masses to help me place the light, medium, and dark values.

Blocking in Values

Next I filled in the large masses with different values of ultramarine blue, starting with the darks and working toward the lights. At this stage, the face is flat and featureless, but it still "reads" as a man with a cap.

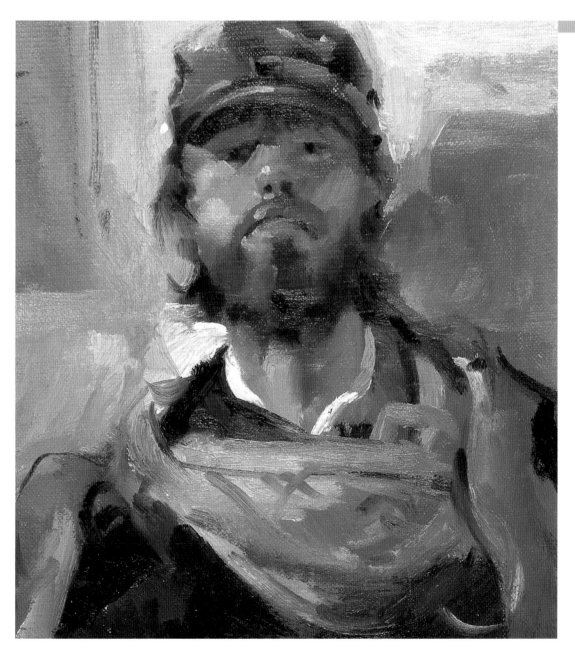

Seriously Blue

I continued to use different values of ultramarine blue to create depth and add details. Notice that the whites of the soldier's eyes are not painted white. They are shaded by the hat, so pure white would be unnaturally bright. The overall mood of this monochromatic portrait is somber—intentionally so.

FOCUSING ON FACES

I've saved the best for last. The human face is a natural focus for oil painting, with no two exactly alike. And the special appeal of children is universal—you had better catch them while you can; they grow up so fast! Whether you choose to paint someone you know or a model, achieving a good "likeness" is no different than painting a landscape or a still life. Closely observe the subject, get the proportions correct, and pay attention to the shapes, planes, and shadows. Not hard at all!

POSING YOUR SUBJECT

In portraiture, you want to capture the physical qualities, the mood, and the personality of your subject. To do so takes a little forethought. Do you want your subject looking directly at you? How much of the head and shoulders will you put in? And do you want to include the hands as a balance to the face? Think about the background. If you are painting a portrait of your grandmother and her favorite room is the kitchen, by all means, pose her there.

A CHILD'S PROPORTIONS

Compared to the oval adult face, a child's round face will have a larger forehead (the brow is at the halfway mark), wider-set eyes, and a shorter nose.

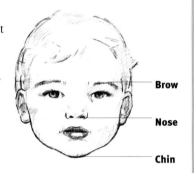

Brow

Nose

Chin

AN ADULT'S PROPORTIONS

Measuring from the top of the head to the chin, the eyes are at the halfway mark. Place the bottom of the nose halfway between the eyes and the chin.

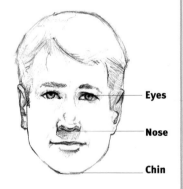

Eyes

Nose

Chin

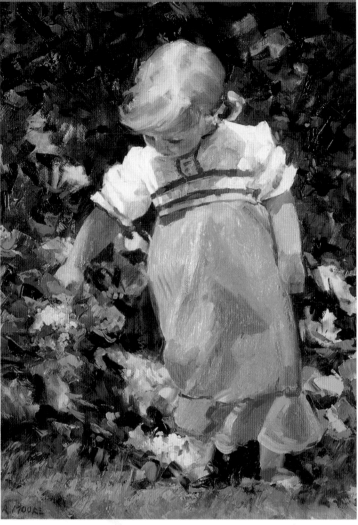

Choosing the Pose
I painted this shy toddler reaching for a flower as an informal portrait. I chose to downplay her facial features and instead emphasized the pose—one that captures the curiosity of youth.

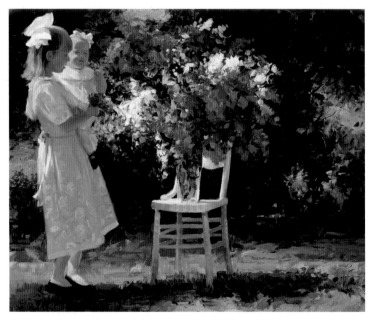

Telling a Story
I like to paint portraits that are a "slice of life"—freezing the moment and the movement midstride. I used delicate colors for the young girl's and baby's clothing to stress the children's youthfulness and innocence and to help keep the overall mood of the painting light.

OBSERVING YOUR MODEL

Certain proportions are useful to know when painting faces. Generally, the middle of the eyes are at the horizontal halfway mark of an adult's head. The top of the ears line up horizontally with the top of the eyes, and the bottom of the ears line up with the bottom of the nose. The pupils of the eyes align vertically with the corners of the mouth. But everyone is different, so notice how the features of individuals depart from the norm. Remember that patience and practice are the keys to success in painting!

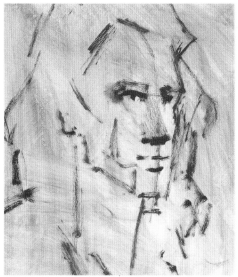

Painting a Face in Monochrome
This is the best way to start painting portraits. Without the need to match skin tones, you can concentrate on the essential proportions of the face.

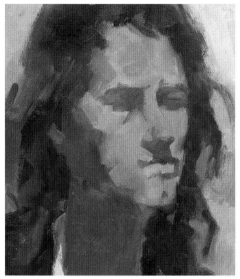

Finding the Shape Through Shadows
After roughing in the guidelines, I blocked in the shadow planes of all the facial features.

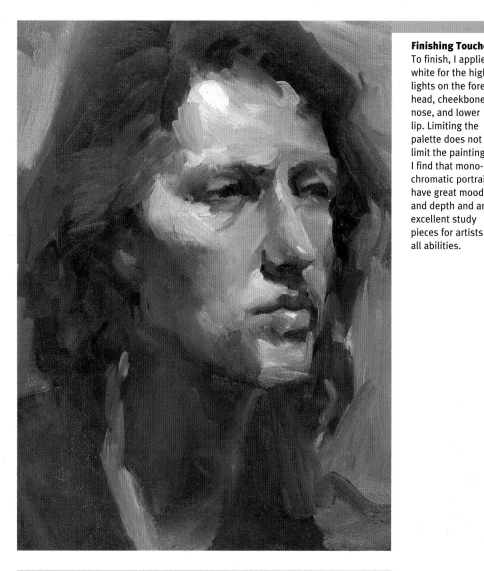

Finishing Touches
To finish, I applied white for the highlights on the forehead, cheekbone, nose, and lower lip. Limiting the palette does not limit the painting. I find that monochromatic portraits have great mood and depth and are excellent study pieces for artists of all abilities.

USING VALUES

The value scale shows the different values of ultramarine blue I needed to mix and where I used them on the face. I find it easier to mix a range of colors I think I'll need before I paint. That way I don't have to stop painting and mix my paints every time I need a new color.

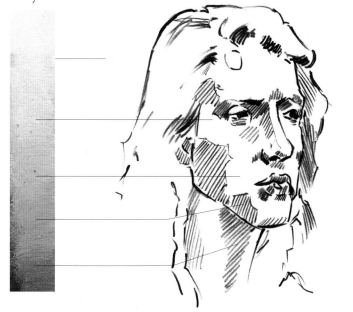

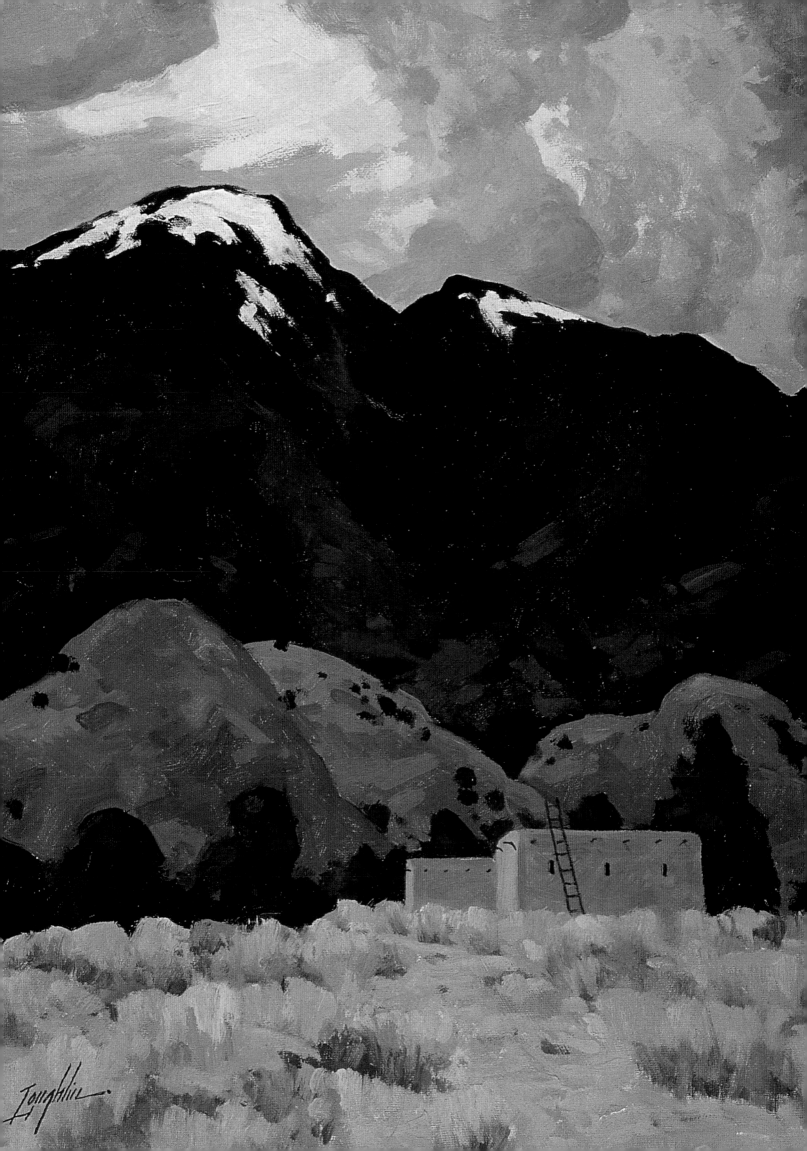

PAINTING WITH JOHN LOUGHLIN

John Loughlin, a New England artist, lived in Lincoln, Rhode Island, and was known for his oil paintings, watercolor paintings, drawings, and fine art prints. Specialized in capturing the natural beauty of the New England countryside, John's work is included in many corporate and private collections throughout the East Coast and nationally. John was a member of the Guild of Boston Artists and a recipient of the Great Gatsby Memorial Award from the Rockport Art Association. He won numerous other awards in regional and national exhibits, including a Medal of Honor for oil painting and election into the American Watercolor Society. John passed away in 2004.

BOULDERS IN SNOW

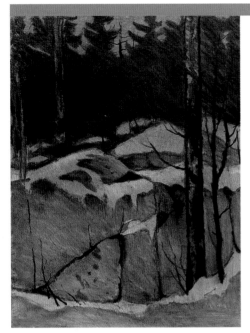

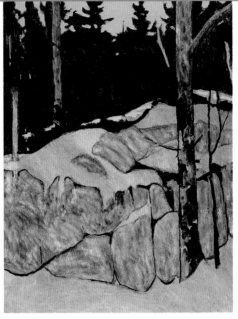

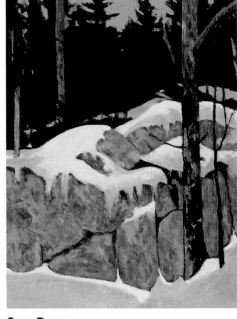

STEP ONE

I begin with a mixture of Mars violet and black thinned with turpentine to tone the entire canvas, making sure I achieve a balanced mid-value hue overall. (If the undercolor is too dark, subsequent dark-value colors won't appear dark enough in contrast; if it is too light, subsequent light-value applications won't read well.) After the wash is dry, I sketch the composition over it. I concentrate on blocking in the areas with the lightest highlights as well as the darkest shadows.

STEP TWO

Using a round brush and a thicker version of the undercolor mixture, I block in the basic shapes of the rocks. Then I block in the dark woods, thoroughly shading the entire area. I also indicate the dark areas of the large tree on the right and some shadows on the underside of the rocks. Next I paint the sky between the trees with a mix of cerulean blue and white. Using the same cerulean blue and white mixture, I add a few small patches of snow in the dark wooded area.

STEP THREE

After painting in New England for many years, I've learned that snow is never actually white. It always reflects other hues, and it changes in value depending on where it's illuminated and shadowed. Here I paint the snow on the rocks and in the foreground using a mix of white, cerulean blue, and cobalt violet. I deepen the mix slightly for the foreground, as this area is shadowed by the rocks.

Undercolor
Black, Mars violet, and turpentine

Snow
White, cerulean blue, and cobalt violet

Rocks

Black and Naples yellow light

Naples yellow light and chromium oxide green

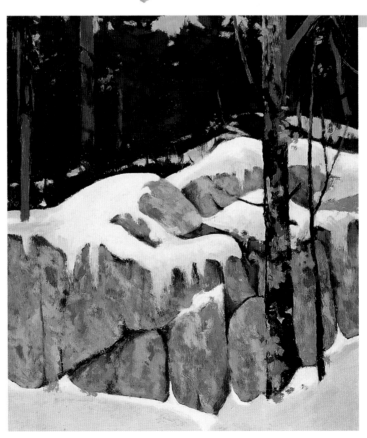

STEP FOUR

I develop the textures of the rocks, creating an overall mottled effect by mixing several different colors. I apply one mix of black and Naples yellow light and another mix of Naples yellow light and chromium oxide green, varying the direction of my brushstrokes to create a random, natural-looking blend of color and allowing small areas of the toned canvas to show through. I apply color to the darkest areas of the woods with mixes of alizarin purple, burnt sienna, and black, and I introduce some colorful foliage with a combination of cadmium orange, Naples yellow light, and burnt sienna.

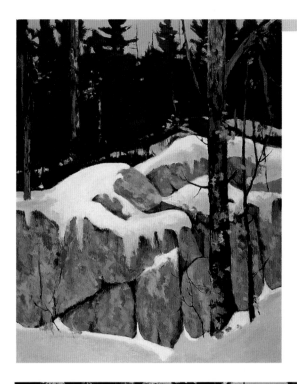

STEP FIVE

To develop the texture of the rocks, I use white to lighten the rock mixtures from step four and then apply the colors using short, choppy strokes. I leave areas of darker gray showing through here and there to emphasize the mottled color. I also add more yellow leaves throughout the composition. Then I retouch the sky and make it more colorful with additional touches of phthalo blue and white.

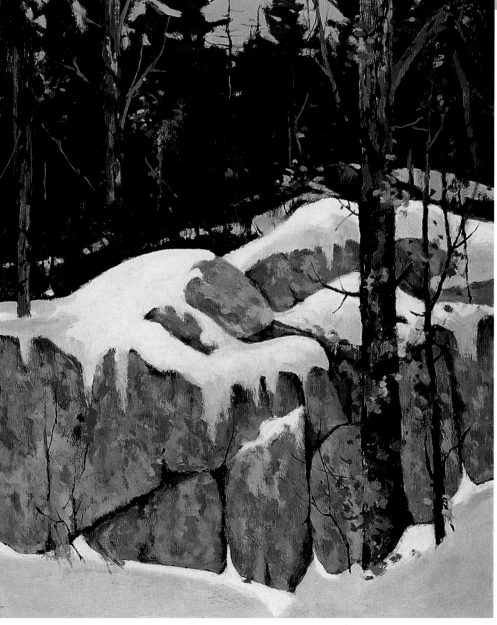

STEP SIX

Now I step back from my painting so I can see where it needs more depth and detail. I decide to add some lighter branches to the trees using a mix of burnt sienna, black, and white. Then I highlight some of the trees with a light green mix of chromium oxide green and yellow ochre. Finally I punch up the violets in the dark areas with a combination of cobalt violet, alizarin purple, and a little white.

BIRCH TREES

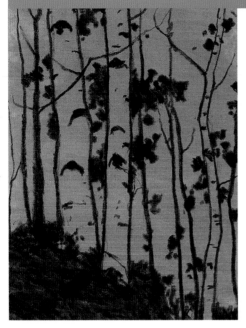

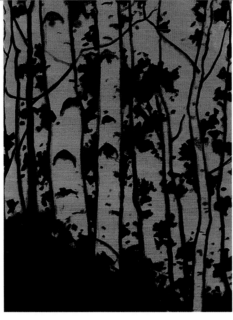

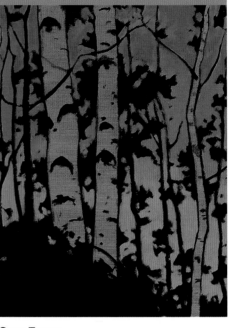

STEP ONE

I use a mix of Mars violet and black thinned with turpentine to tone the entire canvas. Once this underpainting is dry, I sketch the composition with soft vine charcoal, which allows me to erase and correct my composition as I draw.

STEP TWO

I use a small round brush and a mix of black and Mars violet with very little turpentine to paint over the outlines of the birches. I also indicate the smaller branches of the other trees with quick, loose strokes. I then block in the dark leaf shapes and the darker areas of the foreground.

STEP THREE

Now I block in the blues of the sky around the dark shapes. For the upper third, I use a mix of cobalt blue, cobalt violet, and a little white. For the middle third, I use a lighter mix of cobalt blue and white. For the lower third, I use a mix of Naples yellow light, viridian green, cerulean blue, and white.

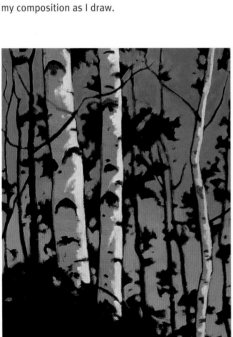

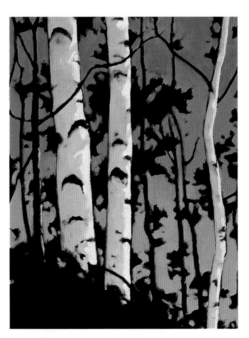

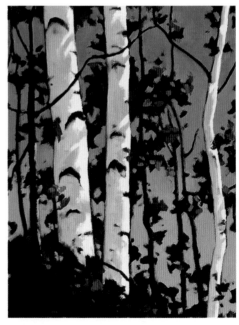

STEP FOUR

Now I'm ready to paint the lighter values—the highlights on the tree trunks. My light source is coming from the upper right, falling on the right side of the three trees in the foreground. I use Naples yellow light and white to cut into the right sides of the trees, painting choppy, irregular strokes to make the light look as though it's filtered through leaves and branches. I apply the paint thickly, using an impasto technique because I want the paint to be more opaque and therefore true to bright, strong light in nature. Many artists like to create the rough, textured look of impasto with the flat side of a painting knife, but I find that my small filbert brush works well here.

STEP FIVE

I don't wait for the thick paint of the highlights to dry before painting the shadowed side of the birches. Instead I blend the light and dark values with crisscrossing brushstrokes to create the natural, wavy, irregular appearance of light. With a mixture of cobalt blue, cobalt violet, and white, I add the shadows to the left sides of the three trees in the foreground, applying a lot less paint than I used for the light sides.

STEP SIX

Once I've blocked in the strongest darks and lights, I'm ready to lay in the colors. I create several slightly varied mixtures of yellow ochre, Naples yellow light, cadmium orange barium, cadmium red light, and alizarin crimson. For the leaves at the bottom left and throughout the shadowed background, I create three darker mixtures—one with a little Mars violet, one with burnt sienna, and one with cobalt blue. Then for the highlighted leaves on the right and in the foreground, I progressively lighten the mix with Naples yellow light and white. I am continually changing my mixtures because I want to create a rich variety of values in the autumn foliage. This creates more depth in the painting.

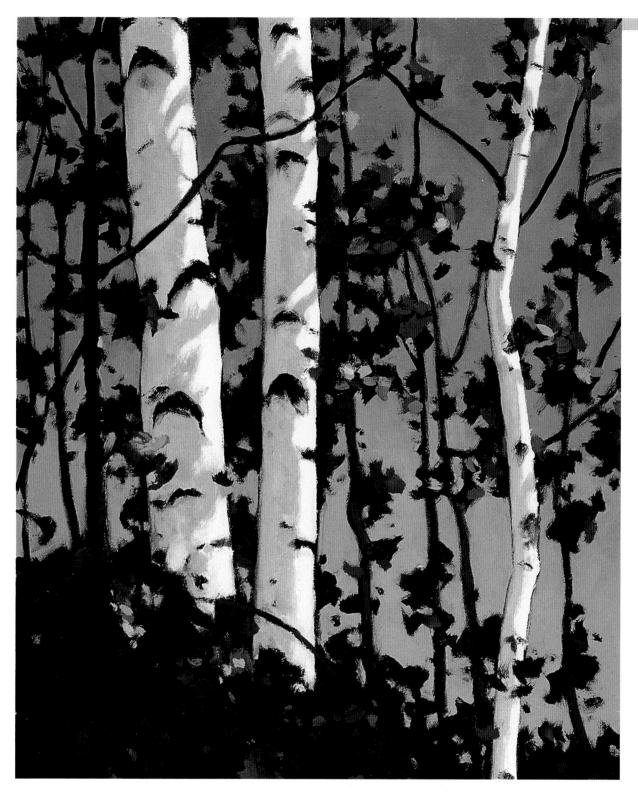

STEP SEVEN

Now I step back and evaluate the birches. I decide the light sides of these trees could use even more texture and that I want to add more warmth with a mixture of Naples yellow light and white. I also want to make the lighting a little more dramatic, so I darken the shadowed sides of the trees with a mixture of cobalt violet, cobalt blue, and a little white. As a final brightening touch, I add some light-colored leaves to a few of the trees and in the foreground. I make these lightest leaves a brilliant yellow that contrasts with the dark oranges and browns and enlivens the entire painting.

NEW ENGLAND BAY

STEP ONE

I begin by covering the canvas with a very light wash of cobalt blue and burnt sienna thinned with turpentine. I use vine charcoal pencil and approach my sketch as a basic outline for where I want to place the colors. I concentrate on capturing the areas where the values change throughout the sky, outlining the shapes of the clouds. Next I indicate the two distant lighthouses on the horizon. Then I block in the dark, large shapes in the landscape, lightly shading these areas with the side of the charcoal.

STEP TWO

Once I'm happy with my sketch, I retrace the outline of each shape with a small round brush and a thin mixture of black and Mars violet. Then I apply all my darkest values. At this stage, I'm still working on my underpainting, filling in the rocks in the foreground and the rest of the land in the distance. Even though the rocks appear to be pure black, I add Mars violet to the mixture to keep the color from becoming too inky and flat.

Dark Values

*Black and
Mars violet*

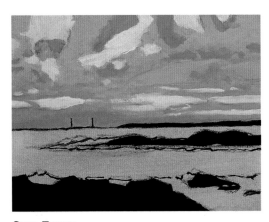

STEP THREE

Now I paint the sky with a mix of cobalt violet and white, stroking horizontally with a small filbert bristle brush. I mix cerulean blue, viridian green, and white for the lower patches of blue sky and create the brighter blue patches of the upper sky with cobalt blue, a very small amount of phthalo blue, and white. For the grays in the upper part of the sky, I mix cobalt violet and white. Then I block in the clouds with a mix of white and Naples yellow light.

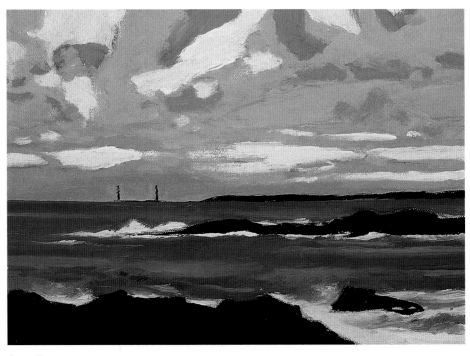

Upper Sky

*Cobalt blue and
cobalt violet* *Cobalt blue
and white*

Lower Sky Horizon

*Viridian green
and cerulean blue* *Cobalt violet
and white*

STEP FOUR

Now I block in the ocean, covering most of the water area with a mixture of viridian green, phthalo blue, and cobalt violet. I add a few dark patches of cobalt blue, cobalt violet, and viridian green. To suggest movement in the water, I add light blue streaks of a cobalt blue and white mixture. I paint the surf around the distant headland and foreground using pure white, varying between thick and thin brushstrokes to create a realistic impression of texture and motion in the tide.

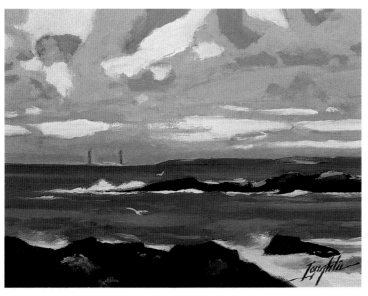

STEP FIVE

Now I add highlights and details to the rocks and distant land forms. With a mixture of Naples yellow light and yellow ochre, I work in the lighter textures of the foreground areas. Then I mix Naples yellow light and cadmium orange barium for the highlights of the middle ground and the land in the background. I lighten the farthest plane of land significantly to emphasize the sun's high midday position and the illuminated horizon.

Foreground Highlights

Naples yellow light and yellow ochre

Distant Highlights

Naples yellow light and cadmium orange barium

STEP SIX

When I step back and assess the painting, I decide to adjust some of the colors. Although I'm happy with the colors I chose in the sky, I want to sharpen the contrast by changing some of the values. I deepen the darkest values by adding more pigment, and I add more white to the lightest values. I also decide some of the values in the ocean are too light and that the surf needs to be brighter, so I add deeper shades of the ocean mixes and then brighten the surf with pure white.

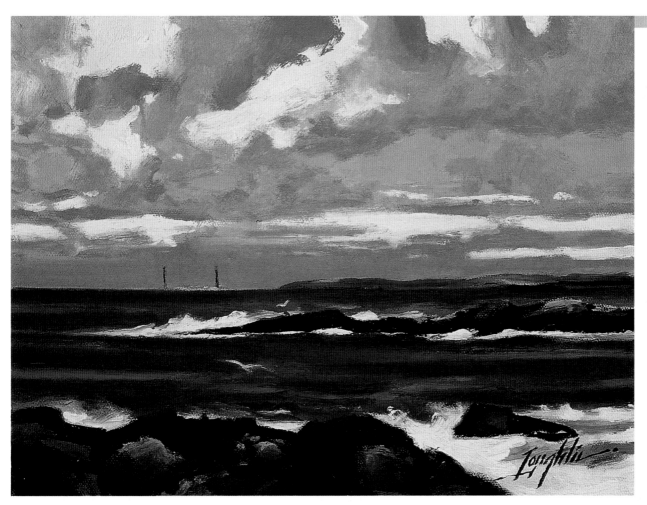

STEP SEVEN

For the finishing touches, I use my small bristle filbert to add a little more detail to the distant headland and in the foreground. For the details in the distance, I use Naples yellow light with a touch of cadmium orange. I mix Naples yellow light, yellow ochre, burnt sienna, and black and lightly brush on some final touches of texture to the foreground.

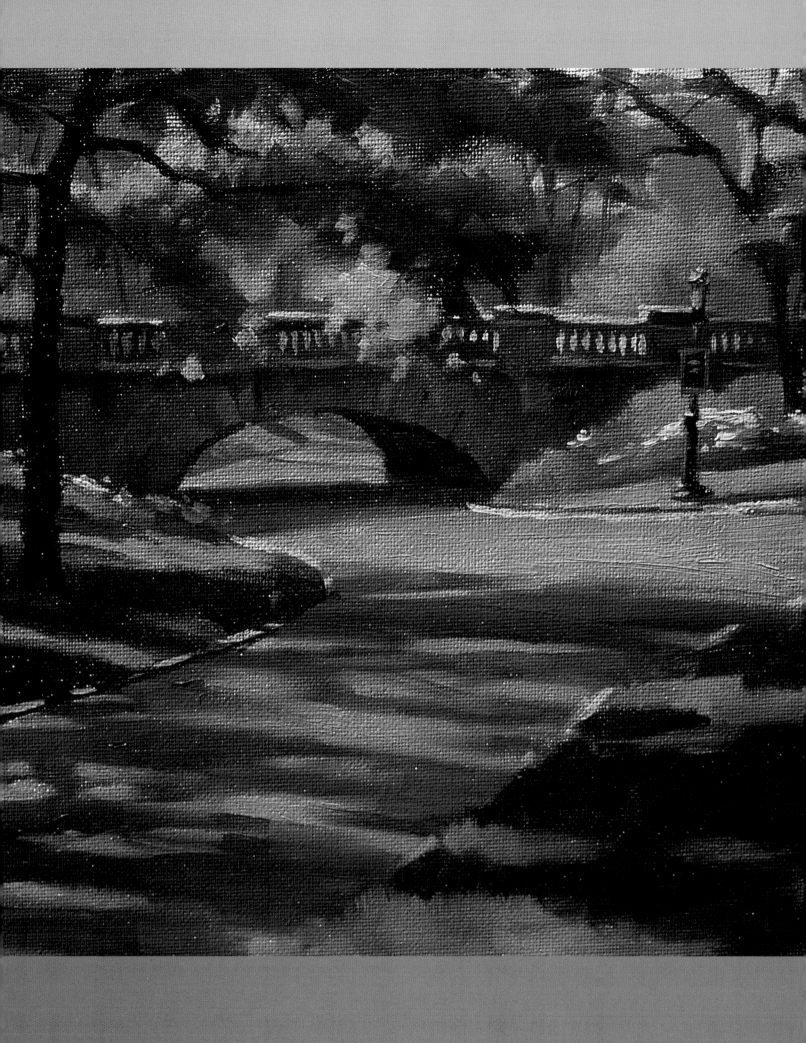

PAINTING WITH
MICHAEL
OBERMEYER

A native of southern California, Michael Obermeyer received a Bachelor of Fine Arts degree in Illustration at California State University, Long Beach. Some of his paintings are featured in collections in the Smithsonian Institute and the Pentagon in Washington, D.C. He recently received the "Award of Excellence" from the La Quinta Desert Plein Air show and the Gold Medal at the Carmel Art Studio. Michael is a member of the Oil Painters of America, The California Art Club, The American Impressionist Society, The Society of Illustrators. and a Signature Member of the Laguna Plein Air Painters' Association. Currently Michael's paintings are shown at galleries in Carmel and Laguna Beach, California, where he also maintains his studio.

FALL LANDSCAPE

STEP ONE

Using a light wash of ultramarine blue, I draw the scene on the support with a small brush, using my field sketch as a reference. I'm not concerned with details at this point—this is just a quick layout to outline the major elements. I also indicate the visual path (in this case, a literal path) that will lead the eye toward my focal point (the large trees on the left).

STEP TWO

Using flat sable brushes, I block in the basic shapes of the darkest trees, starting with the warm, intense colors and values in the foreground. I use a mix of viridian green, cadmium red light, and ultramarine blue, keeping the darkest values in the trees so that the contrasting warm colors around the trees will appear to "pop" forward.

STEP THREE

Now I begin blocking in the sunlit trees with a mixture of alizarin crimson, cadmium yellow deep, ultramarine blue, and cadmium yellow light. I use large flats and brights alternately, painting quickly with thick paint and bold brushstrokes. Then, using medium-sized flats, I paint in the pathway and the variety of dark and light areas on the grass in the foreground with mixes of ultramarine blue and cadmium yellow light.

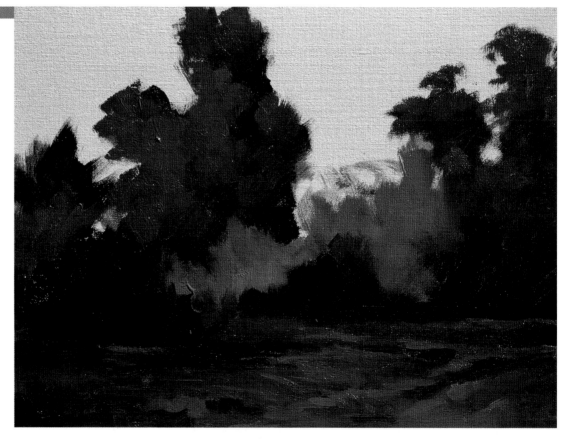

Trees

Alizarin crimson, cadmium yellow deep, cadmium yellow light, and ultramarine blue

Poor Design
In this sketch all the elements are crowded into the center and are on the same plane. The shape of the trees and its branches are too uniform, and the path leads the eye out of the picture.

Good Design
Here a few subtle changes have greatly improved the composition. The center of interest is off to the side, the elements are on different planes and are overlapped, and the eye is led into the scene and stays there.

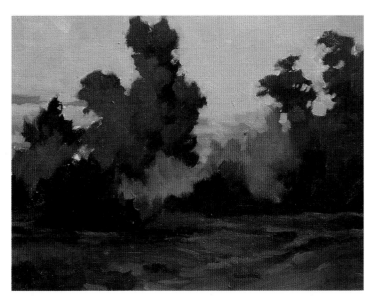

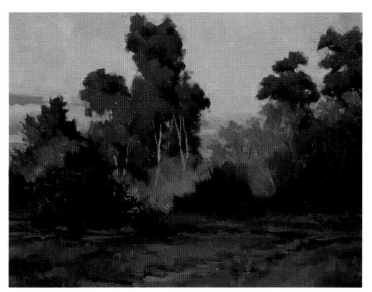

STEP FOUR

With a large flat brush, I paint in the sky with a mixture of cerulean blue, cadmium yellow light, viridian green, and a lot of titanium white. I combine ultramarine blue, alizarin crimson, and white to dab in the dark areas of the low clouds. For the sunlit areas of the clouds, I use a mix of cadmium yellow light, alizarin crimson, and white, painting right up to the edges of the trees.

Sky

Cadmium yellow light, viridian green, cerulean blue, and white

STEP FIVE

Now I add details to the trees with a small flat brush, softening the edges as I work. I use the colors from step three and work all over the trees, never spending too much time in one area. Then I add the tree trunks and the finer details in the foreground grass with a rigger brush. This brushwork is tighter and the edges are sharper than those in the background, which helps bring attention to my focal point.

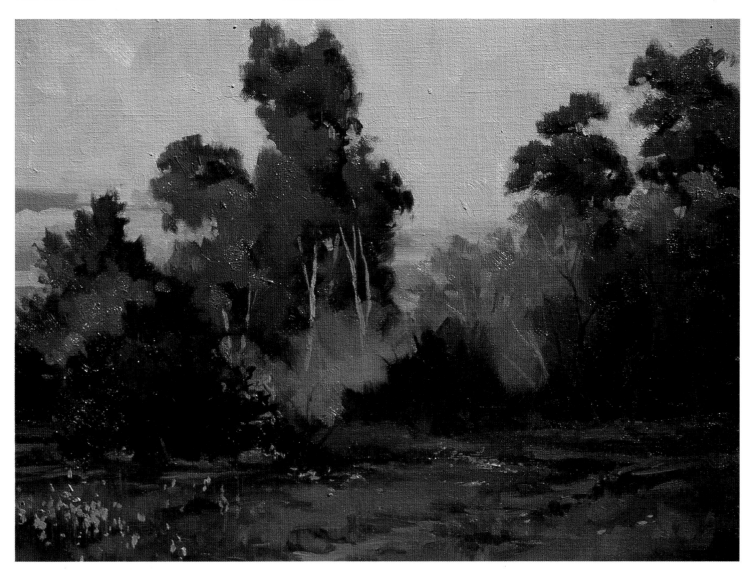

STEP SIX

Finally I step back and take a look at my work. I check to see whether any of the values need adjustment and decide to add some colorful flowers in the foreground to anchor the viewer's eye at the left of my composition, where the focal point is located. With a rigger brush and a mix of cadmium yellow light and white, I lightly dab in the blossoms, taking care to keep them in proportion with the rest of the elements in the landscape. I step back to assess the painting and decide that now I'm happy. The most difficult part is knowing when the painting is finished and putting the brush down!

Desert Casita

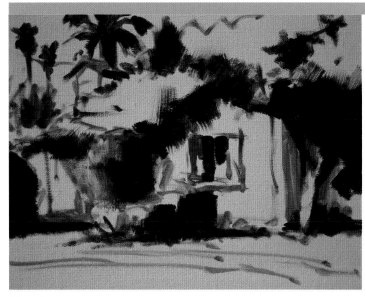

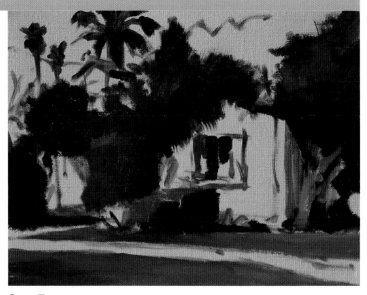

Step One

I use a light wash of ultramarine blue to loosely draw my composition on the canvas. I keep the paint thin so I can easily rework or adjust the sketch if necessary. Then I use a large flat sable brush and bold, quick brushstrokes to block in the darkest areas with a thin mix of ultramarine blue, alizarin crimson, and a touch of viridian green.

Step Two

Next I block in the rest of the basic shapes, working from the warm tones in the front to the cool tones in the back. I paint the tree trunk with a mix of cadmium yellow light, cadmium red light, and white. I use a large filbert and block in the trees and grass with mixes of ultramarine blue and cadmium yellow deep. Then I mix in some viridian green and cadmium yellow light for the cooler areas, keeping the shapes simple.

Step Three

Now I paint the stucco with a thick mix of white and specks of cadmium yellow light, cadmium yellow deep, and alizarin crimson. Using a small flat brush, I dab in the shutters with a mixture of cerulean blue and a little ultramarine blue. I create the shadows on the side of the house with a mix of ultramarine blue, alizarin crimson, and white.

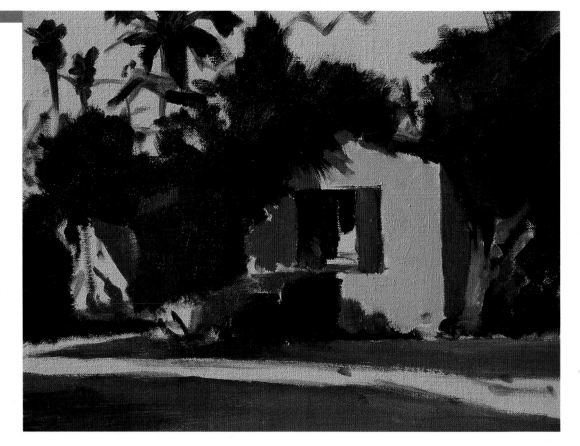

Stucco

Alizarin crimson, white, cadmium yellow light, and cadmium yellow deep

House Shadows

Ultramarine blue, alizarin crimson, and white

Finding a Focus

By making some quick thumbnail sketches of a subject, you can determine the emphasis of the scene. Here you can see how three different formats of the same scene each have a slightly different viewpoint.

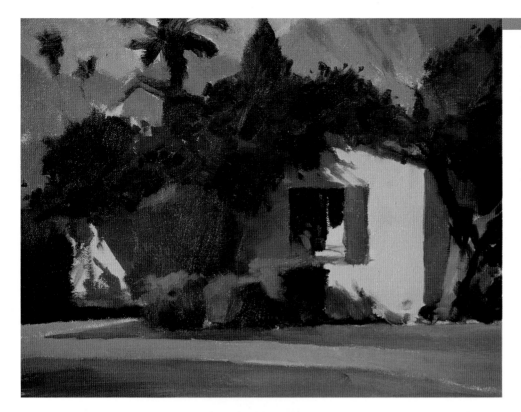

STEP FOUR

Now I begin to work all over the painting with a small flat brush, building up thick highlights and adding a variety of brushstrokes for interest. I refine the shadows on the house with a small filbert, keeping the edges soft. Then I paint the mountains in the background with a mix of white, alizarin crimson, cadmium yellow deep, and a touch of ultramarine blue, adding more ultramarine blue and a touch of alizarin crimson for the shadows. I paint the roof with small flat brushes and a mix of cadmium yellow light, cadmium red light, cadmium yellow deep, and a touch of ultramarine blue. I also paint in pure alizarin crimson for the base color of the flowers.

Flowers

Ultramarine blue, cadmium red light, alizarin crimson, and white

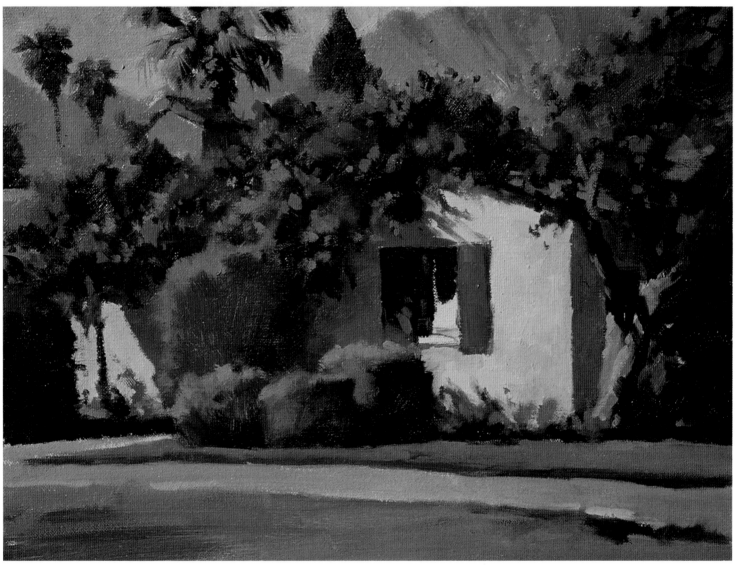

STEP FIVE

For the shadowed flowers, I add ultramarine blue to alizarin crimson. I paint highlights and details in the flowers using alizarin crimson and cadmium red light with a touch of white, dabbing the paint on with small flats and brights. I move around the painting, adding details to the mountain, tree trunk, plants, mountain, and shadows. Next I apply highlights to the shrubs with a mix of the original color plus more cadmium yellow light. I paint more details on the palm trees, keeping their edges softer than those of the foliage in the foreground. Finally I add details on the windowpanes with a small brush and a mix of cerulean blue and a small amount of ultramarine blue.

Central Park

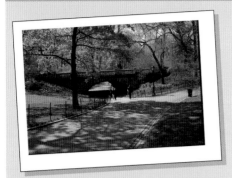

Focusing on Shadows
This snapshot captures the natural, delicate balance between light and shadow in the afternoon. For my painting, I simplify but try to retain the delicate laciness that makes them so interesting.

Shadowed Street

Ultramarine blue, alizarin crimson, and white

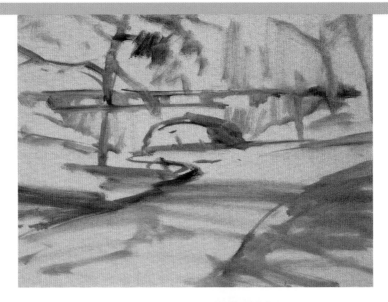

STEP ONE
I quickly sketch in my composition with a thin wash of ultramarine blue, taking no more than five minutes to place the basic shapes. As I sketch, I keep in mind how the strong shadows will affect the other elements in my composition; I want the shadows to be my focal point.

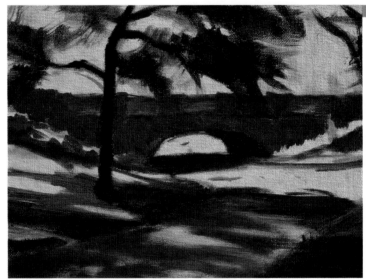

STEP TWO
With a thin mix of ultramarine blue and cadmium yellow light, I block in the shadows on the grass with quick, bold brushstrokes. I place the tree trunks and the bridge with a mix of alizarin crimson and ultramarine blue. Then I use a large flat to work in the cool shadows on the road and trees, keeping the edges soft and the shapes simple.

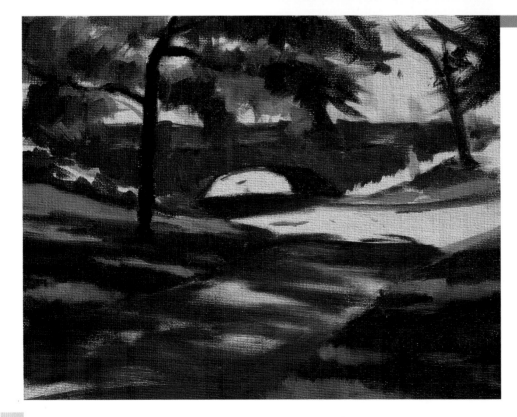

STEP THREE
Now I add the warmest tones: the sunlit grass in the foreground and the light areas of the tree in front. I keep the paint thick, using strong, bold brushstrokes and not worrying about detail at this point. For the grass, I use a mix of cadmium yellow light with a touch of viridian green and a speck of cadmium yellow deep.

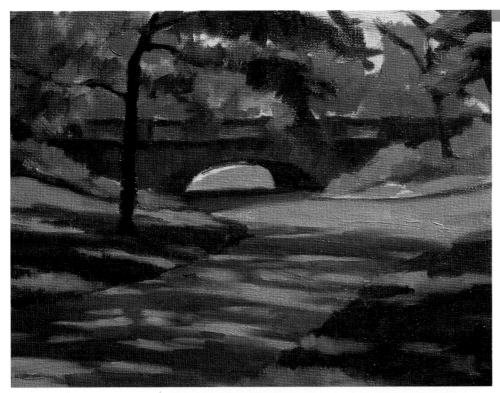

STEP FOUR

I develop the sunlit areas of the street with a mix of cadmium yellow light, alizarin crimson, white, and a touch of cadmium yellow deep. I add the sky (cerulean blue, white, and cadmium yellow light) and the distant trees (alizarin crimson, ultramarine blue, and white). Then I block in the distant buildings with a mix of ultramarine blue and white.

Sunlit Street

Alizarin crimson, cadmium yellow deep, and cadmium yellow light

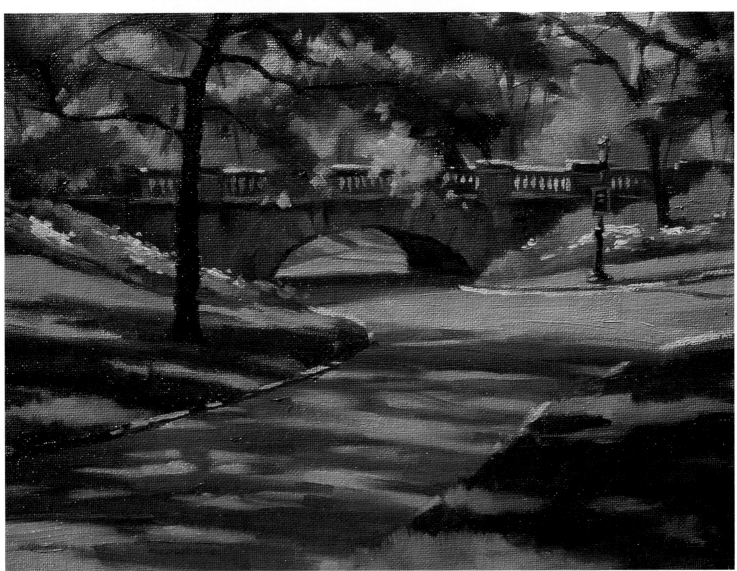

STEP FIVE

With small flats, I work throughout the entire painting, adjusting values as necessary and adding branches and a bit more detail to the trees in the foreground. With the same small brushes, I continue developing details on the bridge, the curbs, and the flowers. I include a little more detail on and under the arch of the bridge, keeping the edges sharp to draw some attention there. I place the signpost and refine the tree trunks, but I try not to overwork any one area of the painting and avoid putting in too much detail. I step back to assess my work again and decide that the contrast between the sunlit patches and the cool shadows is well balanced; my painting is done!

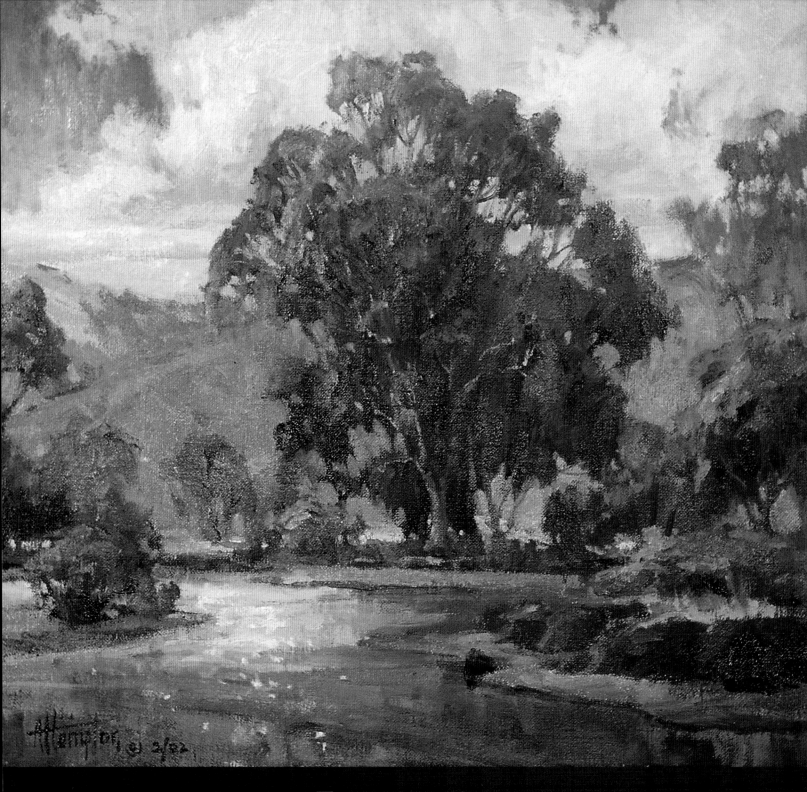

PAINTING WITH
ANITA
HAMPTON

Anita Hampton has been painting for most of her life. Although she has studied under renowned instructors and at various colleges, she considers herself primarily self-taught. Anita is considered one of the leading plein air painters in the United States, and her work has been published and exhibited in museums, galleries, and major private collections around the world. She is a signature member of the California Art Club and Laguna Plein Air Painters of America, as well as Oil Painters of America. Anita won the 2001 Franklin Mint Award in the Oil Painters of America National Exhibition and was one of eight artists invited to attend the Plein Air Painters of America exhibition in Catalina, California, in 2002.

SPRING LANDSCAPE

STEP ONE

I sketch directly on my canvas with a small flat brush and a mix of viridian green, yellow ochre, and turpentine. Then I block in the largest light shape—the cloud formation to the left of the large tree—with a thick mix of white, a little cadmium yellow pale, and cadmium red light. I darken the sky with a gray mix of cobalt blue and cadmium red light, gradually adding more color with cobalt blue, cadmium red light, cerulean blue, and ultramarine blue. Then I cover the distant mountain range with a mix of white, ultramarine blue, quinacridone rose, and a touch of yellow ochre. I carry the color through the trees to the right of the canvas, so the mountains don't seem to drop off into space somewhere in the middle of the painting.

Sky

STEP TWO

I create the dark foliage with a mix of ultramarine blue, viridian green, burnt sienna, and a little yellow ochre. I block in the center of interest (the large tree), warming the upper left where the light falls with more yellow ochre and a touch of cadmium red light. For the shadowed right side, I cool the mix with viridian green and a little burnt sienna. I adjust the mixes as I paint the outlying foliage, often changing the dominant dark color, so the foliage is made up of a variety of greens. This color variation is true to nature and makes a more realistic painting. As I paint the background trees at the top right, I allow some light color from the sky to mix with the dark paint and then I blend it with light, feathery strokes (but not too much, or the color will look chalky!).

Dark Tree Mass

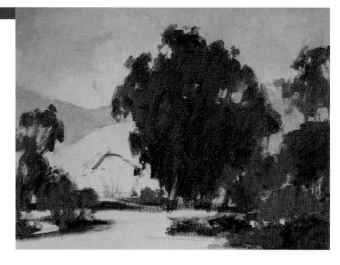

STEP THREE

I block in the mountain directly behind the tree with a mix of white, viridian green, cadmium red light, and yellow ochre. For the background, I want to show that the land recedes into the distance, so I use a cooler mix of white, cadmium yellow pale, phthalo yellow-green, and touches of cadmium red light and cerulean blue. The banks of the bay have more cadmium red light and cerulean blue with a touch of yellow ochre. Because the eye is drawn to brighter colors and warm colors "pop" forward, I warm the colors around the large tree to draw attention to it.

Mountain

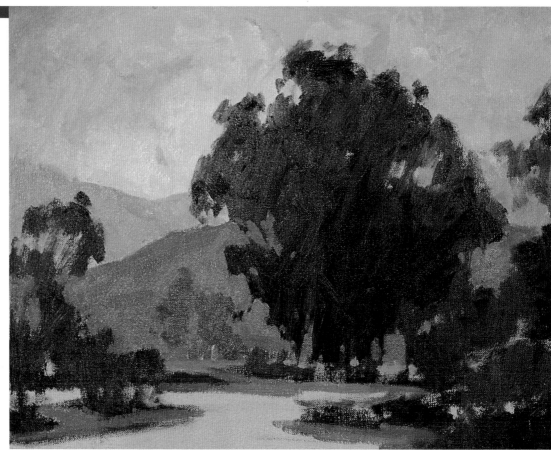

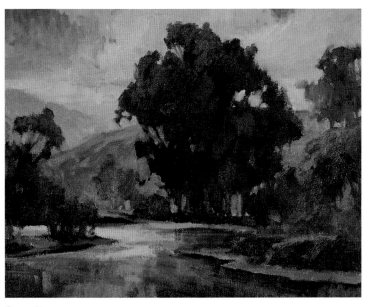

Step Four

I paint the left bank with a mix of white, cadmium yellow pale, cadmium red light, and cerulean blue, darkening the mix as I work downward. Then I lay in the reflections of the dark tree with horizontal strokes and a mix of ultramarine blue, viridian green, burnt sienna, and a little yellow ochre. For the sky's reflection, I mix white, cobalt blue, yellow ochre, and cadmium red light, gently blending the light and dark colors together.

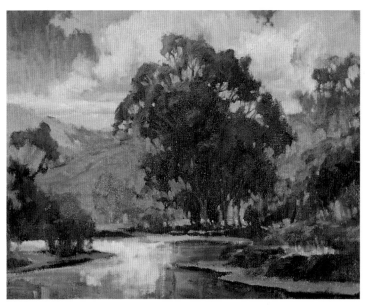

Step Five

I was inspired to paint this sky by the stormy weather condition that formed magnificent clouds in a crystal clear atmosphere; the colors seemed to pop out of the sky! I start by applying more color in the upper sky, using vertical strokes to mirror the vertical strokes in the water. I use basically the same colors I used in step two but with fewer grays and whites. I make the blue sky darkest at the top, lightening and warming it toward the horizon.

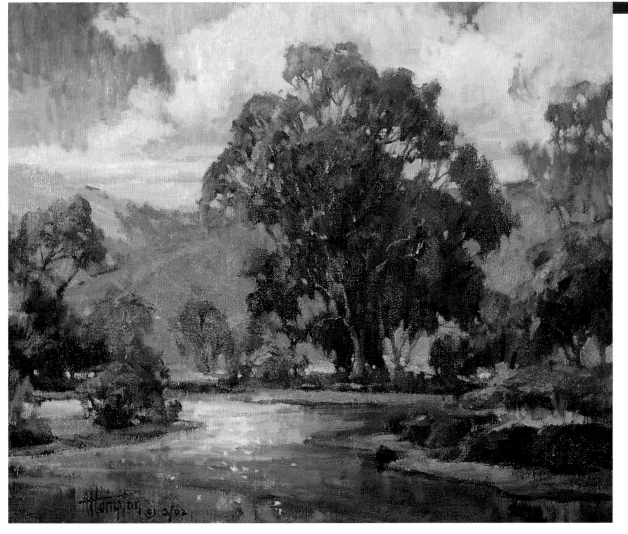

Step Six

I add the tree highlights with varying mixes of white, yellow ochre, phthalo yellow-green, cad. red lt., and cerulean blue. I add more highlights to all the foliage with mixes of white, viridian green, yellow ochre, burnt sienna, cad. red lt., cad. yellow pale, and ultramarine blue. For the highlights on the mountains, I add white to a mix of cad. yellow pale, cerulean blue, and a touch of quin. rose. Then I paint over the water with a few horizontal strokes of cad. red lt., blue-violet, and a touch of yellow ochre. I add detail to the large tree trunk with a mix of burnt sienna, ultramarine blue, and yellow ochre. I add a few touches of color to the outlying areas. Finally I use a mix of ultramarine blue, burnt sienna, and viridian green for dark accents in the large tree and outlying foliage.

Roses

Choosing a Light Source
Natural light (such as light from a north window) is much cooler than artificial light (such as light from a lamp or studio light). Here I chose to use both because I like the lively contrast between the cooler natural light from a window to the left of the scene and the warmer hues created by a studio light on the right.

Step One

Once I'm happy with my setup, I lay in a thin wash of Indian yellow with a large bristle brush. Then I add a touch of quinacridone rose and apply the color liberally with broad stokes to quickly cover the canvas. For the edges, I create a thin mix of quinacridone rose and cobalt blue. I establish the cooler hues on the right by adding more blue to the mix. For the warmer hues in the flower area, I add more quinacridone rose. To avoid harsh color changes, I gently blend the edges of these washes with a paper towel. Then I block in the basic shapes of my composition with a mix of sap green, cadmium orange, and cadmium red light.

Step Two

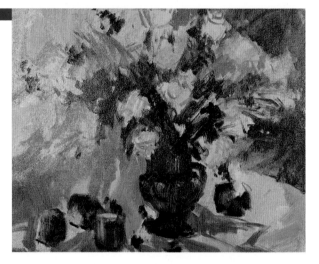

I block in the darkest values of the leaves with a mixture of sap green, transparent oxide red, and cobalt blue. I further develop the darkest values with varying mixes of a little phthalo yellow-green, rose, cad. red light, and cobalt blue added to the original green mixture. The vase has more red with only a little green, and the leaves have more green with only a little red. For the apples, I mix rose, transparent oxide red, and phthalo yellow-green. Next I block in the shadows on the cloth with a mix of white, cobalt blue, and transparent oxide red. I want the cloth to have rich variation, so I create several shades of this mix by adding varying amounts of cad. red light, cerulean blue, yellow ochre, and cad. orange. For the candleholder, I mix white, rose, cobalt blue, and a touch of yellow ochre.

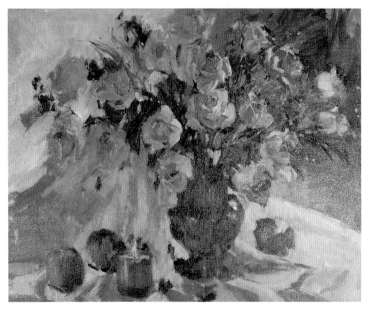

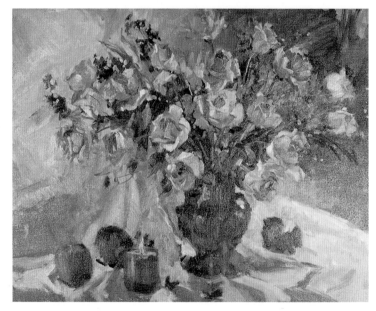

Step Three

Now I paint the roses with a small flat brush and a basic mix of rose, transparent oxide red, Indian yellow, and a touch of phthalo yellow-green. For the flowers on the right, I warm the mix with cadmium red light or cadmium orange. For the flowers on the left I cool the mix with rose, cobalt blue, and a touch of white. For the warmest gray versions of the mix, I add a little cadmium yellow light, Indian yellow, or cadmium orange. Next I block in the light spots on the tablecloth around the vase with a mix of white, cobalt blue, transparent oxide red, and cadmium yellow light.

Step Four

I warm the petals on the right with different mixes of white, cadmium yellow light, cadmium orange, and a little cadmium red light. Then I mix rose, cobalt blue, and transparent oxide red into some of the shadowed petals in the center of each rose, blending the color with light strokes to soften any hard edges. For the highlights, I mix white, rose, and a touch of cobalt blue. I paint the leaves on the left with white, cobalt blue, and a touch of yellow ochre. For the warmer leaves on the right, I mix white, cadmium orange, phthalo yellow-green, sap green, and transparent oxide red. I paint the stems with a mixture of white, rose, cobalt blue, and a touch of yellow ochre.

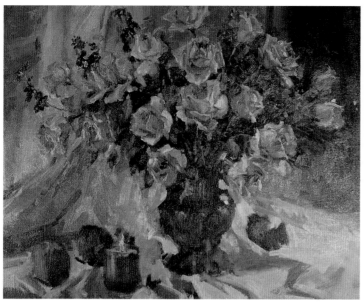

**Flower Base
(Center)**

White, rose, transparent oxide red, and Indian yellow

**Cool Flowers
(Left)**

*Base + rose
and cad. orange*

Base + white, cerulean, rose, and cad. yellow light

Base + white, cobalt blue, and rose

**Warm Flowers
(Right)**

Base + white, cad. yellow light, and cad. orange

Base + cad. orange + cad. red light

Base + white, cad. red light, and cad. orange

STEP FIVE

I use a variety of gray mixes to develop the cloth and background. For the darker areas of the background and the folds in the tablecloth, I use mixes of cobalt blue, transparent oxide red, cadmium orange, phthalo yellow-green, and a little Venetian red. I add touches of lighter colors to the background with white, cobalt blue, rose, cadmium orange, and a little cadmium yellow light. Where the warm artificial light falls on the table, I add cadmium yellow light and cadmium orange.

**Leaf Base
(Center)**

Sap green, transparent oxide red, and cobalt

**Cool Leaves
(Left)**

Base + white, yellow ochre, and cobalt blue

Base + white, cobalt blue, and sap green

Base + sap green, and cobalt blue

**Warm Leaves
(Right)**

Base + white, cadmium orange, and phthalo yellow-green

Base + white, Venetian red, and sap green

Base + white, sap green, and transparent oxide red

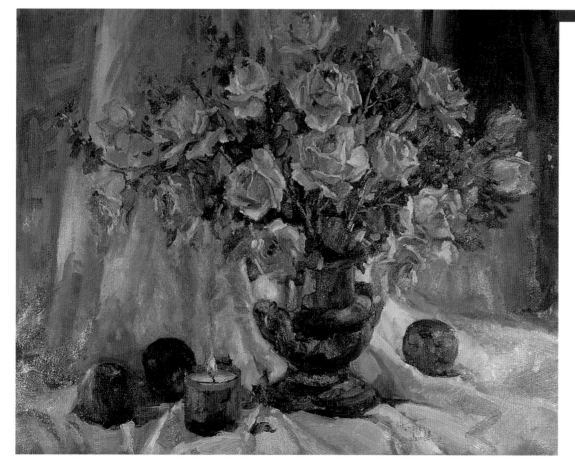

STEP SIX

Now I add details to the apples. For the stems, I use a mix of yellow ochre, phthalo yellow-green, cobalt blue, and sap green. For the darker parts of the apples, I mix rose, transparent oxide red, and sap green. I touch up the stems with a mix of sap green, transparent oxide red, and cobalt blue. I paint the candleholder with a mix of white, rose, cobalt blue, and a touch of yellow ochre, warming the right side with a mixture of cad. yellow light and cad. orange. For the left side, I add more rose and cobalt blue to the mixture. For the flame's center, I create a thick mix of white and pure cad. yellow light. For the darker area of the flame, I use a mix of white, cad. yellow light, and cad. orange, adding a touch of cad. red light next to the yellow center. At the base of the flame, I add a dark mix of white, rose, and cerulean blue. To create smoke, I add transparent oxide red and cobalt blue to the mix and brush this color upward from the tip of the flame. When I assess the painting, I decide to change the cloth folds. I want the background to have more linear, vertical shapes to counterbalance the round forms of the flowers.

CALIFORNIA COAST

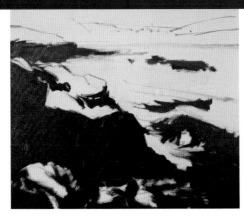

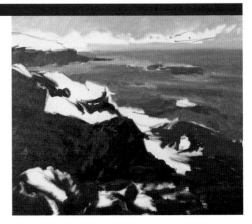

STEP ONE

I begin sketching directly on the canvas with a thin mix of cerulean blue and yellow ochre and a small bristle brush. As I sketch, I am always aware of the division of my canvas—I don't want any shape to cut the canvas in half vertically, diagonally, or horizontally, nor do I want shapes that are completely equal in size. Variety is the key to creating interest.

STEP TWO

I create various mixes of transparent oxide red, sap green, and ultramarine blue for the rocks. Then I apply the darks of the water with a mix of ultramarine blue, transparent oxide red, and a little white.

STEP THREE

Next I add the water midtones; at the top right, I apply a mix of quinacridone rose, cobalt blue, and white, blending it into the wet paint. For the sky, I use a mix of white, viridian green, and a touch of cadmium red light.

Water Midtones

Ultramarine blue, transparent oxide red, white, viridian green, and quinacridone rose

Headland

White, viridian green, cadmium red light, yellow ochre, cadmium yellow light, cadmium red light, ultramarine blue, transparent oxide red, and quinacridone rose

Foam Highlights

White, cadmium yellow light, cadmium red light, cerulean blue, and cadmium yellow pale

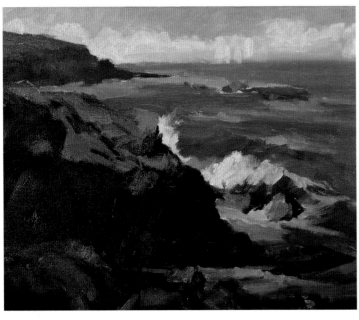

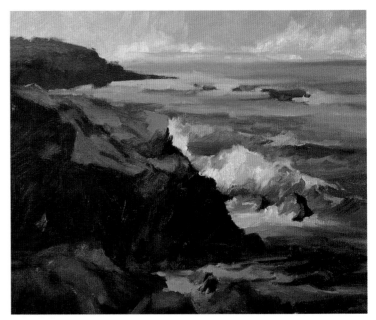

STEP FOUR

I paint more midtones in the water and then apply the light color on the rocks with a mix of sap green, transparent oxide red, yellow ochre, and cadmium yellow light. I darken the foam with a mix of white, cobalt blue, quinacridone rose, cadmium yellow light, and a touch of cadmium red light. Then I paint the clouds with a mix of white, cadmium yellow pale, and cadmium red light, blending slightly to create soft edges.

STEP FIVE

The focal point of this scene is the breaking wave, so I apply more detail there, adding brighter colors and creating more foam. As I add more color to the water, I lighten the values near the horizon to bring out more contrast in the foreground. Then I develop the clouds by adding more lights (white, cadmium yellow pale, cadmium red light, and a touch of viridian green) and darks (white, quinacridone rose, cobalt blue).

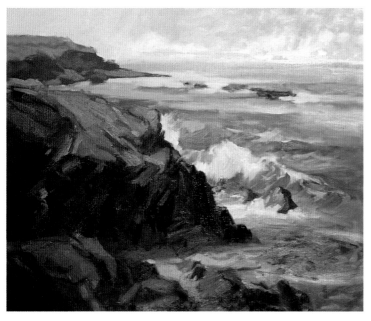

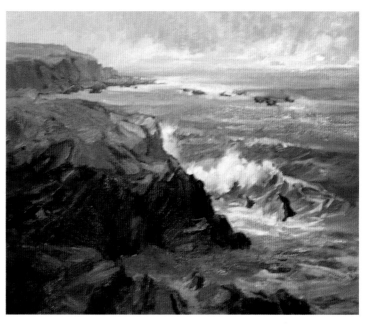

Step Six

I break down the shapes in the main rock by building up the texture with more light and dark values. I create highlights with a mix of white, transparent oxide red, viridian green, yellow ochre, and cadmium red light. Then I switch to a mix of sap green, yellow ochre, and cadmium red light for the dark areas. I adjust the headland by randomly adding a range of values with a small sable brush.

Step Seven

I am careful not to apply too much detail in the areas outside of my focal point because I don't want them to distract from the center of interest. As I continue, I decide to slightly alter the direction of the lower rock formations to point toward the wave; this creates more action and a contrasting diagonal line of movement. To soften the edges of the rocks, I blend the edges with a dry sable brush.

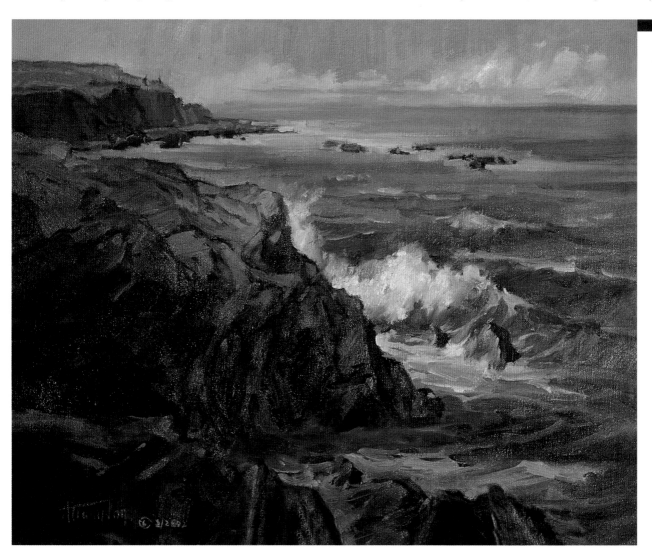

Step Eight

At this final stage of the painting, I try to make sure that every brushstroke I add will enhance (and not detract from) the focal point of my painting. I decide to add the figures at the top of the headland with grayed-down mixes of the original headland colors so they don't stand out too much. I add more darks to the crevices in the rocks with a small sable brush and apply more color and interesting shapes to the foreground foam. I step back to check my work and, finally satisfied, add my signature.

PORTRAIT OF A CHILD

Reference Photos
Painting portraits in oil can take many hours, even days. Most children have a hard time sitting still for this long. Although a photo can't compare to a live subject posing for you, take photos of the children you wish to paint. That way you can take your time with the portrait.

STEP ONE
I want to emphasize my model's beautiful hair, so I sketch the head and shoulders first with yellow ochre. Then I create some guidelines for the facial features. For the slightly tilted angle of her face, I draw a curved center vertical line. Then I create the central horizontal line through the middle of the vertical line. Because Audrey is a child, her eyes, nose, and mouth all fall below this line. Below the eyeline, I add two more parallel horizontal lines to position the base of the nose and the center of the mouth, making sure my lines are and perpendicular to the vertical line.

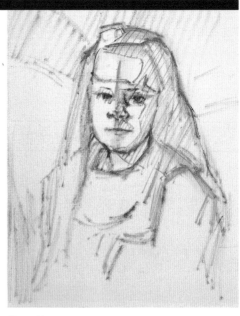

STEP TWO
Now I draw in her facial features with burnt sienna and a clean round brush, keeping the paint fairly dry to make clean, crisp lines. If I need to remove a portion of the drawing, I dip a paper towel in solvent and lift off the unwanted paint. Next I indicate the hairline on the forehead and draw the sides of the face. I block in the shadows with pure cerulean blue, using parallel, hatch lines to keep the basic shadows clear and defined. I'll use these lines later as guides.

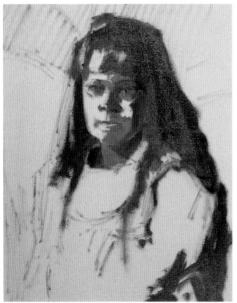

Lights in Hair

white

+ cad. yellow pale

+ yellow ochre

+ cad. yellow deep

+ cad. red light

+ cerulean

+ cad. yellow pale

STEP THREE
Now I lay in the darkest values in the hair with a mix of burnt sienna, viridian green, yellow ochre, and a touch of cad. orange. To create contrast within this large, dark shape, I separately apply touches of each color from the mix. For the lighter shadows, I lighten the mix with yellow ochre and cad. yellow deep. For the shadows around the eyes, I use a medium filbert and a mix of burnt sienna, viridian green, cad. orange, and a small amount of yellow ochre, adding separate touches of each color to create variation within the shadowed skin tones. Then I add the small shadow on the left sleeve with a mix of cobalt blue, quinacridone rose, and a little yellow ochre, twirling the brush in a loose, swirling motion that mimics the fabric patterns.

STEP FOUR
Next I add the lights in the hair with a medium bristle brush and a thick mixture of white, yellow ochre, cad. red light, and a small amount of cerulean blue. I use large, wide strokes and add touches of the original color mixture over the light hair to keep it from looking like a flat surface of plain, solid color. With a mixture of white, cad. yellow deep, cad. red light, and a touch of cerulean blue, I block in the light bodice of the dress. I make this value slightly darker than it appears, as I'll be applying the lighter embroidery over it. Using a variety of color mixtures, I roughly block in the floral print of the dress. I'm always tempted to work on details right away, but adding details too soon can make subjects look cluttered and cause colors to conflict with each other. So, at first, I paint as loosely as possible.

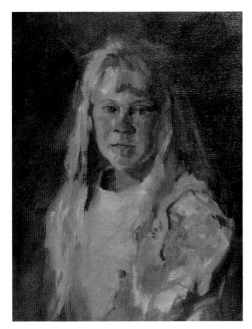

STEP FIVE

I accent Audrey's light blond hair by adding a dark gray background of ultramarine blue, burnt sienna, yellow ochre, and a little thinner. For the lighter areas, I add more yellow ochre to the mix. I let the background blend with the hair, pulling the brush with light linear strokes to create soft edges; tight, unblended edges can make a figure look as if it is pasted on the canvas. While the paint is still wet, I add more highlights to the hair with a small flat brush. Again I work some of the paint into the background to create a loose, natural texture.

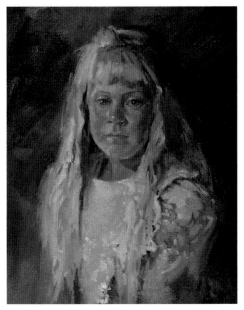

STEP SIX

Now I build up the skin tones with cad. red light on the cheeks and chin and a mix of white, cad. red light, and a little yellow ochre. For the skin's soft texture, I use a dry sable brush to smooth the paint and soften the edges. Now I develop the details of the organdy dress, bringing out the details with a mix of white, cad. yellow light, cad. red light, and a touch of cerulean blue. Then I apply a lighter shade of this mixture with feathery strokes. Because I want Audrey's hair and eyes to command the most attention, I simplify the dress fabric, making it more muted. I develop the eyes with the colors shown at right and then I build up the hair with several thick brushstrokes.

STEP SEVEN

At this stage, I like to view my paintings in a mirror, which gives me a fresh view of my work and helps me spot areas that may need minor changes. I find I need to lower Audrey's right shoulder and darken the right side of her face. I darken the skin slightly, as I'd added too much white to the mixture. Finally I raise the right corner of her mouth slightly, simplify the light shapes on her left sleeve, and add more detail to her left eye with a few final highlights.

Eyes

White
+ cerulean
+ yellow ochre
+ more yellow ochre

Light Skin Tones

White
+ cad. yellow pale
+ cad. yellow deep
+ cad. red light
+ more cad. red light
+ rose
+ yellow ochre
+ cerulean
+ cad. orange

Dark Skin Tones

Yellow ochre
+ cad. orange
+ cad. red light
+ burnt sienna
+ rose
+ viridian green
+ cad. orange
+ cerulean

HENDRY BEACH

STEP ONE

I sketch the composition directly on the canvas with a small flat bristle brush and a mix of cerulean blue and yellow ochre thinned with a little turpentine. If I need to make adjustments in my drawing, I can easily wipe off the color with a paper towel and solvent. I place the basic shapes carefully, making sure I have a variety of sizes and lines and a good placement for my center of interest—the trees on the left.

STEP TWO

I begin by blocking in the dark trees with a large bristle brush and a mixture of viridian green, ultramarine blue, burnt sienna, and yellow ochre thinned with a little turpentine. As I lay in these shapes, I occasionally change the dominant hue by adding more of one of the colors to the mixture. I block in the rest of the foliage and the reflections, working toward my lightest areas (the clouds and sky). I mix white, yellow ochre, and a small amount of cadmium red light and cerulean blue for the white clouds. For the sky, I mix white, ultramarine blue, cerulean blue, and a touch of quinacridone rose. As the blue sky nears the horizon, I apply a mix of white, cerulean blue, and a touch of cadmium yellow pale. I take extra care to thoroughly clean, dry, and load my brush each time I change colors.

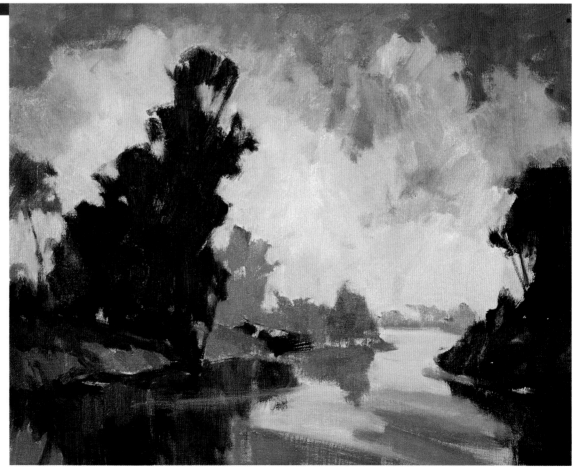

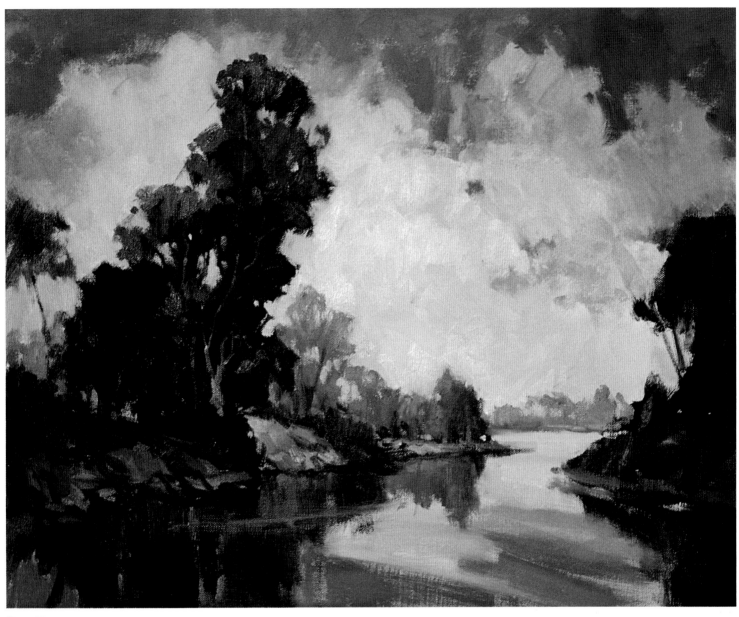

STEP THREE

Now I develop the main shapes, starting with my center of interest. Using a small bristle brush, I apply color to the foliage shapes on the left with a mix of white, yellow ochre, cadmium red light, and touches of phthalo yellow-green and cadmium yellow deep. I add the darker values in the shadows with a mix of white, viridian green, ultramarine blue, yellow ochre, and a touch of cadmium red light. I am careful not to overdevelop any of these outlying areas—this could detract from the center of interest. I paint all the tree trunks with a small rigger brush dipped in a mix of white, cadmium red light, viridian green, and yellow ochre.

HENDRY BEACH (CONTINUED)

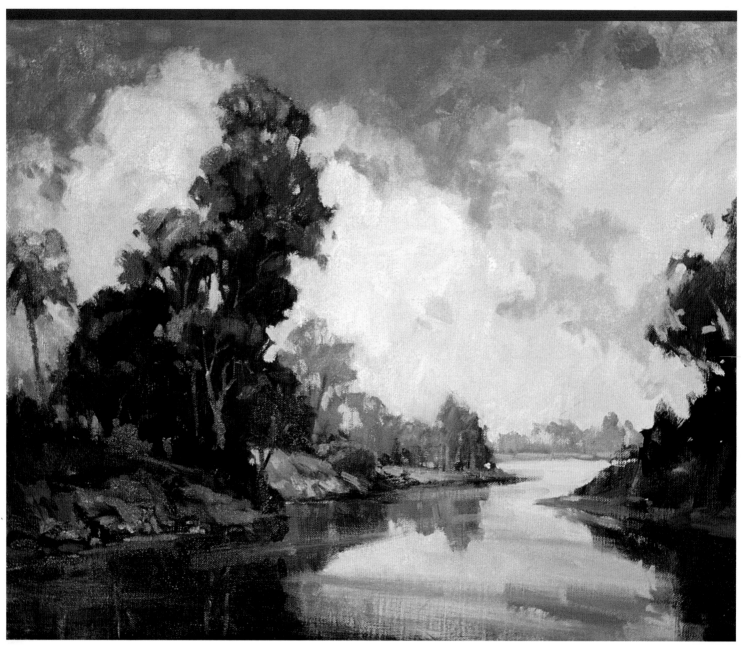

STEP FOUR

I develop the center of interest using a small bristle brush and my light and dark mixtures from step three. If I need a lighter value, I add a little more white to my mixes. I also work on developing the outlying areas with a large bristle brush. Using a large brush helps me maintain the large, soft shapes I've already created. During these final stages, I use more color and less gray in my mixtures as I slowly build up toward clean color. I also make sure to save the cleanest, purest colors for the foreground. Then I step back and view the final painting from a distance. If there are any areas that need correction or more attention, I handle them now.

ENHANCING DEPTH

This sketch combines several techniques for showing depth (sharpening or blurring details, overlapping objects, linear perspective, and emphasizing size differences), but the differences in scale are really accentuated in the road, fence, and trees. Notice that the receding lines of these elements narrow to the vanishing point on the horizon, bringing more attention to the depth of the scene.

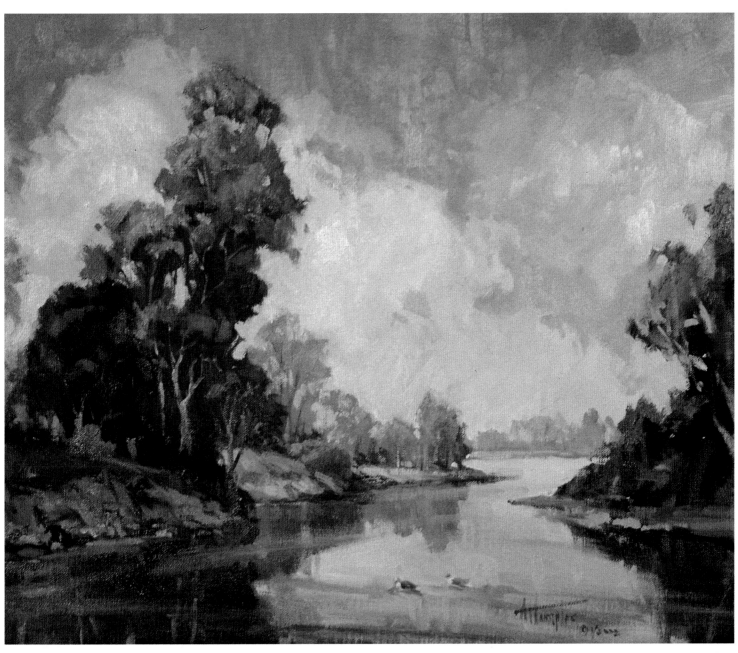

STEP FIVE

I carefully add clean color to various areas of the canvas that I want to highlight, and I add the ducks in the foreground for interest. In contrast to the muted tones underneath, these pure colors will "pop," adding interest and excitement. I don't want to overdo this stage, so I take special care and add only as much clean color as I can without losing the authenticity of my subject or distracting from my center of interest. I want less gray in the blue sky, so I mix white and cobalt blue with a little ultramarine blue and quinacridone rose, and I apply the mix with a large sable flat without disturbing the paint underneath. Finally I sign my name!

COMBINING METHODS

Combining overlapping techniques with texture variation is a great way to create the illusion of depth. In this thumbnail sketch, the hills are overlapping and the clouds become smaller as they move toward the horizon. There is more definition in the foreground elements, and they gradually lighten as they recede toward the hills.

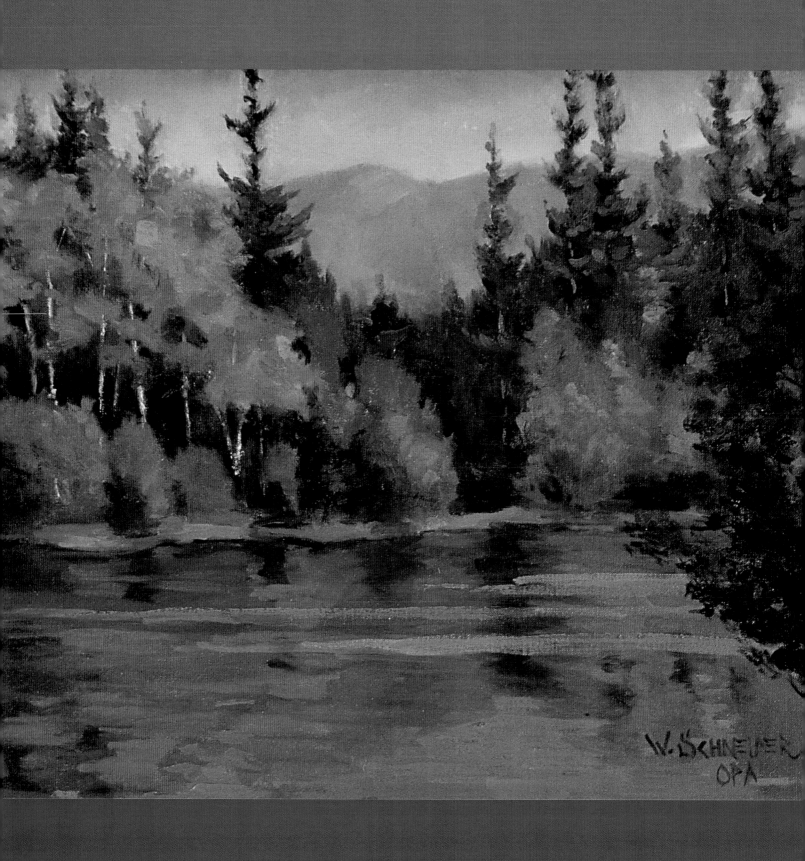

PAINTING WITH WILLIAM SCHNEIDER

After trying out careers in the music and financial industries, Bill Schneider has returned to his first love: painting. He studied at the American Academy of Art and has won awards in several national juried shows. Bill's work is represented by galleries in California, Oklahoma, Illinois, and Wisconsin and has been published in *American Artist's Magazine* as a finalist in the Portrait Category of their annual Art Competition. He has won "Best in Show" awards at both the Woodstock Fine Art Exhibition and the Heartland National Exhibition 2002, and he was awarded signature status by the Oil Painters of America in 1998.

CHICAGO STREET SCENE

STEP ONE

I tone a stretched linen canvas with a warm underpainting of terra rosa and cadmium yellow deep. Then I use vine charcoal to draw the horizon line about a third of the way down the canvas and sketch in the main shapes. With a warm mixture of black, ultramarine blue, transparent oxide red, and alizarin crimson, I block in the deepest darks (the fence and the foreground shadows). Then I lay in the lightest area—the warm gray sidewalk. For the secondary darks in the fence and flower boxes, I add viridian green and a little raw sienna to the original dark mixture. I paint the remaining dark areas thinly with a medium bristle filbert, and I block in the background with a mixture of terra rosa, black, and white. The distant tree is a mixture of viridian green, black, terra rosa, and white. Working forward with a medium flat bristle brush, I define the light side of the farthest building on the right with a mix of terra rosa, raw sienna, white, and viridian green.

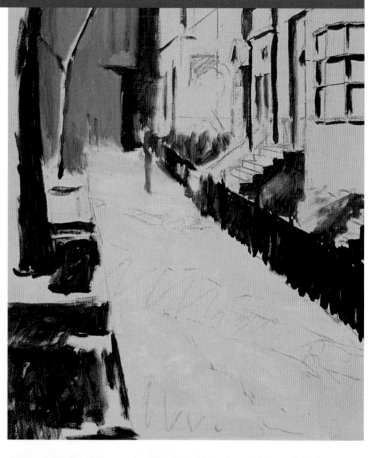

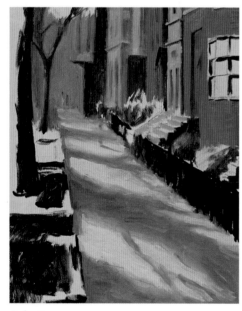

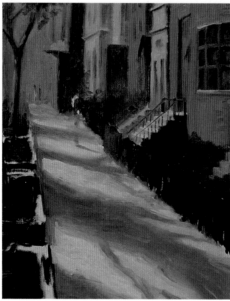

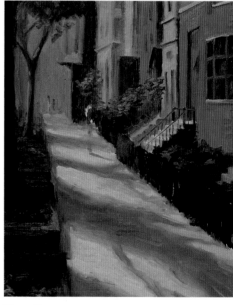

STEP TWO

I mix terra rosa, raw sienna, cad. yellow deep, viridian green, and white for the brick buildings and then paint the light areas on the tree by adding raw sienna and white to the dark mixture from step two. I paint the building next door with two values—the light side is a mix of viridian green, raw sienna, white, and terra rosa. (I use the same mixture for the rest of the light sidewalk.) For the dark side, I use the same mix but substitute transparent oxide red for terra rosa. I mix viridian green, raw sienna, white, and transparent oxide red for the windows and the dark side of the tree. I use a palette knife to loosely suggest shadows on the sidewalk with raw sienna, black, transparent oxide red, and white. I paint the porch roof with viridian green, ultramarine blue, raw sienna, and white.

STEP THREE

Working forward, I paint the porch and stairs with a mix of raw sienna, white, cadmium yellow deep, viridian green, and white, and I create the windows and doors. I apply a slightly darker value of the brick mixture in the shadows of the round building. I also use this darker value to indicate a few bricks. Then I paint in the porch rails, the window edges, and the fence with a dark green mix of viridian green, raw sienna, terra rosa, and white. Notice that I don't try to paint individual bars in the fence; I merely place a few vertical strokes to indicate the posts. I build up the values in the dark green of the shadowed foliage near the porch and in the flower boxes with a mix of black, cadmium yellow light, and ultramarine blue.

STEP FOUR

Here I pay close attention to the contrasts between the warm, sunlit patches and the cool shadows; this contrast will help set the mood of this scene. I paint the flower boxes and the large tree with two values: The darks consist of transparent oxide red, ultramarine blue, raw sienna, and a little white; the light areas are a mixture of transparent oxide red, viridian green, raw sienna, cadmium yellow deep, and white. Next I finish the foliage in the flower boxes and the yards. For the distant sunlit leaves, I use a mixture of black, cadmium yellow light, terra rosa, and white. Then I create a lighter mixture for the leaves in the foreground with viridian green, cadmium yellow light, and white.

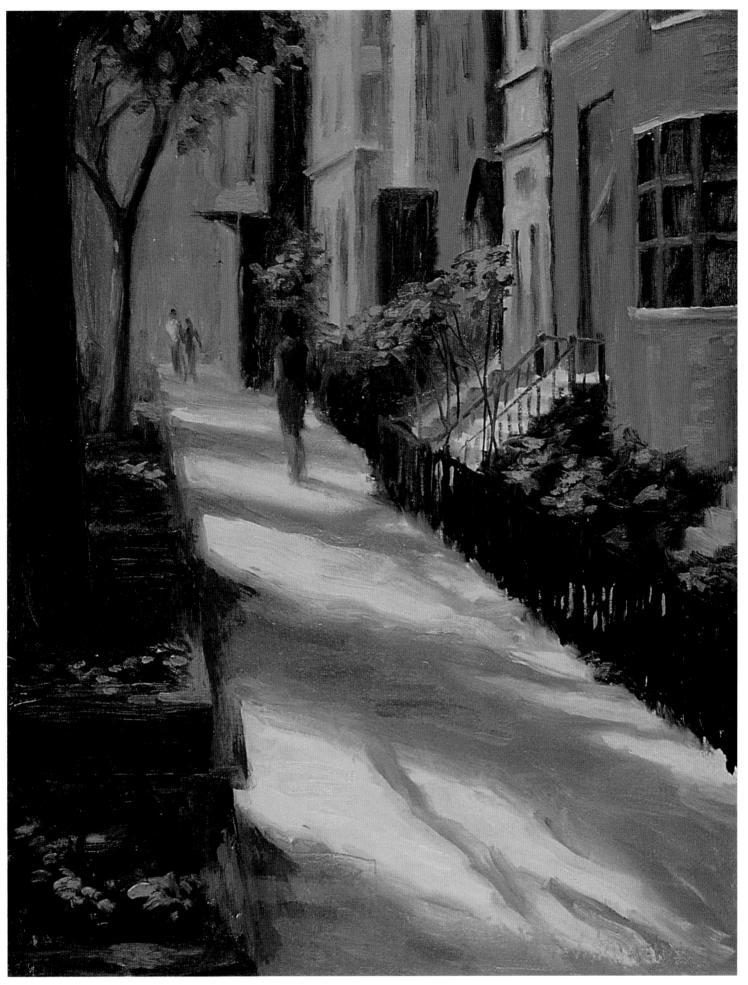

STEP FIVE

Now I suggest the figures with a small sable brush. I paint the red skirt with a mix of terra rosa, alizarin crimson, and white, adding a little black for the shadows. The blouse is the color I used for the porch (see step three) with a touch of black for the shadowed side. I mix terra rosa, raw sienna, viridian green, and white for the flesh tone. Finally I use some of the porch and leaf colors to indicate the spaces in the iron fence. In this case, it's better to paint the negative spaces with the background color rather than trying to paint the narrow lines of the fence itself.

SNOWSCAPE

STEP ONE

I start by toning a stretched canvas with a wash of terra rosa and viridian green thinned with turpentine; this warm underpainting will serve as a good base color for building the white snow. After wiping off most of the wash and letting the canvas dry to the touch (about 10 minutes), I use vine charcoal to divide the canvas into thirds horizontally and vertically and to sketch in the general placement of the main elements: the distant tree line, the pine trees, the middle ground buildings, and the foreground tufts of grass.

STEP TWO

Next I establish my extremes: the lightest and darkest values. They set up a frame of reference for all the other values in the painting. I use a mixture of alizarin crimson, ultramarine blue, and transparent oxide red with a large filbert bristle brush to block in the darks. All of the middle ground snow is the same value (a mixture of white, ultramarine blue, black, terra rosa, and raw sienna), so I just swipe it on with one stroke of the palette knife.

STEP THREE

I block in the sky with a mix of white, ultramarine blue, black, alizarin crimson, and raw sienna. The sky at the horizon is lighter and creamier, so I add more white and raw sienna to my original mixture. I paint the distant trees using a darker value of the sky mixture, softening the edges by blending them slightly into the sky. I try to keep the shapes of the trees irregular so that they don't look too symmetrical, like cookie-cutter cutouts.

Basic Tree Mix #1
Ultramarine blue, black, cadmium yellow light, terra rosa, and white

Basic Tree Mix #2
Ultramarine blue, black, cadmium yellow light, terra rosa, and white

Basic Tree Mix #3
Cadmium yellow light, black, ultramarine blue, and terra rosa

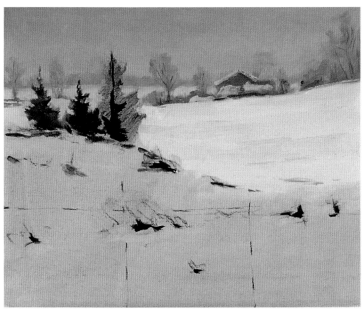

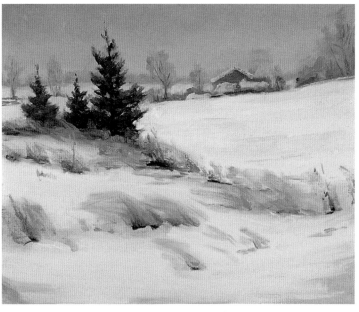

Step Four

Working forward, I lay in the white values of the distant and middle ground snow, making sure the contrast between them is noticeable. Then I block in the buildings with a combination of the basic tree mixture #1 and some more terra rosa and raw sienna. For the shadows in front, I block in a slightly darker version of my snow color (see step two). Next I paint the pine trees with a medium bristle filbert, using the three basic tree mixes (see page 64) and leaving some of the dark value to indicate the tree trunks.

Step Five

Now I work on the closest tree. For interest, I add a warm mix of ultramarine blue, terra rosa, raw sienna, and speck of white to indicate dead pine needles. I paint in the foreground snow with a warm mix of white, terra rosa, ultramarine blue, and raw sienna. Using a large bristle filbert, I lightly drag in the grasses in the middle ground. Finally I place a few sharp, defined strokes with a small round brush to indicate individual tufts of grass in the foreground.

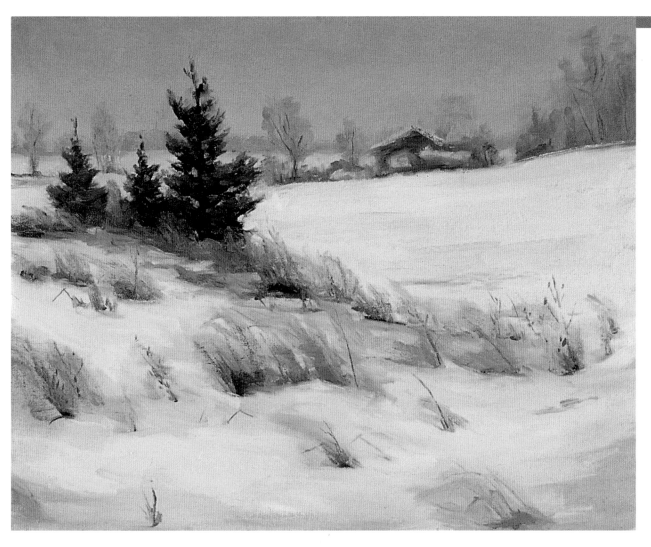

Step Six

Once I step back and assess my work, I decide to paint a few more tufts of grass in the foreground and add some red to the barn to complete the design. One final observation—this painting has no pure or intense color. It is really a symphony of beautiful grays. In general, the world is a much grayer place than we think at first glance.

McPherson's Pond

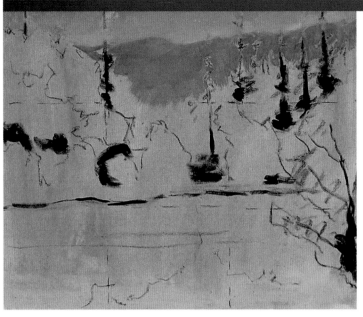

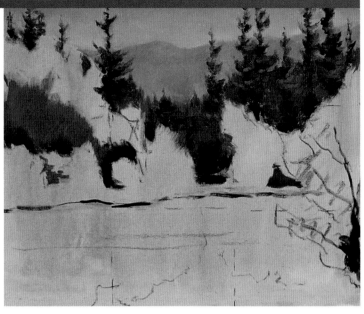

Step One

I was fascinated by the many colors my field study revealed in this scene and decided to render this landscape in more detail. I begin by toning my canvas with a thin wash of cadmium red light, terra rosa, and ultramarine blue. Using vine charcoal, I divide the canvas into thirds horizontally and vertically and sketch in the main landmarks, referring to my field study as I draw. I establish the darks with a mix of ultramarine blue, alizarin crimson, and transparent oxide red and then block in the background (see step two).

Step Two

I establish some of the secondary darks with a mixture of ultramarine blue, transparent oxide red, alizarin crimson, and raw sienna. As I lay in a light blue for the sky (see sample on page 67), I flatten and smooth out the edges with a palette knife. I darken the top of the sky by adding black and ultramarine blue to the mix and then paint in the mountains with a mixture of ultramarine blue, terra rosa, raw sienna, and white. For the distant gray trees, I use a mix of ultramarine blue, raw sienna, alizarin crimson, and a little white.

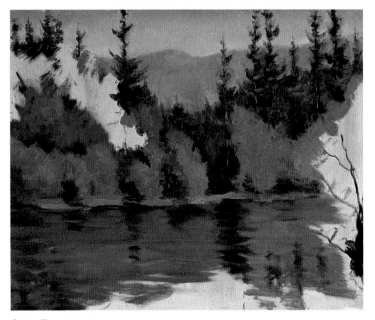

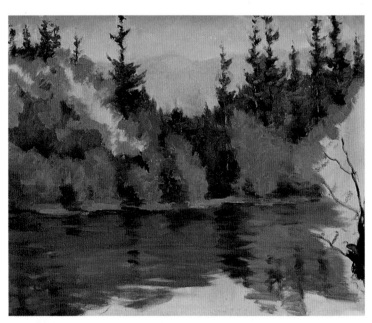

Step Three

Next I block in the rest of the trees with both light and dark green tree mixes (see sample on page 67). I paint the front pines with a mix of ultramarine blue, black, cadmium yellow light, and a speck of white. The tops of the branches reflect the sky, so I add viridian green, white, and alizarin crimson to the mix. Using two small sable brushes (one with sky color and one with tree color), I alternate between using both brushes, blending and softening the edges where the trees meet the sky. Then I block in the water.

Step Four

I lay in the reflections in the water using the tree mixtures that I've grayed down with more terra rosa, raw sienna, and white. Painting thinly, I lay them in with horizontal strokes and a large bristle brush to show movement in the water. For the dark reflections, I add ultramarine blue and terra rosa to the mix. I block in the shadows of the aspens with a grayed, purplish mix of ultramarine blue, cadmium red light, white, and raw sienna.

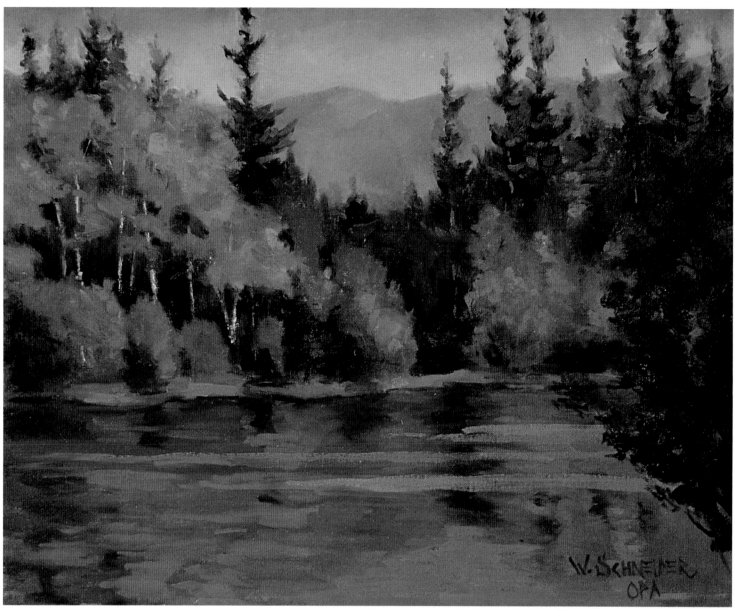

STEP FIVE

Now I paint the aspens using a mix of cadmium yellow deep and cadmium yellow light and some of the shadow colors (see below). I also paint the aspen trunks with a mix of white and raw sienna. Adding a little ultramarine blue and cadmium red light to the mixture, I work the reflections of the aspens into the water. Then I mix some of the dark sky color with a little black and add the reflections of the sky in the water. Using a medium bristle brush and thick paint, I drag this color across the water in a single stroke to indicate ripples on the water. For the bush in front, I begin with the shadows and then add the thick highlights. Using a small sable and some of the bush reflection color, I paint "holes" in the bush where the distant trees show through. Finally I add a little detail to the bushes in the middle ground and sign my name.

Observing color
This quick field study that I painted on site helps me gauge the actual colors I observed in this scene. When painting fall colors, the natural tendency is to make them too intense. Try this experiment when painting outdoors: Tie a yellow or red piece of cloth to a tree, and you'll be able to see how much grayer the leaves really are in comparison.

Sky	**Sky Reflections**	**Light Tree Mix**	**Dark Tree Mix**	**Light Aspens**	**Shadowed Aspens**
White, lemon yellow, ultramarine blue, and black	*White and lemon yellow with more ultramarine blue and black*	*Ultramarine blue, lemon yellow, terra rosa, raw sienna, and white*	*Light tree mix plus more ultramarine blue*	*Cadmium yellow deep, cadmium yellow light, and white*	*Ultramarine blue, cadmium red light, white, and raw sienna*

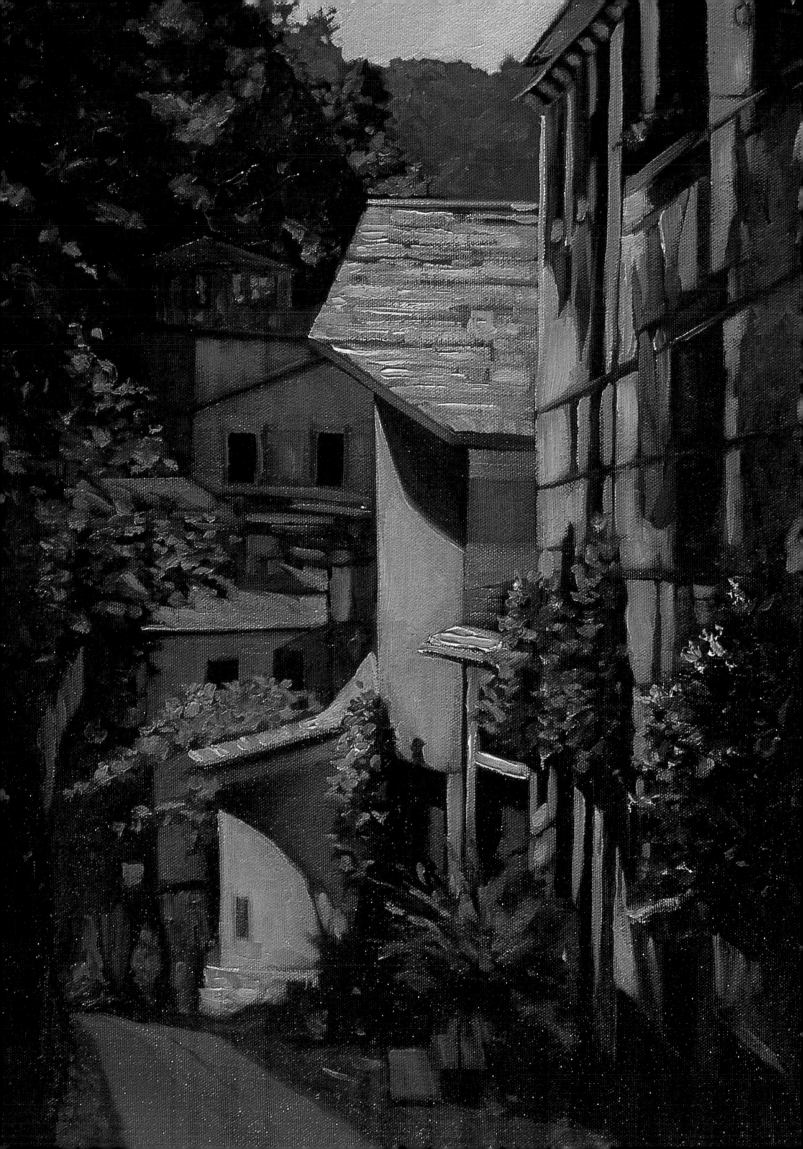

PAINTING WITH TOM SWIMM

Since early childhood, Tom Swimm has felt an instinctive need to paint. Although he is self-taught, he has long been inspired by the work of Van Gogh, Monet, and Hopper, and he considers these masters his teachers. To Tom, being an artist is about challenging himself to evolve creatively. Tom's first one-man exhibition was at the Pacific Edge Gallery in Laguna Beach, California. His work has also been featured in several other California galleries, at ArtExpo New York, and at the APPAF exhibition in Paris, France. His paintings have appeared on the cover of *Skyward Marketing's In-flight Magazine* in 2001, as well as on the cover of *Artist's Magazine* in 1992. Tom won the People's Choice award at Echoes and Visions in 1997 and the Art of California Gold Award in 1994. Born in Miami, Florida, and raised in New York, Tom currently resides in San Clemente, California.

Doorway

Selecting Your Photo

I selected a photo that had bright colors and visual interest and cropped it in various ways to find a pleasing composition. I decided the foreground was too dark and not important to the scene, so I "zoomed in" on the doorway itself, eliminating the dull, distracting areas. I wanted to avoid placing the door in the exact center of the composition, so I set it to the right, which gave me room to include flowers on the left.

Step One

I start with a light underpainting of yellow ochre, cadmium red light, and burnt sienna. I darken the mixture with sap green and then with alizarin crimson to block in the archway on the left with a large flat brush. I indicate the shadow across the door with a mix of Prussian blue and Payne's gray. I block in these main areas with very thin washes of color. I make the application thin enough that I can still see the drawing underneath, which will help me when I develop details.

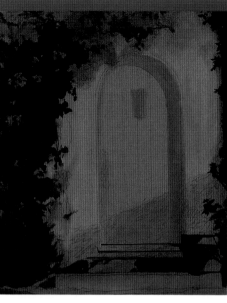

Step Two

When working with oil paints, I like to work from dark to light, so I add the darkest colors to the painting at this stage. Using a medium flat brush, I apply a mixture of sap green and alizarin crimson to the leaves and the foreground shadows. Using the outline underneath as a guide, I'm actually drawing as I paint. To add interest, I leave some negative space. To create the leaves, I use the flat side of the brush and make short, choppy brushstrokes, alternating the direction of each stroke. I use a dry brush to pull some color from the canvas and indicate breaks in the foliage, adding a sense of realism and depth.

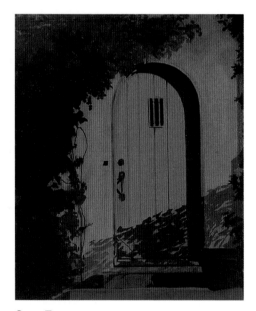

Step Three

Using Prussian blue mixed with Payne's gray, I paint the doorway shadow and small window opening, as well as the shadows cast by the door handle. Next I add a mix of phthalo violet and Payne's gray to the lacy shadows cast from the trees on the right. As with the leaves, I use a variety of brushstrokes and leave some "holes" in the shadows, which breaks them up and adds visual interest. Using yellow ochre mixed with burnt sienna and a little cadmium red light, I add the middle values of the front steps and foreground, along with some detail in the tree branches and door hardware. Then I define the flowers with the same dark red mixture.

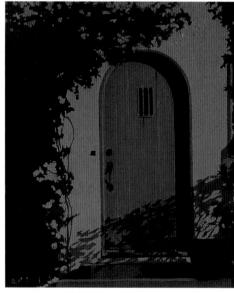

Step Four

This is where it starts to get fun and the painting comes to life! In this step, I add the last colors of the underpainting before applying the highlights. Using a mixture of blue-violet and flesh with a little white, I paint the surface of the doorway wherever it isn't shadowed. Then I paint the entire surface of the wall with a mix of flesh and a little white, using the negative spaces I'd created in the previous step as a guide. After covering the largest areas, I embellish some of the details, such as the vertical grooves in the door, with a slightly darker mix of blue-violet and flesh.

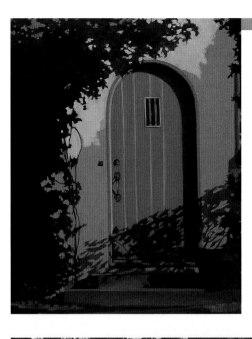

STEP FIVE

Using a mixture of flesh and white, I go back over the entire wall to punch up the lights. I load my brush more heavily with color now and vary the direction of the brushstrokes to add some texture. I also bring up the other highlighted areas in the door and the foreground. When I'm adding highlights, I like to paint loosely and let the brush do the work. I'm not concerned with trying to get a perfectly smooth, even surface. By varying the direction of the brushstrokes and the pressure, I create an illusion of dimension and reality. Flat, two-dimensional surfaces are boring in any painting, so be spontaneous. Paint boldly and have fun!

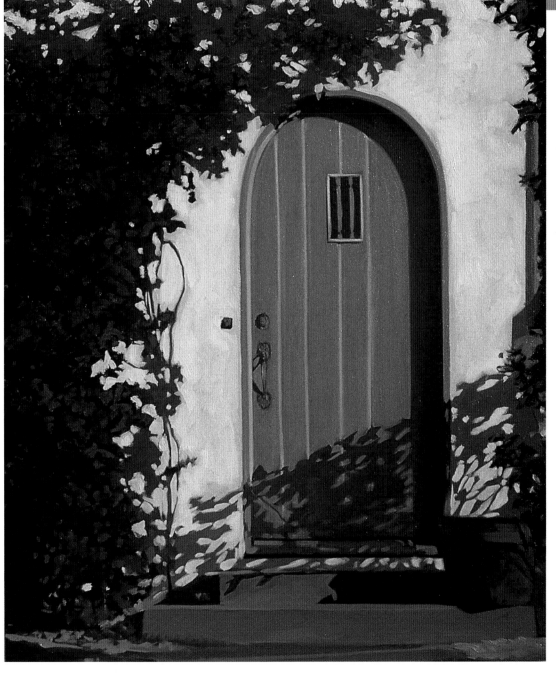

STEP SIX

Now I add more interest and texture to the wall with a final application of brilliant yellow mixed with white. I also soften the highlights in the door by going over them with a dry brush. Using yellow ochre and cad. red light, I apply one more layer of color to the front steps and create some highlights with flesh and white. Once I'm satisfied with these final elements, all that remains is to bring life to the flowers and leaves. I bring out the color of the leaves by adding various green mixtures, starting with the darkest and working up to some final highlights. As with the door, it's important to stay loose and not try to cover the whole area. I paint around some of the dark areas to create the illusion of bright sun hitting the leaves. Finally I add the brightest flowers with a mix of cadmium red light and alizarin crimson for the bougainvillea and add a few touches of brilliant yellow and cadmium orange for both the flowers on the right and the patch of grass in the foreground.

BOAT

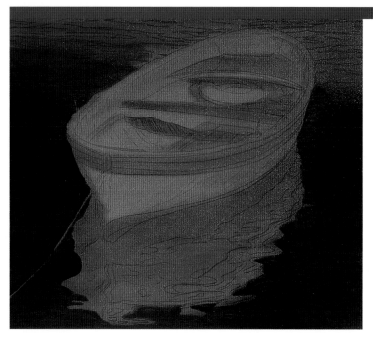

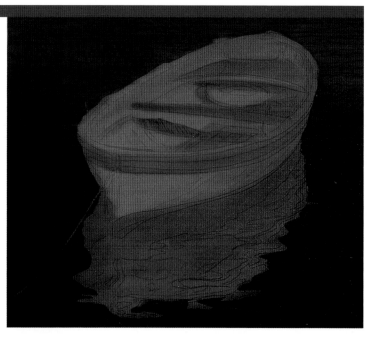

STEP ONE

Once I'm happy with my sketch, I start applying very thin washes with a large brush. First I block in the basic shapes of the boat and its reflection using a mixture of yellow ochre, alizarin crimson, and burnt sienna. I use very little pigment at this point, as I don't want to cover up my drawing, which I'll still need for reference. Then I add a little Payne's gray for the shadowed areas of the boat. Next I paint the water with various mixes of Prussian blue, viridian green, sap green, cerulean blue, and phthalo violet.

STEP TWO

Now I develop the water by building up each of the values. Although the finished boat will be almost white, I use much darker colors for its reflection, mixing some of the colors I used for the water with the boat color mixture of yellow ochre, alizarin crimson, and burnt sienna. This creates a deeper blue version of the boat's color, which gives the illusion of depth and transparency.

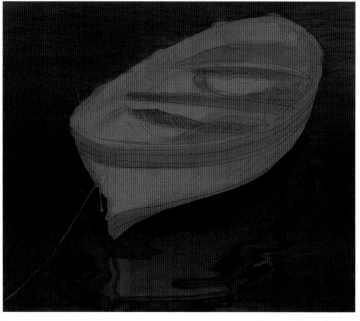

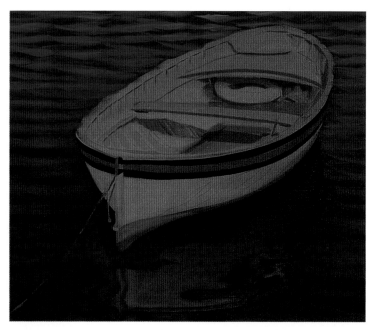

STEP THREE

For the reflections of the hull, I add burnt sienna and raw sienna to the cerulean blue and viridian green mixture. Then I add a red tint to the shadows with a mixture of alizarin crimson, cadmium red light, and Payne's gray. Next I switch to a medium-sized flat brush and draw with the paint, adding dark, contrasting ripples. I create the reflected red stripes with alizarin crimson, cadmium red light, and Payne's gray. For the main part of the hull, I use a mixture of yellow ochre and alizarin crimson. Again I keep my brushstrokes fluid to convey the feeling of the boat floating on the water.

STEP FOUR

Now I define the individual ripples in the water with four slightly different mixes from step one. I work from top to bottom, placing the lighter values toward the top, which heightens the realism of the water and adds depth and contrast to the painting. I also let some of the darker underpainting show through to give the waves more dimension. Next I add a thin coat of flesh over the sunlit areas and define the shadows with a mix of Payne's gray, flesh, and cerulean blue. I darken this mix for the two lines of trim on the outside of the hull. For the middle of the trim, I mix cadmium red light and Payne's gray and use minimal brushstrokes to give the lines a smooth, uninterrupted look.

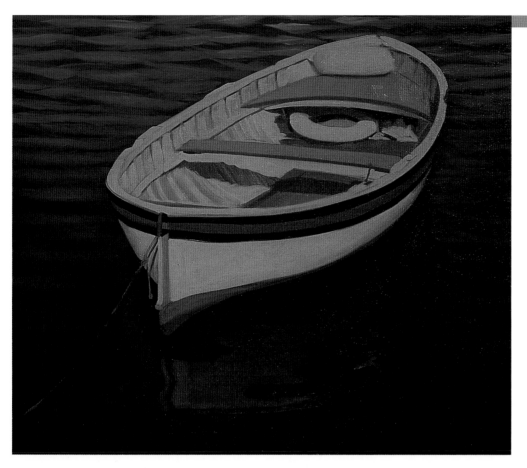

STEP FIVE

Now I paint the seats and the wood with a mixture of cadmium red light and flesh. Then I whiten the boat, loading a medium brush with a thick mix of white and brilliant yellow. I apply the paint liberally, varying the direction of my brushstrokes to create interest and texture. Accuracy is important, but I don't spend too much time on any one area; I don't want to over-work my colors. I let my brush do the work and try to create an impression of the details rather than painting photorealistically. A slightly unfin-ished look can actually give a painting more character than a perfectly realistic rendering.

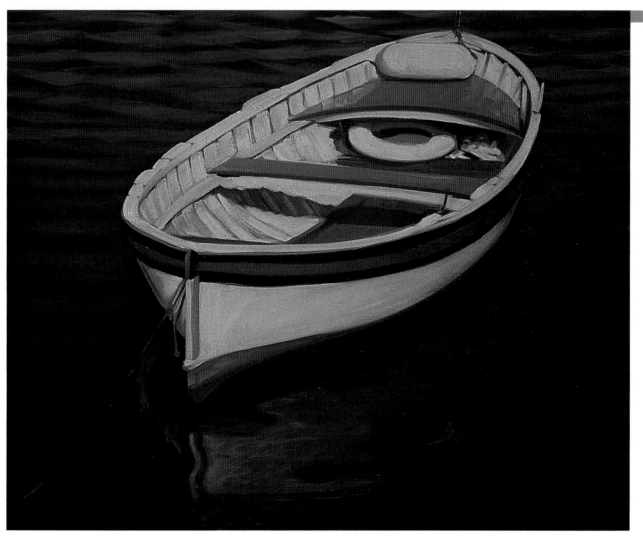

STEP SIX

I continue building up the white of the boat. Then I make a few adjustments, adding lighter reflections to the hull in the water and defining the elements inside the boat and on the wood trim. Finally I touch up the rope and add a few more highlights to the water at the top of the painting.

EUROPEAN STREET SCENE

Outlining Shapes
I begin with a rough drawing, outlining the basic shapes with a fine-point marker. At this stage, I'm concentrating on making sure the perspective and proportions are correct; I'll add the details when I paint.

STEP ONE
Once I'm happy with my sketch, I apply the first layer of paint in thin washes to establish the basic relationship of colors and values. With a large brush, I use colors straight out of the tube, starting with cerulean blue for the sky, background hills, street, and one building. I use sap green for the foliage and mix burnt sienna and yellow ochre for the remaining buildings. To define some of the shadowed areas, I apply a little Payne's gray. Next I'll add the darkest values.

STEP TWO
Using a medium flat brush and a mixture of Prussian blue, sap green, and alizarin crimson, I paint the dark foliage and define the dark shapes of the windows and shadows. I avoid using black, as I feel it brings a harsh, artificial tone that does not really exist in nature. Experiment and you'll find you can vary the hue of even the darkest areas in your paintings without ever using black. Next I add more color to the roof in the center with a mix of yellow ochre and Payne's gray, varying the direction of my strokes to create interesting textures.

STEP THREE
Here I bring out the middle values with stronger color and thicker paint. I use variations of a blue-violet and Payne's gray mixture for the hillside, the building in the center, the street, and the shadows on the wall on the right. I also add some middle values of the same mixtures to the foliage, the vines growing on the roof of one of the buildings, and the trees in the background. Once the darks and middle values of the underpainting are complete, I'm ready to enliven the scene.

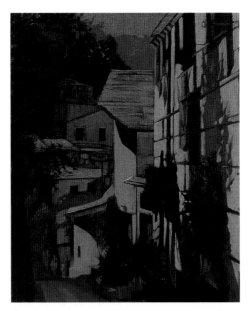

STEP FOUR
I load the brush with flesh and work on the large wall of the building on the right, painting around the shadows and some of the architectural details. Using a combination of flesh and yellow ochre, I add highlights to the yellow buildings. For the darker buildings and some rooftops, I use the blue-gray mixture from step three. Then I apply a mixture of cadmium red light and yellow ochre to the building at the bottom center. It's important to have fun and let the brush do the work from this point on; I try not to spend too much time on any particular area.

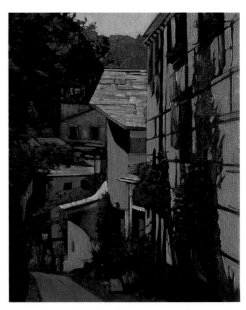

STEP FIVE
For the plants and foliage, I apply a variety of green mixtures (see color mixtures below), varying the direction of my brushstrokes and painting around the dark areas that I already established in my underpainting. At this stage, the scene should have a feeling of true dimension and depth.

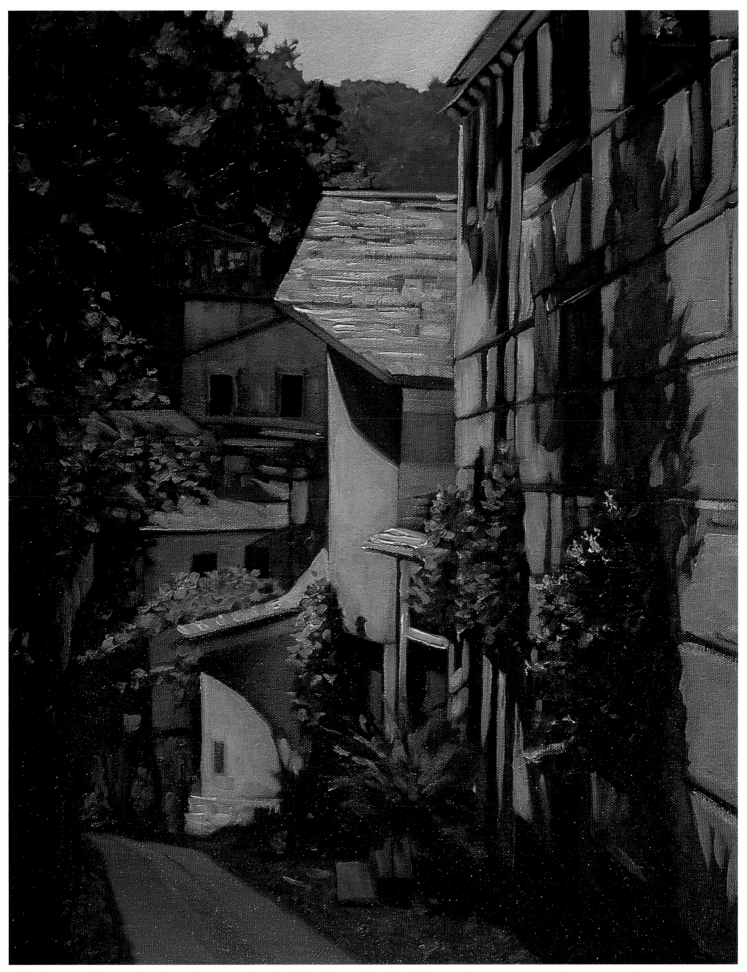

STEP SIX

I step back and take a look at what I've completed so far and decide what I need to adjust. I want the sky to have a hazy feeling to heighten the contrast in the buildings, so I mix white with a little flesh color and blue-violet. I create the brightest highlights on the rooftops with a mixture of white and brilliant yellow. To add a sense of texture and realism, I keep my brushstrokes loose. I mix cad-

mium yellow light and white for the final highlights on the yellow buildings. I also apply this color to some areas of the wall on the right for interest. I bring up the lighter values of color in the other buildings and then add highlights to the foliage using sap green mixed with cadmium yellow light and viridian green mixed with yellow ochre.

Nighttime Café

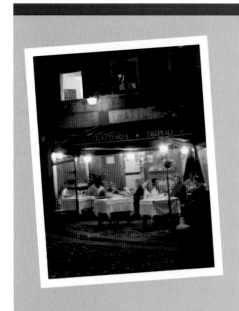

Taking Photos at Night
When photographing a scene like this for reference, I use a 35mm SLR camera on a tripod to keep the focus sharp. The newer digital cameras also work very well. I prefer to turn off the flash feature to get the most realistic, natural light.

STEP ONE
I've chosen a smaller canvas for this piece because I want to create a more impressionistic rendering without worrying about refining every detail. First I make a very rough drawing of the basic shapes in the composition on the canvas. Then I tone it with a thin base coat of magenta acrylic paint.

STEP TWO
Once the base coat is dry, I establish just the basic values of light and shadow with a thin oil wash that allows the drawing to show through. I use a large flat sable brush and Payne's gray, burnt sienna, and raw sienna, working very quickly and using bold, loose brushstrokes to cover the basic elements.

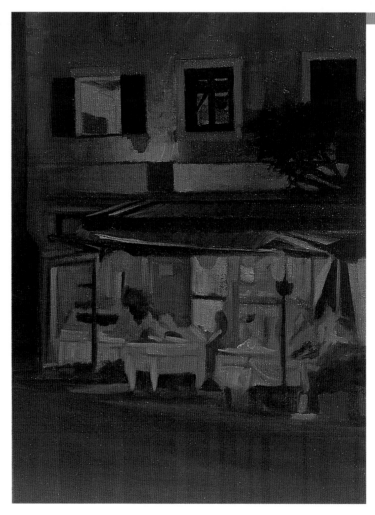

STEP FOUR
Next I mix blue-violet and Payne's gray and use the edge of a small flat sable brush to draw in some details on the building. I build up the color in the awning with more sap green, and then I add some Naples yellow for the highlights. I add further definition to the café interior with a mix of burnt sienna, Naples yellow, and Payne's gray. For the tablecloths, I use a mix of phthalo violet, blue-violet, and flesh, varying the direction of the brushstrokes to simulate the folds in the cloth.

STEP THREE
Now, using the drawing as a guide and referring to the photo for color, I block in the dark and medium values. I mix alizarin crimson, Prussian blue, and sap green for the darkest colors in the tree foliage and the window shutters. Then I use a mixture of phthalo violet and cerulean blue for the building. Next I mix sap green and burnt sienna to begin defining the details in the café awning and interior. I use a variety of all these colors for the foreground to establish the shadows and reflected light.

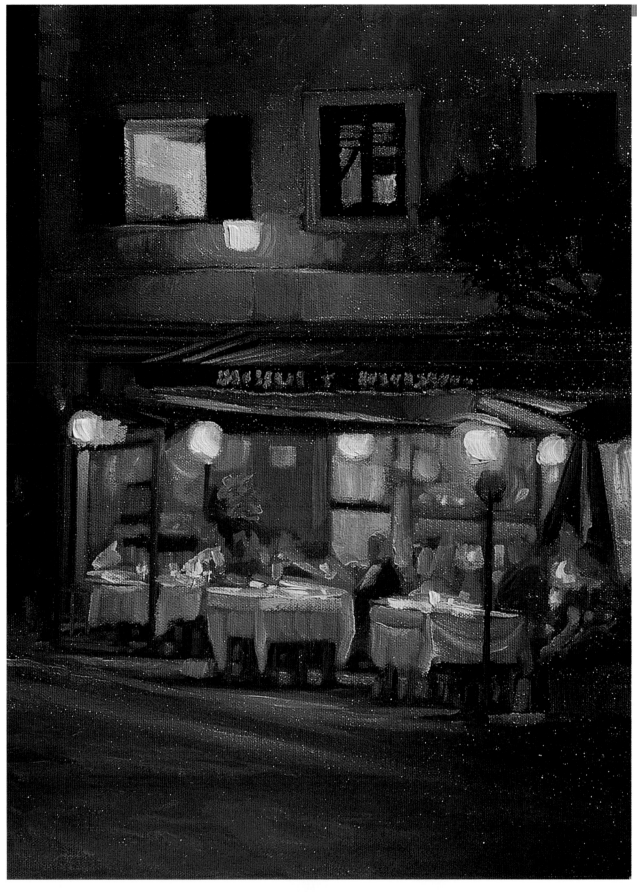

I've saved the brightest colors for last (shown below); I set up my palette with cadmium yellow light, cadmium orange, brilliant yellow, yellow ochre, blue-violet, and white. I use cadmium yellow light as a base for the windows and the lamps, and then I blend in some cadmium orange to create the glow effect. I build up more details in the figures and the café with cadmium red light, yellow ochre, and cadmium orange. Then I mix brilliant yellow with white and apply it to the tabletops and to the lamps; I use the same color to add a few other random accents. Next I apply some yellow ochre to the foreground and use blue-violet for the lettering on the awning.

*Cerulean blue +
sap green*

*Phthalo violet +
blue-violet*

*Sap green +
yellow ochre*

*Cadmium red +
Payne's gray*

*Brilliant yellow +
white*

*Cadmium yellow +
white*

PORTOFINO HARBOR

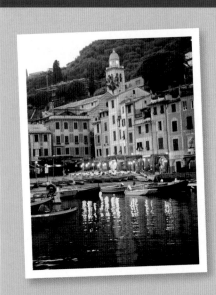

Eliminating Elements

While sketching from my photo, I decided to leave out the scaffolding on the hillside building and a lot of the confusing hardware and motors on the boats. I even cut a boat from another photo and pasted it over a distracting motor (front left) to improve the composition a bit. These are decisions that should be made before you begin the painting, so you'll have a clear vision of the end result.

STEP ONE

Once my sketch is in place, I cover the entire canvas with a wash of magenta acrylic paint. Then I quickly apply my transparent oil underpainting to help define the areas of light and shadow. My palette is very limited here; color isn't as important as value. I use sap green for the hills, raw sienna for the buildings and some highlights, and cerulean blue mixed with a little Payne's gray for the sky, water, and shadows.

STEP TWO

I begin with the darkest areas of the buildings and trees, using a large flat brush and a dark mix of alizarin crimson, sap green, and Prussian blue. I add some cerulean blue to this mix for the water and the undersides of the boats and add a little burnt sienna for the boats and reflections. With a mix of blue-violet, sap green, and Payne's gray, I paint the trees, leaving small areas of the darker color showing through for variation. For the water, I use a mix of blue-violet and Payne's gray, creating ripples with short, horizontal brushstrokes. I paint the light reflections in the same manner with a mix of yellow ochre and burnt sienna.

STEP THREE

Now I begin refining the buildings. With a medium-sized flat brush and a mixture of yellow ochre, Naples yellow, flesh, and blue-violet, I start defining the lighter areas around the windows and edges of the buildings. Then I add some detail to the central tower with a mixture of blue-violet, phthalo violet, and a little Payne's gray. Using the photo as a guide, I paint in all the areas in the scene in this color range. I keep things simple, though, and try not to re-create the photo exactly. I want a good representation of my subject, but I can record my impression of it without spending hours laboring over every single detail.

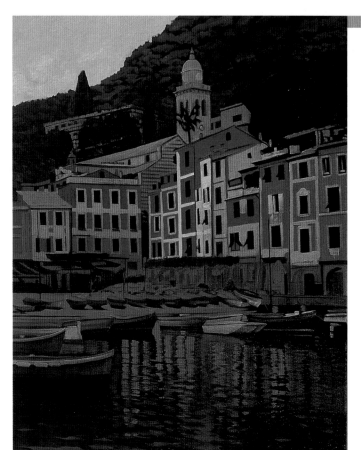

STEP FOUR

I need to create some contrast in the shadows of the buildings. With a mix of blue-violet and Payne's gray, I paint some of the rooftops, the plaza area, and the hulls of some of the boats. I also add some more details to the docked boats with a mix of cerulean blue, cadmium red light, and yellow ochre. Then I use burnt sienna to loosely paint some details on the café. I mix a little white and flesh into blue-violet and paint the highlights on the hulls of the boats in the foreground. Then I mix cerulean blue with white and paint the sky, adding a few suggestions of clouds with a pastel mixture of flesh and white.

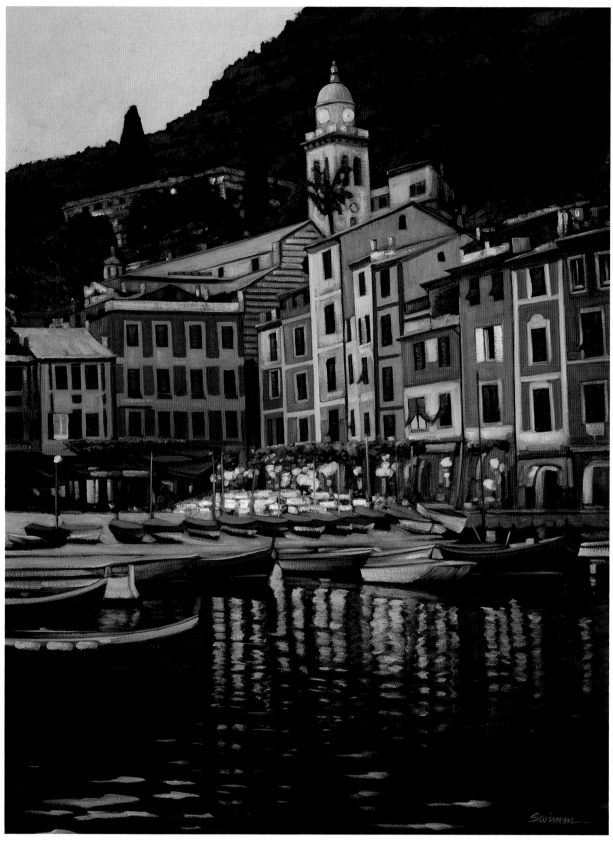

Clock Tower Detail
I use my smallest flat brush to "draw" in the details of the tower, turning my brush on its side to get a thin, clean edge.

Glowing Lights Detail
I apply thick yellow and white paint in a circular motion to capture the glow of street lamps at night.

Reflections Detail
I use the edge of a flat brush and create short, tapered, horizontal strokes to render realistic reflections in the water.

STEP FIVE

I suggest some details in the buildings, using a mix of alizarin crimson and cadmium red light for the façades on the left and the trim on the right. I mix burnt sienna and flesh for the façades on the right, adding touches of yellow ochre or raw sienna. To "punch up" the light for more contrast, I mix cadmium yellow light and yellow ochre for the reflections on the water and the doorways. I add white to the same mixture for the clock tower. Then I mix a little white with blue-violet and paint a few highlights on the water in the foreground. I also add this color to the plaza, the boats, and a few of the rooftops. I highlight the trees with a mix of sap green

and yellow ochre and add some detail to the awnings with a mix of cerulean blue and viridian green. With a mix of white and cadmium yellow light, I paint some of the café tabletops. Now I add the brightest highlights. Using cadmium yellow light mixed with a small amount of white, I paint the glowing lights in the café. I lighten up the windows and indicate the shutters with a mix of cerulean blue and Payne's gray. I step back and look for any other areas that need sharpening or contrast, adding a highlight here and there to harmonize the overall painting.

SUNLIT PATH

STEP ONE

With the gate set off to the left and the sunlit path angled right, this composition invites you into the painting, enticing you with a glimpse of the house behind the gate. After sketching the scene on the canvas and applying a magenta acrylic base wash, I lay down a thin wash of oils as an underpainting. I use a large flat brush with burnt sienna, sap green, blue-violet, and phthalo violet.

STEP TWO

Next I establish the large areas of the darkest colors and begin to define the windows, walls, and roof, as well as the shadows in the foreground. I use the edge of a large flat brush, which allows me to paint details in the gate and the shadows. I mix sap green, Prussian blue, and alizarin crimson for the darks, then use a mixture of Prussian blue and yellow ochre on the foliage. The walls of the house are a blend of blue-violet, Payne's gray, and burnt umber, and the foreground shadows are a mix of cerulean blue and Payne's gray.

STEP THREE

I add a thick layer of paint to the walls of the house with a mix of Payne's gray, burnt umber, and white. Then I add a mixture of burnt umber, cadmium orange, and white to the roof tiles and to the underside of the eaves. I highlight the same area with a mix of phthalo violet, Payne's gray, and white, and I paint the windows with a mix of cerulean blue, Payne's gray, and white. For the foliage, I mix variations of cerulean blue and sap green, adding brilliant green for the lightest areas. I also define a few shadows using the wall colors.

STEP FOUR

Now I add the brightest highlights. For the sky, I mix a little flesh color with white. I paint around some of the overhanging trees and also add a few "openings." Using the edge of a small flat brush as a drawing tool, I add highlights to the scrollwork in the gate. With the same brush, I paint the large areas of light in the foreground, carefully painting around the shadow areas I've already established. I mix brilliant yellow and white and layer this on top of the colors I've just applied. This really makes the sunlit ground "pop" and warms it up.

STEP FIVE

To finish, I mix some variations of sap green and cadmium yellow light with a little white and cadmium orange for the sunlit areas. Next I mix cadmium yellow light, cadmium orange, and brilliant green to paint the openings in the fence where light shines through. For the brick wall, I mix yellow ochre, white, and cad-mium orange, adding a little cerulean blue for the shadows. For the scrollwork on the gate, I mix burnt sienna and cadmium orange. For a little color accent, I add the flowers on the left with a mix of phthalo violet and white.

ROCKY SHORELINE

Choosing a Viewpoint
I took a number of photos at this location, but a lot of them didn't turn out to be very compelling compositions. In some, the rocks were too overpowering, and in others the angle of the beach was flat and uninteresting. I selected this photo because it had all the elements I wanted to capture and the point of view gave me a sense of standing right there on the beach.

STEP ONE

I sketch the scene, adding only as much detail as necessary to separate the light and dark areas. After applying the base coat, I use a large brush to block in the basic shapes with thin washes of cerulean blue, Payne's gray, burnt sienna, and raw sienna. I define the darkest values in the rocks with a mix of burnt sienna and Payne's gray, varying the direction of the brushstrokes to keep the forms from looking too static.

STEP TWO

Now I add the underpainting for the water; I mix cerulean blue and blue-violet for the lightest areas and add phthalo violet and Payne's gray for the darkest areas. I also paint the sand below the tide pool in the foreground. I'm careful to paint around the brightest areas of the water where I'll later add the highlights. Then I mix raw sienna and cerulean blue and blend this mixture into the water that I've already painted—this gives the effect of transparent, shallow water. Then I apply this same mixture to the shaded bluffs in the background.

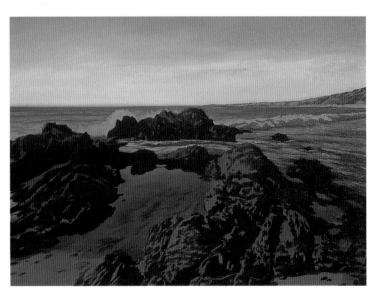

STEP THREE

To brighten the values in the surf, I apply a mix of blue-violet and white to the waves and to the ocean in the background. Next I apply a mix of Naples yellow and yellow ochre to the brightest areas in the hillside. Then I add the white caps in the water with a mix of flesh and light blue-violet. I want to capture the hazy sunshine in this late afternoon scene, but I also want to create a subtle transition from the blue at the top to the bright yellow at the horizon.

STEP FOUR

Now I mix four colors and apply them from top to bottom: The first is a mix of cerulean blue, blue-violet, and white. I lighten this mix with white for the second hue. The third color is a mix of flesh and white, and the fourth is a mixture of brilliant yellow and white. I use a large flat brush to apply the color and work quickly, keeping the paint wet with medium. I vary the direction of the brushstrokes and add thick areas of the flesh and yellow mixes to create the clouds.

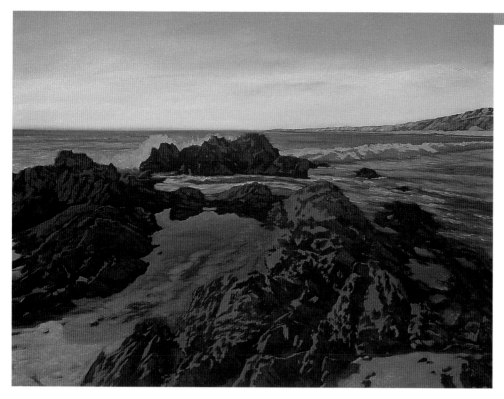

Step Five

Now I want to bring out some details and variations in the shaded areas of the rocks. I mix blue-violet and Payne's gray for the rocks on the left and mix raw sienna and Payne's gray for the others. I fill in large portions of the shaded areas but leave some of the darkest color showing for depth. I also use the same color to paint the rocks' reflections in the water, which creates a lot of contrast and interesting patterns. Then I paint the foreground sand with a mixture of yellow ochre and Naples yellow.

Water

Cerulean blue + *Blue-violet +* *Blue-violet +*
Payne's gray *Payne's gray* *white*

Rocks

Burnt sienna + *Cadmium* *Cadmium*
flesh + *yellow +* *yellow +*
cadmium orange *white* *white + flesh*

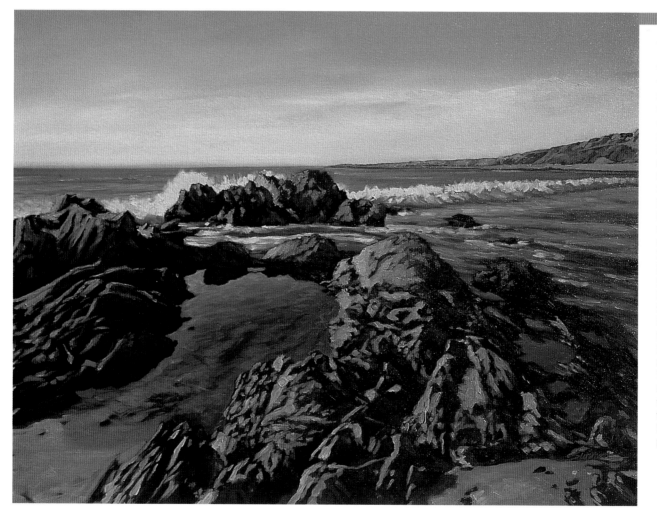

Step Six

I mix Payne's gray, white, and phthalo violet for the mid-range values in the grayish rocks on the left. Then I mix burnt sienna, flesh, and yellow ochre with a small amount of cadmium orange for the remaining rocks on the right. I use a mix of flesh, white, and cadmium yellow light for the brightest areas in the rocks, and I add more white to these mixtures for the tops of the waves and the surf. Now I step back and take a final look, making any small adjustments that will accentuate the overall color harmony of the painting.

MISSION-STYLE VILLA

Applying Artistic License
I liked the depth and the panoramic feel of the scene in this photo, but the foreground was dull and not very colorful. I decided that once I had faithfully rendered the main elements of the composition, I'd get creative and spontaneous with the field in the foreground. Taking liberties like this with the way you portray a scene is referred to as "using artistic license."

STEP ONE
Once my simple sketch and magenta acrylic base coat are in place, I use a large flat brush to lay in thin washes of cerulean blue, sap green, burnt sienna, and phthalo violet over the basic shapes. I mix cerulean blue and violet for the hills in the background, adding a little Payne's gray to darken the shadowed areas. Next I add the darkest values and define the details in the trees and the building. I add a mix of sap green and Payne's gray to the hillside foliage, and then I mix sap green, alizarin crimson, and Prussian blue to create a dark mixture for the tree trunk and the various building details. I use a medium flat brush to paint around the brightest areas of light that I'll work on next.

STEP TWO
I paint the sky with a mix of cerulean blue and white. Then I mix cerulean blue, phthalo violet, and Payne's gray for the farthest hill. I add a little sap green to a few areas of the hill for interest and add sap green and alizarin crimson at the bottom of the hill. I bring up the midtones in the trees with a mix of sap green, brilliant green, and yellow ochre. Then I add another wash of blue-violet and phthalo violet to the building. To suggest a lavender field, I create a mix of blue-violet and phthalo violet and apply it to the foreground with loose, random strokes.

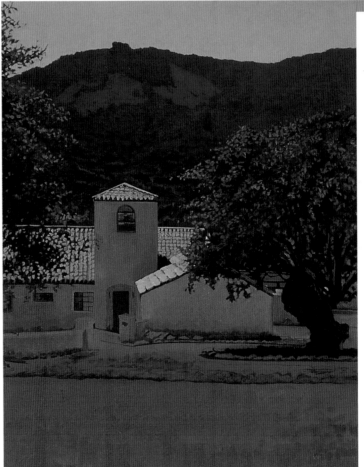

STEP THREE
Now I lighten the rooftops and the trees and enhance the shadows of the building with strong colors. I mix flesh with cadmium orange for the roof tiles and add brilliant yellow to the mix for the brightest areas. For the tree highlights, I mix variations of sap green, brilliant green, and yellow ochre, adding more texture and detail than I did in the background. For the building walls, I use a mixture of blue-violet, phthalo violet, and white. I add some flesh and yellow ochre to the mix to bring out the reflected light, varying the colors to keep the walls from looking too flat and boring.

Tree and Building Details

I use a small flat brush for the tree leaves, adding a variety of values and making quick, random, dabbing strokes. For the tiles on the roof of the building, I use the same small flat brush, but this time I make even, deliberate strokes to create the symmetrical rows.

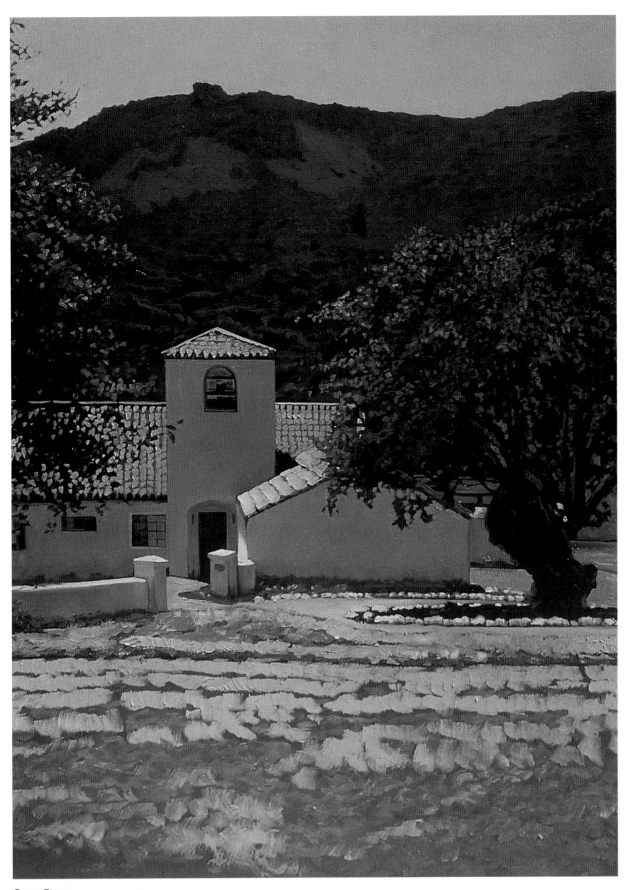

STEP FOUR

I mix brilliant yellow and white for the final building highlights and the rocks around the driveway. Then I add more highlights to the landscape with a mix of flesh and Payne's gray. I paint the foreground with a large flat brush and various mixes of brilliant yellow, cadmium orange, phthalo violet, blue-violet, and cadmium yellow

light. At this stage, I use a lot of color, varying the direction of my brushstrokes and keeping them loose to create merely the impression of the flowers and the field, not a realistic portrayal of every leaf and petal. This additional texture also allows the colorful foreground to "pop" forward.

The Dulcimer Player

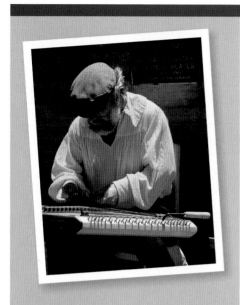

Capturing a Likeness

The reference photo I chose had a nice composition and didn't need much cropping. I also liked the pose; the man was concentrating on his music, not looking up, and I felt this would help me capture the essence of this introspective moment. For me, this painting is not so much about the musician as a face to be recognized but as an artist who is bringing his gift to the world anonymously.

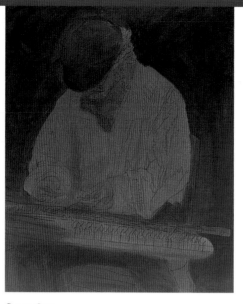

Step One

I start this portrait the way I do any subject—with a rough sketch and underpainting, followed by thin layers of color. Once the magenta base coat is in place, I apply transparent oil washes of yellow ochre, burnt sienna, and Payne's gray to the basic shapes of the figure with a large flat brush. Then I layer a thin wash of Prussian blue on the hat and apply large, sweeping strokes of burnt sienna color to the background.

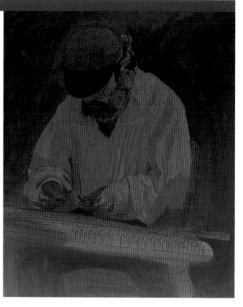

Step Two

Using the edge of a medium flat brush, I first add Payne's gray and then cerulean blue to the folds of the shirt and the shadows in the hands. For the beard, hair, and facial shadows, I use a mix of burnt sienna and Payne's gray. I define the glasses with Prussian blue and darken the brim of the hat with a mix of Prussian blue and alizarin crimson. I also add a little yellow ochre to the front of the hat to indicate the reflected light.

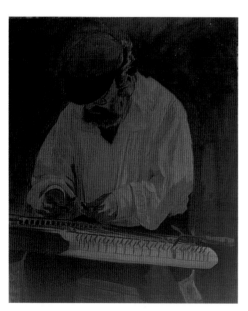

Step Three

Now I establish the darkest values in the painting with a mixture of Prussian blue, alizarin crimson, and Payne's gray. I use a thick, opaque layer of this mixture for the pants and the details in the dulcimer, and then I add some burnt sienna to the mix for the wood tones of the instrument. I add cerulean blue to the highlighted areas and begin to define the chair with burnt sienna and Payne's gray, using the thin edge of my flat brush to "draw" the details.

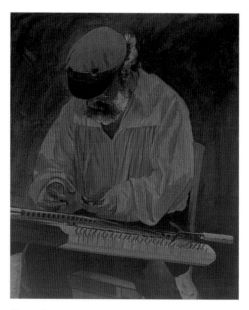

Step Four

I add yellow ochre with thick, loose strokes that follow the folds in the shirt. Then I refine the face and neck with a mix of Indian red and Payne's gray. I lighten the hands with a mix of cerulean blue and Indian red, and I mix yellow ochre and cerulean blue for the shadows of the dulcimer keys. Then I apply yellow ochre to the front of the dulcimer. With a mix of cerulean blue and white, I add highlights to the hair and beard and blend some of this color into the light parts of the hat.

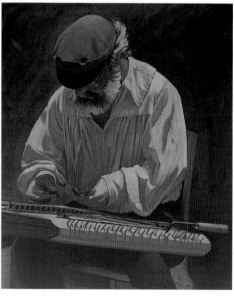

Step Five

Next I fill in the negative spaces of the light areas in the shirt and the dulcimer with rich, warm color. With a mix of cadmium yellow light and Naples yellow, I paint the brightest areas of the shirt. For the highlights in the hands and at the top of the dulcimer, I use a mixture of flesh and Naples yellow. I also add a little Naples yellow to the uppermost part of the hat and brighten the highlights in the hair and beard with a mix of flesh, white, and blue-violet.

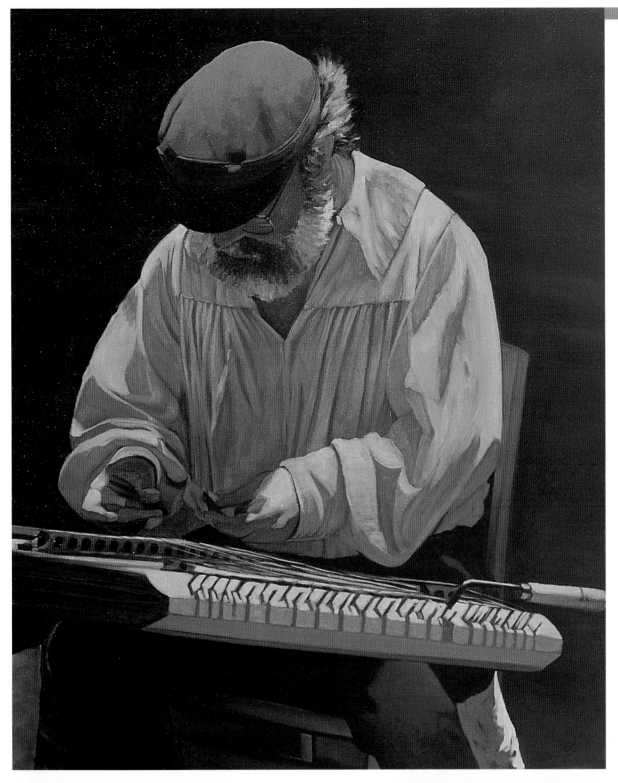

STEP SIX

Now I just need to add one more layer of paint to accentuate the highlights. I mix cadmium yellow light and white and apply it to the upper areas of the shirt. Then I mix brilliant yellow and white and add another layer of color to the top of the dulcimer, the highlights in the hands, and the remaining accents in the dulcimer. I also drybrush a little yellow ochre into the folds of the shirt to harmonize the areas of light and shadow.

Cap Detail
Capturing a sense of realism and texture in fabric can be easier than you think, if you just remember to keep your brushstrokes loose and varied. In this detail of the cap, you can see that a gradation of values and changing the direction of the brushstrokes gives it a three-dimensional quality without a lot of detail.

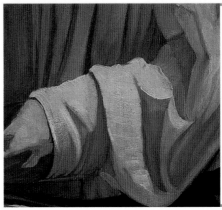

Shirt Detail
I use the same technique I used for the cap and then highlight the folds of the shirt with multidirectional brushstrokes, painting quickly and loosely. The key is not to overwork any one area; try to be spontaneous and let the brush do the majority of the work! You'll actually end up creating a more realistic painting.

Carmel Sidewalk

Step One

Using a fine-point marker, I make a rough drawing on the canvas and then cover it entirely with a thin base coat of magenta acrylic paint. I establish the basic areas of color and value with a thin wash of oils (burnt sienna, Payne's gray, cerulean blue, and raw sienna) and a large flat brush, working quickly and loosely. Again the idea is to cover the canvas without being too concerned about detail or "staying within the lines." I block in each area according to the values I see in the photo, creating a base for the contrast between the light and shadow. I draw in the darkest values of the trees and foliage with a medium flat brush and a mix of alizarin crimson, sap green, and Prussian blue. Next I use a mixture of cerulean blue and Payne's gray for the street shadows. I add some yellow ochre to this mixture to vary the contrast in a few places, and I also apply it to the underside of the building at the upper left. Then I use a mixture of blue-violet and Payne's gray to block in the shadows on the sidewalk. I add Payne's gray and burnt sienna to this mix to define the shadows in the tree trunk and the sidewalk in the foreground. Then I apply a mix of sap green and cerulean blue to create some contrast in the trees.

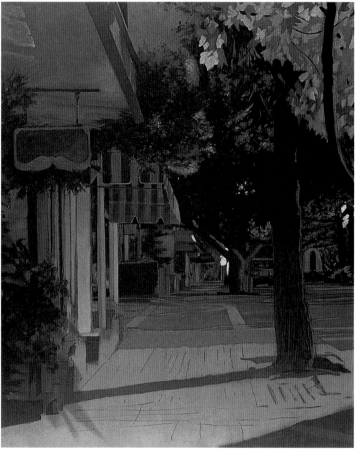

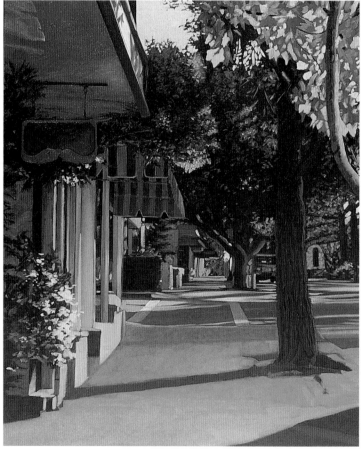

Step Two

I mix blue-violet, flesh, and Payne's gray for the window frames and doorways. Next I mix a variety of different greens for the trees, using sap green, brilliant green light, yellow ochre, and flesh. I "draw" in the trees with a small flat sable brush, referring to my reference photo to guide my color choices. Then I block in the signs and awnings with a mix of cadmium orange and alizarin crimson. I add more detail to the shadows in the street with the Payne's gray and cerulean blue mixture from step one. I paint some of the negative space in the distance with a mixture of brilliant yellow and white.

Step Three

I paint the sky with a mix of cerulean blue and white. I use the negative space as a guide and paint around the foliage, "punching" light in between to break up the solid mass of leaves. I brighten up the foliage at the upper right with a mix of cadmium yellow light, sap green, yellow ochre, and Naples yellow. Then I mix a few variations of cadmium yellow light, cadmium orange, flesh, and brilliant yellow to use in the street, the building highlights, and the tree trunks. By mixing a little of each color with white, I get a lot of exciting highlight colors. I use a mixture of blue-violet, white, and flesh to paint the crosswalk lines and then fill in the sidewalk with a mix of Naples yellow and white. Then I dab on a thick mix of sap green and white for the bush in the foreground and apply a mix of white, cerulean blue, and brilliant yellow for the bright flowers.

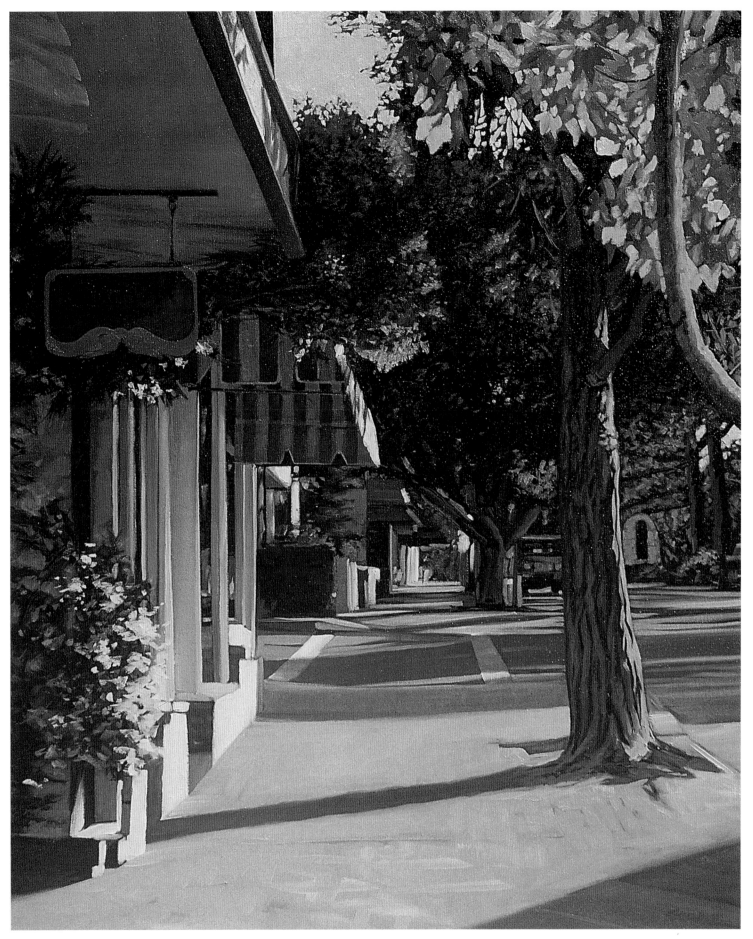

STEP FOUR

Now I fill in the brightest highlights and add the final details. First I accentuate the awning with cadmium red light. Then I add another layer to the building and the sidewalk, varying the direction of my strokes and the thickness of the paint to create texture and interest. I make some random shapes in the shadows of the tree with a mix of raw sienna, Payne's gray, and cerulean blue, being sure to leave some darks showing through underneath. Finally I step back from the canvas and add a few more pinpoint highlights with a mix of brilliant yellow and white.

Hawaiian Harbor

Step One

Once my sketch and base coat are in place (see page 4), I create the underpainting. I've chosen four colors to block in the basic elements: cerulean blue for the sky and water, burnt sienna mixed with sap green for the trees and land masses, and raw sienna for the brightest highlights on the buildings and the boat. I apply these base colors thinly, using a large flat brush and thinning the paint with medium. Details and accuracy are not important at this point, and you don't have to be afraid of painting "outside the lines." Keep it loose!

Step Two

I have two goals for this step: to paint the darkest colors and to enhance the details. I choose a medium flat brush so I can add definition to the drawing a little more accurately. I use a mix of alizarin crimson and sap green for the trees, a mix of Prussian blue and Payne's gray for the water, and a mixture of burnt sienna and sap green for the details in the boats and the buildings. Then I mix cerulean blue with Payne's gray for the rooftop on the left and the shadowed details on the dock pilings, on the boat, and on the building on the right.

Step Three

Next I add more details and establish the mid-range values in the shadows with flesh, blue-violet, cerulean blue, and Payne's gray. I use the flesh color to lighten the values and Payne's gray to mute the color. Next I develop the tree trunks, the grassy area by the dock, and the remaining water reflections with a mix of sap green and raw sienna. As in the previous step, I use a smaller flat brush to refine the details.

Painting Water Reflections

Water can take on many forms, whether calm and still or turbulent and in motion. And the reflections of objects will appear quite different depending on the state of the water. In water at rest, images are reflected almost the way a mirror reflects, but they aren't exact copies. When the water is moving, reflections are distorted images of the objects they reflect—they're elongated and have blurred edges. Here are a few guidelines for painting reflections in any type of water. First note that the colors in the reflections will be a little less intense than they are in the objects themselves. And light-colored objects will appear somewhat darker; dark-colored objects will appear just a bit lighter. Finally remember that the object's form won't appear quite as crisp and distinct in the reflections, even in very calm water, as shown in these steps of painting a boat and its reflection.

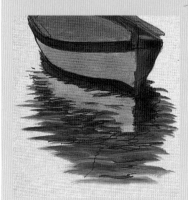

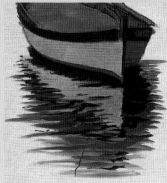

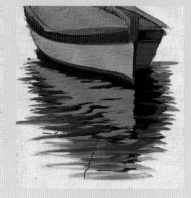

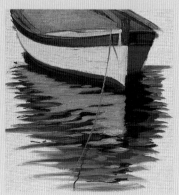

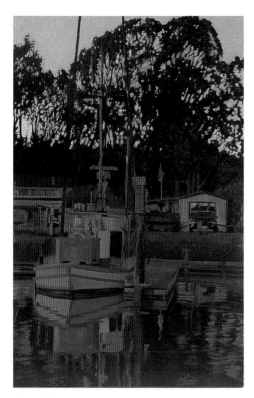

Step Four

For the sky, I mix cerulean blue, blue-violet, and white. I paint the top of the sky first; then I load a small brush with sky color to "punch holes" through the tree branches, creating the negative spaces between the leaves. I gradually add white to the sky as I approach the horizon line. To highlight the trees, I apply a mix of sap green, burnt sienna, and raw sienna, leaving some of the dark color showing through.

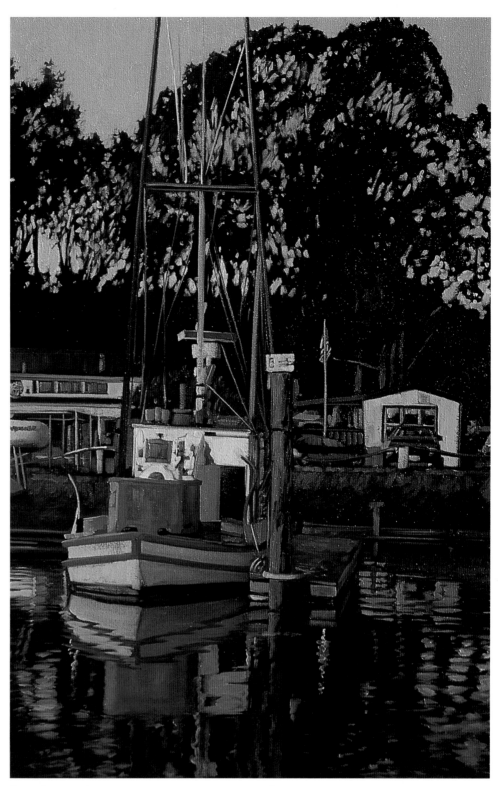

Step Five

All that's left is to fill in the remaining areas with the lightest values, which will bring the painting to life and really make it look like a sunset scene. First I mix burnt sienna with cadmium orange for the tree trunks, the wood pilings, and a few of the miscellaneous details in the boat, dock, and water. I add some flesh to this mixture for some of the reflections in the water. Then I lighten some shadows on the boat and the dock using blue-violet mixed with flesh. For the final highlights, I mix cadmium yellow light, flesh, and white for the hull and the wheelhouse of the boat, the buildings, and a few of the details in the mast and the flag. I refer back to my reference photo one last time and tweak any final details and highlights, applying the paint sparingly with a small brush.

Nautical Still Life

Composing the Scene

The shape and color of nautical objects make for wonderful still life compositions. As I walked around the deck of this boat, I took a bunch of photos at various angles; I wanted to give myself a lot of choices for the final composition. But I kept coming back to this spot—the reflected light created an interesting contrast with the cast shadows. I decided to crop the photo to make the ropes the dominant visual element, allowing the shadows to fill in the lower half of the image.

Step One

To simplify the beginning step, I project the photo image onto a canvas and use a fine point marker to sketch the composition. As the painting progresses, I will actually "draw" in greater detail with a brush and paint—in the same way I would use a pencil or charcoal. Next I cover the entire canvas with a thin base coat of magenta acrylic paint.

Step Two

Now I establish the basic tonal values with thin mixes, applying the color loosely with a large flat sable brush. I use flesh for the lightest areas, then yellow ochre for the highlights at the upper right. I block in the mast, the life preserver, and the wooden posts with burnt sienna. Then I add Payne's gray to the ropes and the shadows in the foreground. Detail isn't important at this stage; this layer is a rough guide, so it's okay to paint "outside the lines."

Mid-Range Values

Payne's gray, cerulean Blue, flesh, Indian red

Payne's gray, cerulean blue, phthalo violet

Mix above plus white

Cerulean blue, flesh

Mix above plus white

Step Three

I work from dark to light, layering lighter colors on top of the underpainting to create a sense of depth and texture. At this stage, I want to establish the darkest colors to define the deep outline and shadow details. Using a medium flat sable brush, I draw the outline of the ropes, also defining the shadowed areas. Instead of using black, I mix equal parts of alizarin crimson, sap green, and Prussian blue to create a rich, deep hue. Sometimes I use more of one color in the mix; for instance, I'll add more crimson to make the color a touch warmer.

Step Four

Next I add the mid-range values. I create drama in the foreground shadows by using subtle color variations, applying Payne's gray, cerulean blue, flesh, Indian red, phthalo violet, and white in different combinations (see color samples) and blending with a medium flat brush. Note that the shadows closest to the ropes reflect the warm colors of the wood, and they gradually become bluer in the foreground. For harmony, I use the same colors to build up the shape and detail in the ropes, the metal plate at the base of the mast, and the label on the life preserver.

Step Five

Now I mix the colors for the ropes (see color samples), applying the blues first and then the warmer colors in between these brushstrokes to add depth. I use diagonal brushstrokes to match the contour and texture of the ropes. Then I add highlights in the mast and wooden post with yellow ochre mixed with cerulean blue. For the deeper wood areas and the life ring, I use Indian red and burnt sienna. I add the brightest highlights to the ropes, mixing cadmium yellow light and cadmium orange. Finally I paint in the bright areas in the background using cadmium red light mixed with white and brilliant yellow mixed with white.

Ropes

 Phthalo blue, light blue violet

 Light blue violet, white

Phthalo blue, light blue violet, white

Phthalo violet, flesh, white

 Raw sienna, white

Highlights

 Cadmium red light, flesh, white

 Flesh, yellow ochre, white

 Brilliant yellow, white

 Cadmium orange, cadmium yellow light, white

Step Six

I apply highlights with a mixture of flesh, cadmium yellow light, and white to the top of the railing, the posts, and the ropes where they are in direct sunlight. For the deck, I first apply a mix of brilliant yellow and white. Then I paint over it with an even lighter color—a mix of cadmium yellow light, cadmium orange, and white. I paint the remaining highlights in the life ring with a mix of cadmium yellow, cadmium red light. Then I mix flesh into this color to add a few accents in the ropes and shadows. I step back, look at the painting, and then make a few minor refinements to harmonize the color and details.

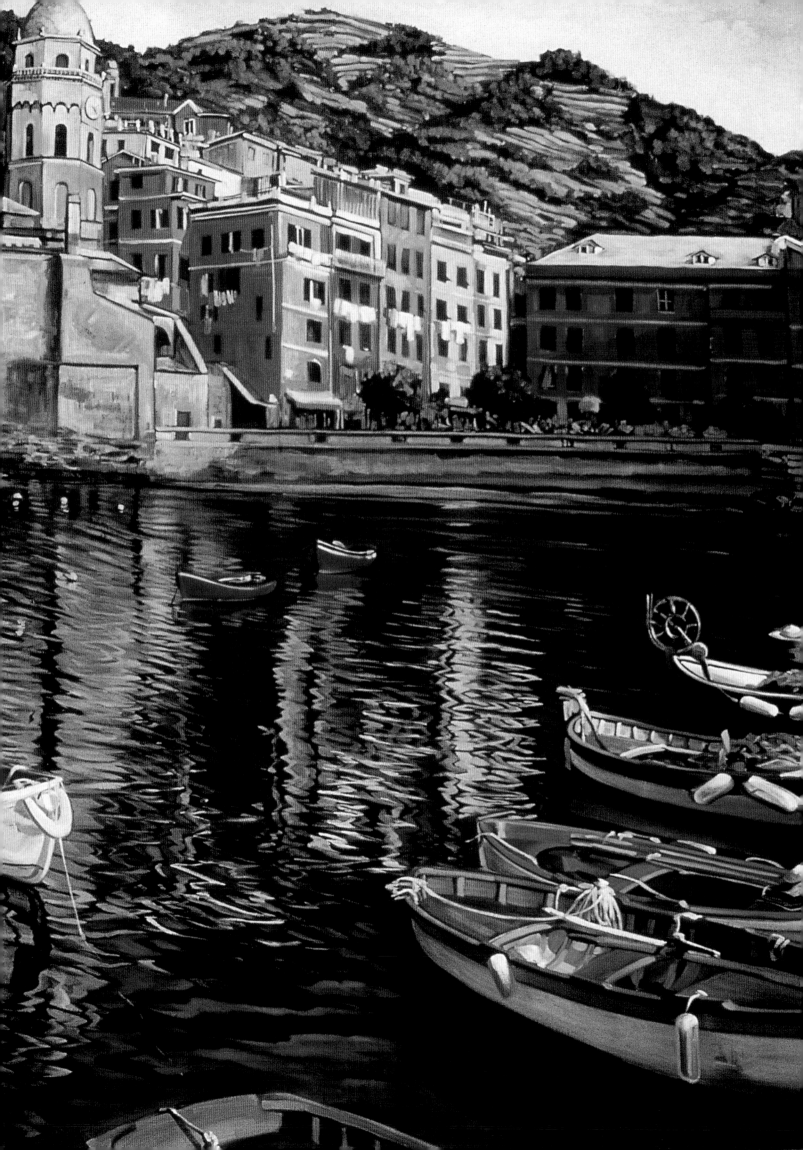

PAINTING WITH CAROLINE ZIMMERMANN

Caroline Zimmermann began painting in oils at age 6, earned her Bachelor of Fine Arts degree in Illustration from California State University at Fullerton in 1989, and obtained her Master of Fine Arts in Painting from the California College of the Arts and Crafts in Oakland in 1994. She currently resides in the artists' community of Laguna Beach, California, where she has lived, surfed, and painted for more than 18 years. Caroline travels extensively and enjoys painting abroad, most notably in Italy. She has also exhibited at the Laguna Beach Festival of the Arts for 15 years. Her work is featured in California galleries in Laguna Beach, as well as in Mono County in the Sierras, Sonoma, and Mammoth Lakes.

TROPICAL PALM

STEP ONE

To create a contrasting underpainting, I use a mix of alizarin crimson, dioxazine purple, Indian yellow, transparent orange, and magenta. I thin the mixture with turpentine and apply the wash with a medium brush. I will be dedicating the top 2/3 of the canvas to the sky, so I decide to add more orange in the sky area, as orange is the complement of blue. I do this with a mix of Indian yellow, transparent orange, and quinacridone pink. Then I let the paint dry before continuing to the next step.

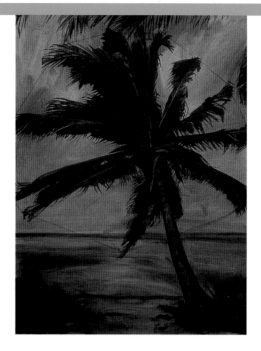

STEP TWO

First I mix alizarin crimson with a little dioxazine purple. Then I sketch the scene, establishing the horizon and the lines of the palm tree's trunk. I make dots where I will place the ends of the leaves and connect the dots to create the palm's shape.

I finish blocking in my basic shapes by adding more purple to the crimson mixture and placing the darker areas of the trunk, the leaves in the bushes, and the shadows below the tree. (To create the palm tree's leaves, see the detail on page 97.)

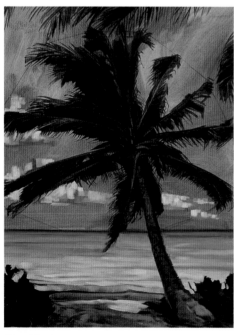

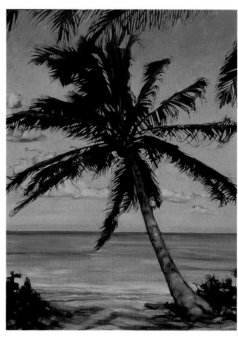

Foliage

Sap green and lemon yellow

Sap green and alizarin crimson

STEP THREE

The color of the water changes as the depth changes, becoming darker as the water gets deeper. I begin with the darkest areas of water at the horizon, using broad strokes of ultramarine blue with dabs of phthalo blue and phthalo green. I work toward the shore, mixing in tints of phthalo blue and green and gradually adding white as the water becomes more shallow. I keep lightening the mixture until there is very little green pigment left, and I add a touch of lemon yellow for the shallowest areas. I paint the sand and any bits of flotsam on the beach with white mixed with transparent orange, Indian yellow, and dioxazine purple. I add dark colors to the foliage of the shrubs with a mixture of ultramarine blue, dioxazine purple, and sap green. I block in the dark parts of the clouds with a mixture of dioxazine purple, ultramarine blue, and a little white, and then I outline the general cloud shapes. I don't emphasize them too much as they're merely the backdrop, and I don't want them to conflict with my main subject.

STEP FOUR

Now I block in the colors of the sky. I mix one part ultramarine blue to three parts white and just a dab of phthalo blue. When painting the sky, I "cut in" around the palm leaves, meaning that I create the shapes of the leaves by painting the sky around and between them. (This technique is called "negative painting," because you define an object by painting the negative space around it rather than painting the object itself.) Next I add more variation to the color of the water using light blue mixtures of phthalo green and phthalo blue. For the shallowest water, I use white mixed with a dab of dioxazine purple and Indian yellow. Then I add a bit more yellow and orange to the white and develop the highlights on the sand. I paint the dark areas of the palm leaves with sap green mixed with alizarin crimson and allow the painting to dry before I continue to the next stage.

PAINTING THE PALM LEAVES

Step One
While the paint is wet, I block in the palm leaves by removing paint instead of adding it. To do this, I clean my brush with solvent, blot it on a rag, and lift the color away to indicate where the highlights will be. This is a forgiving technique for indicating lighter areas without the mess of adding white paint.

Step Two
I create the shapes of the palm fronds by painting the sky and clouds in and around them, as described in step four on page 96. Then I use my small flat brush and short, deliberate strokes to create the tips of the leaves. I start at the center of the branch and stroke outward, lifting my brush at the end to create the sharp point.

Step Three
Now I indicate the undersides of the palm leaves (in shadow) using a dark mixture of sap green and alizarin crimson. (I render each individual leaf with this color.) Then I paint the top sides of the leaves, continually adding more sap green to the mix until there is very little red pigment left in the mixture.

Step Four
Next I add the highlights using sap green mixed with varying amounts of each yellow color in my palette, plus transparent orange and white. I alternate between dark and light to define the details of the branches. I bring the lightest whites of the clouds into the leaves with the same cutting technique I used before.

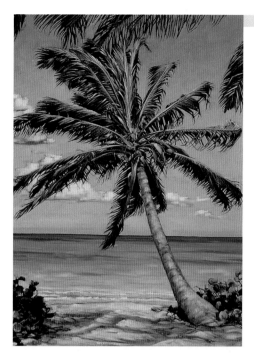

STEP FIVE
Now I focus on the palm tree. I concentrate on showing the motion the wind creates as it blows through the leaves. I follow the steps outlined below to develop the palm fronds and then paint the center of the tree, making my strokes follow the round shape of the trunk. I paint the coconuts and the texture of the trunk with mixtures of dioxazine purple, transparent orange, and some of the green mixtures of detail step four.

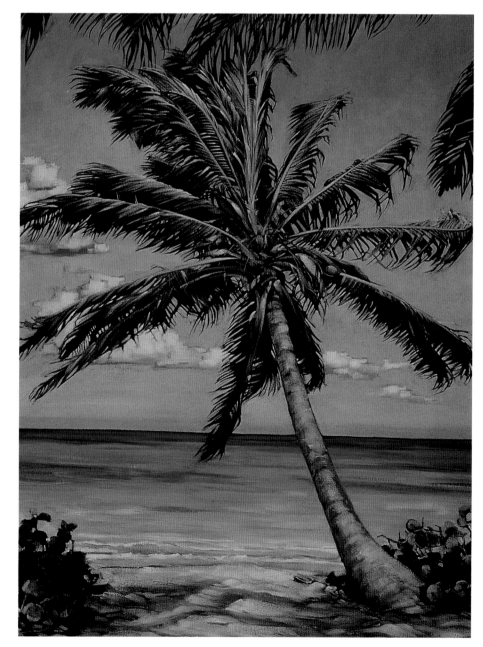

STEP SIX
I apply the brightest highlights of the leaves, trunk, sand, water, and clouds at the very end of the painting so that these elements seem to shimmer in the tropical sunlight. I finish the painting by applying a glaze over the entire surface to unify the painting and adjust some of the colors. My goals are to deepen the top of the blue sky, tone down the red of the upper branches, and deepen the foreground shadows. So I prepare a glaze with a hint of ultramarine blue added to alkyd resin medium (a medium that speeds up the drying time of oil paints) and apply it to the upper areas and the foreground with a small brush. Then I coat the entire painting with a clear glaze of medium, rubbing away the excess with a flannel rag.

ROOSTER

STEP ONE

To accent and create contrast with the greens and yellows of the rooster, I apply an underpainting using a mixture of alizarin crimson, dioxazine purple, Indian yellow, transparent orange, and magenta. I paint loosely and boldly with a large brush, eliminating the white of the canvas. I make the top portion of the canvas warmer and lighter and the lower half cooler and darker.

STEP TWO

I sketch my composition with a medium bright brush and a thin mix of alizarin crimson and dioxazine purple. I work loosely and start developing the rooster's feather patterns. I want him to be proud and upright, with a billowing tail. As I build the rooster from a series of oval shapes, I pay attention to the relationship between the head and the rest of his body and try to capture the feeling of motion in his legs. To simplify the background, I make the wall out of rocks, and loosely indicate cracks and lines.

STEP THREE

Next I develop the comb and the throat feathers with a medium flat brush, using a thin mixture of alizarin crimson, sap green, and magenta. Then, using a large flat brush, I work on the texture of the stucco wall, creating bits of stone and mortar and inventing patterns. I create my own brown mixtures using varied amounts of dioxazine purple, transparent orange, Indian yellow, and titanium white, scattering bits of rocks and sticks on the ground. I enjoy using my imagination, as it's a pleasant change from constantly referring religiously to a photograph. I let the paint dry long enough to "set," so that it's tacky (but not necessarily dry) and won't be easily smeared.

STEP FOUR

Using a large flat brush, I block in the darkest colors of the stones with a warm brown that I created from tints of purple and ultramarine blue mixed with transparent orange. I bring up the wall with white mixed with transparent orange, Indian yellow, cadmium yellow medium, and purple. I paint neck feathers (see color mixes on page 99) and block in the dark teal feathers with a mix of ultramarine blue and sap green. When I paint roosters or chickens, I use bold, wide brushstrokes and a lot of color to paint the feather.

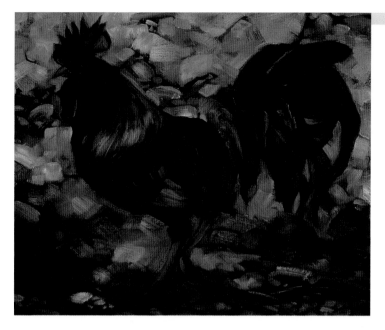

Step Five

Now I render the details, adding smaller stones near the base of his tail with lighter shades of purple. I apply highlights to the tail feathers and legs using various mixtures of phthalo green and white. I begin the eye with a dark mixture of alizarin crimson and transparent orange and paint the lighter area with a touch of cadmium yellow medium. I purposefully don't use "earth colors"—such as raw umber, burnt sienna, or ochres—because I like to create these tones by combining complementary colors with more vibrant pigments. For example, I use the complements of purples and blues—variations of yellow and orange—tinted with white to make vivid browns.

Neck Feathers

Transparent orange and cad. yellow medium

Transparent orange and dioxazine purple

Tail Feathers

Phthalo green and ultra. blue

Phthalo green, lemon yellow, and white

Comb

Cad. red medium and white

Cad. red medium and alizarin crimson

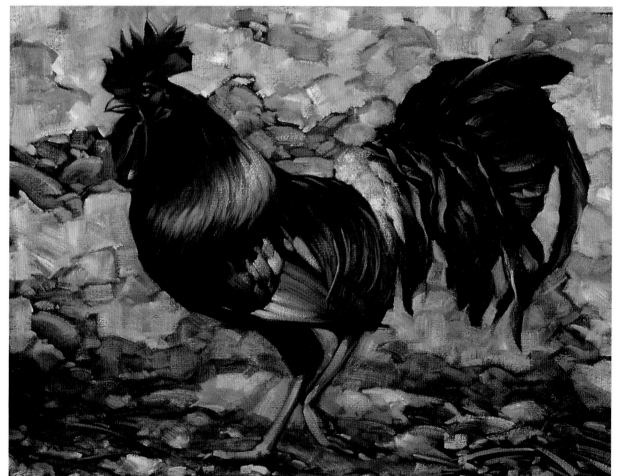

Step Six

I place a tiny speck of white on the upper part of the pupil. This simple touch makes the eye come to life. I add a tint of cadmium red medium to the rooster's comb and use cadmium yellow light mixed with Indian yellow to accent the golden neck feathers and the tips of the back feathers. I mix phthalo green with lemon yellow tinted with white for the feet. To accentuate the rooster's rich colors, I make the background recede with a transparent glaze of alkyd resin, ultramarine blue, a touch of dioxazine purple, and sap green. I use a soft flannel rag to wipe away areas that are too dark. Then I apply a light coating of alkyd resin medium tinted with transparent orange. When the glaze dries, I bring out the highlights again and continue this process of adding layers of highlights until I'm satisfied. For the finishing touches, I tint the feathers with light brushstrokes of white. I use a smaller brush for the delicate, small feathers and the pieces of hay under his feet. With a medium flat brush, I create the farmyard dirt and stones with varied mixes of sap green, dioxazine purple, ultramarine blue, and a small amount of white, leaving the area under his feet dark to indicate shadows. Using vertical strokes to create texture, I go over the background again with a mixture of white and yellow.

Rustic Still Life

Step One

For most underpaintings, I instinctively use the complementary colors of the subject to create the most visual intensity—for example, red for a green plant or orange for a blue sky. However, in this sunflower painting, I am using the reds of the underpainting not only to contrast, but also to create depth in the darks of the background surrounding the flowers. I covered the white of the canvas with a mixture of alizarin crimson, dioxazine purple, Indian yellow, transparent orange, and magenta, thinning each pigment with a few drops of solvent to create a fluid, transparent mixture.

Step Two

I sketch the basic shapes with a combination of alizarin crimson and dioxazine purple mixed with solvent to create a fluid mix that lends itself to drawing with a brush. I create the general composition by drawing basic geometric shapes, keeping the definition to a minimum. Then I start blocking in the darkest areas, as shown.

Step Three

Once I am satisfied with the general harmony of my composition, I draw the objects in greater detail. Using thinned alizarin crimson, I plot out the textures and patterns of the various elements. The better the drawing, the easier and more fun the later stages become as I apply the opaque paint. I compare this stage to the creation of a cake: I've measured my ingredients, mixed them, and now I am preparing to bake. The success of my creation begins here, and taking shortcuts can lead to messy and time-consuming mistakes.

PAINTING THE SUNFLOWERS

Step One

In many paintings of sunflowers, the flowers are placed in a bright, sunlit setting. But I want to tone them down in my painting to enhance the mood, so I begin with a very dark mixture of cadmium yellow medium, transparent orange, and dioxazine purple.

Step Two

For the dark centers, I use a mixture of ultramarine blue, dioxazine purple, sap green, and alizarin crimson. I begin gradually lightening the petals with a mix of cadmium yellow light and transparent orange. This creates a rich, yet slightly lighter hue.

Step Three

Now I've laid in my darkest values and I'm ready to build up the lighter colors of the petals. I touch each petal with a mixture of lemon yellow and Indian yellow, stroking in the direction of the growth—from the center outward to the distinct points of the petals.

Step Four

Although I want my overall painting to be dark and moody, I still like the contrast of vivid highlights on the petals. This heightens the dramatic feeling of the painting. I add the final light touches to the petals with a slightly lighter version of the mix used in detail step three.

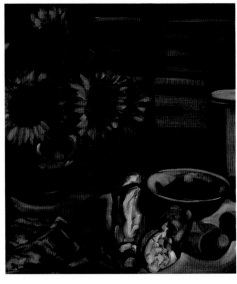

Step Four

I combine cadmium yellow medium with transparent orange and a dash of dioxazine purple to begin the sunflower petals, working from dark to light. I define my underpainting with opaque pigments, blocking in the colors with bold strokes and a large flat brush. For the greens of the leaves, I mix various values of sap green and lemon yellow. I create the fabric of the towel with a combination of ultramarine blue, phthalo blue, and white, applying the darkest values first. I paint the darkest shadowed areas with variations of ultramarine blue, dioxazine purple, sap green, and alizarin crimson. I also use various mixes of this "black" for the centers of the flowers, the candelabra, and the background shadows. I let the painting dry completely before applying glazes.

Step Five

In this painting, the glazes play a major part in developing details and creating mood. I think of glazing as pushing and pulling the subjects of my painting in and out of the picture plane. For example, I think the yellows of the sunflowers are too bright and need to recede into the background, so I push them back with a glaze of alkyd resin, ultramarine blue, sap green, and a touch of dioxazine purple. I use a soft flannel rag to wipe out areas I want to pull forward, leaving other areas dark, such as the bowl, the shadows, and the wooden drawers in the background. When the glaze dries, I bring out my highlights again and continue glazing and highlighting, creating more luminous depth with each layer.

Eggs and Bread Dark Values

Transparent orange and dioxazine purple

Transparent orange and cadmium yellow medium

Eggs and Bread Light Values

Transparent orange and lemon yellow

Transparent orange and white

Step Six

This is the step that I consider the most fun. I apply the brightest whites to the bowl, the platter, and the white crusts of bread. I add a subtle dab of white on each egg, the towel, and the canister to make the painting sparkle and give optimal depth. I add some final touches, applying a few more highlights to sharpen the foliage and flower petals.

Martini Still Life

Step One

I begin with transparent washes of Indian yellow, transparent orange, and magenta. Once the painting is completely dry, I loosely sketch in the composition, using a medium flat brush and a mix of alizarin crimson and dioxazine purple. I block in the basic shapes, sketching the martini glass and the shaker inside two cylinders to help define their forms.

Step Two

Once I am satisfied with the general harmony of the composition, I begin to draw the objects in more detail. I use alizarin crimson mixed with solvent and a medium flat brush to begin plotting out the forms of the glass and the reflective patterns on the silver shaker. It's important to establish the correct perspective of the glass and the shaker at this point; as always, the better the drawing, the easier and more fun the later stages become!

Step Three

The best way to convey a reflective metal surface (such as the shaker) is to juxtapose light and dark shapes. I use a small flat brush and a mix of alizarin crimson, sap green, and magenta to add more detail. While the paint is still wet, I also paint in a "reductive" manner; I clean my brush with solvent, blot it on a rag, and lift away paint where the highlights will be. With this technique, I utilize the white of the canvas to indicate the highlights rather than relying on messy white paint.

Step Four

Now I layer from dark to light to build a rich reflective surface. First I create foliage behind the shaker with mixtures of sap green and alizarin crimson. Then I add small amounts of cadmium yellow medium to combinations of alizarin crimson, sap green, and ultramarine blue to create the wood surfaces, adding a little more cadmium yellow medium for the panel in the background. For the dark areas of the silver and the glass, I use mixes of sap green, ultramarine blue, and alizarin crimson. I also block in the olives (see detail at right).

Step Five

When painting glass and metal, keep in mind that you're actually painting reflections of light. There are many variations in the grays of this scene; I use mixtures of complementary colors that are already on my palette, always adding a touch of white to create a muted tone. I mix the warm grays with lemon yellow and dioxazine purple and use a mix of ultramarine blue and transparent orange for the cool grays. I also use touches of cadmium yellow medium and white to form highlights, build up middle tones in the olives, and paint reflections in the glass.

Painting the Olives

Step One
I loosely sketch the shape of the fork and the olive with alizarin crimson mixed with solvent.

Step Two
Next I block in the darks of the olives using a dark green, which is a combination of sap green and transparent orange.

Step Three
Then I apply mixes of sap green and cadmium yellow medium to the light areas of the olives, using cadmium red medium and alizarin crimson for the pimentos.

Step Four
I use a mix of sap green and lemon yellow for the highlights, and then I add a final touch of white. Next I add the pimento highlights with a mix of cadmium red medium and cadmium yellow medium.

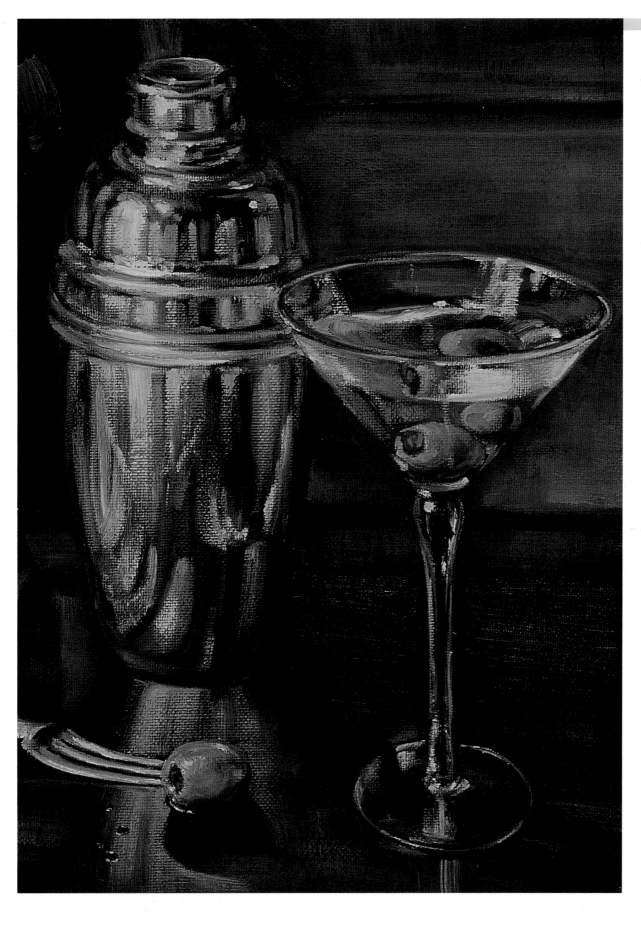

STEP SIX

Now I put some sparkle on the reflective surfaces and bring out the highlights. But to maintain the optical illusion of depth and reflection, I pay close attention to the darkest shapes. I apply the lightest values (white mixed with touches of the gray tones from step five) to the reflections on the shaker, the fork, and the liquid in the glass. Then, to create the thin white highlights, I drag the edge of a medium flat brush perpendicularly across the painting surface. Finally I add the final highlights to the olives and the painting is complete— cheers!

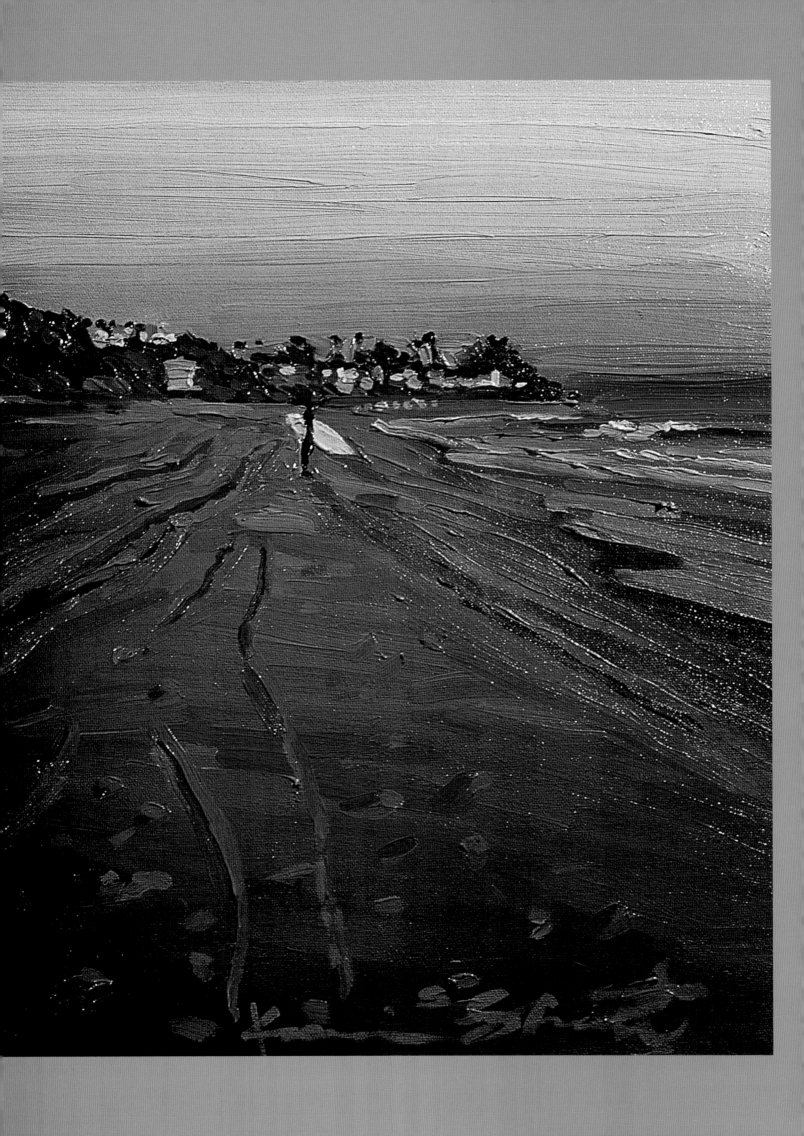

PAINTING WITH KEVIN SHORT

Kevin Short's art training started as a child with watercolors and crayons on the kitchen floor. Years later, he studied painting at the University of New Mexico and Pepperdine University at Malibu, California, and he graduated with honors from Art Center College of Design in Pasadena, California. Kevin now dedicates much of his art to depicting the disappearing vistas of California. Between exhibitions of his work, he teaches workshops and gives demonstrations to beginning and experienced artists alike. Kevin is a member of the American Society of Marine Artists, the California Art Club, the Laguna Plein Air Painters, and Oil Painters of America, and he is also the president of the Capistrano Plein Air Painters' Association. An international award-winning artist, his artwork is featured in private collections around the world.

SUNSET BEACH

STEP ONE

Using a large filbert brush, I start with a thin mix of the darkest shadow color (Carbazole violet mixed with quinacridone violet, medium blue, and white) and draw over my pencil sketch. I paint the darkest sections first: the shadows of the tracks, the edge of the bluffs, and the surfer (see color sample at right). Then I use pure cadmium red light, quinacridone red, and cadmium orange to block in the sand and sky and medium blue for the ocean. Because this is a sunset scene, the overall tone of the painting is warm, so even the "cool" shadow colors will seem warm next to the warm tones.

Track Shadows

Medium blue, carbazole violet, quinacridone violet, and white

Sketching the Visual Path
I begin by sketching out some small layout ideas to help me figure out the "flow" of the design. In this case I'm using the perspective, the surfer's gaze, and the surfboard as strong directional elements. The arrows on the thumbnail sketches show how the viewer's eye will be led first to the surfer and then out to the rest of the painting.

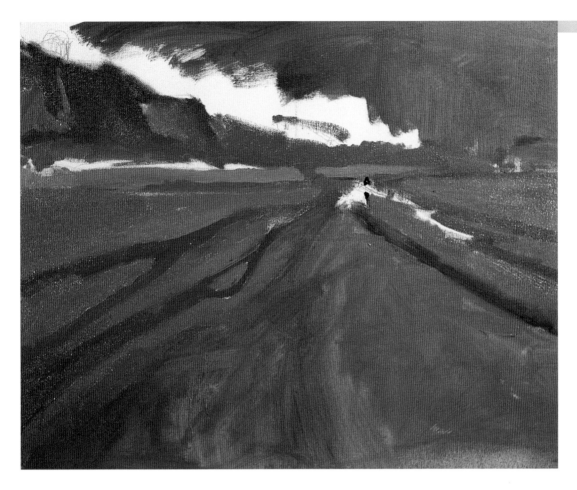

STEP TWO

My goal at this point is to get rid of the white of the canvas by blocking in all the major areas of color. With a medium bristle brush, I scrub in cadmium red light, quinacridone red, and cadmium orange for the sand near the shoreline. I blend in some more cadmium red light and cadmium orange as I paint toward the tire tracks, and I add Carbazole violet to this same mixture to block in the rocky bluffs. Then I mix the sand color with medium blue, phthalo green, and white for the water.

Ocean

Carbazole violet,
medium blue, and white

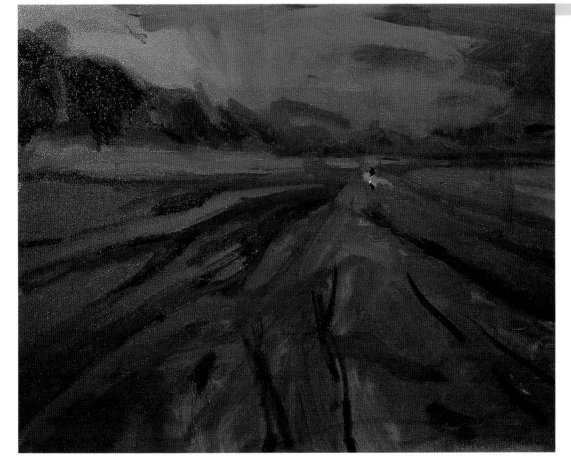

STEP THREE

With a medium round brush, I block in the rest of the sky, blending from top to bottom as I work. I use pure colors here—I can always correct them later if they look too bright. Next I apply cadmium yellow medium with a touch of phthalo green at the top. (This is also the same color I use for the surfboard.) Then I use cadmium orange in the lower half of the sky, and I add a little quinacridone red at the horizon line. The distant ocean is a lavender mix (see color sample above) that I blend up into the sky, adding a little quinacridone red to make it hazy and help create the illusion of depth. The foam on the waves isn't actually white; the dark part is a greenish blue (phthalo green mixed with white, cadmium yellow medium, and medium blue), and the highlights are pink (quinacridone red mixed with white, and a little cadmium yellow medium). I place all these colors with a small round brush.

SUNSET BEACH (CONTINUED)

STEP FOUR

Next I start working on the distant bluffs. With a small filbert and a combination of phthalo green, cadmium yellow medium, and some of the orange sky mixture from step one, I paint the sides of the middle bluffs. As the bluffs recede into the distance, I add a little more sky color to the blend. For the closest part of the bluffs, I use a rich mixture of cadmium orange, quinacridone red, cadmium yellow medium, and a little white and lay it on thickly with a small filbert. I also mix the sand shadow color into the bluff shadow color to create a third value that I use to further develop the forms of the bluffs.

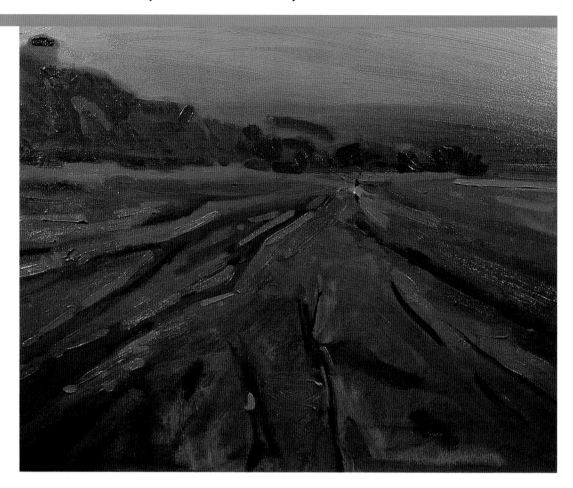

STEP FIVE

I add the lifeguard tower and distant houses with a mix of cadmium orange, cadmium yellow medium, phthalo green, and a little white. The houses farthest away are a cool, rosy purple (a mix of Carbazole violet and white with a little of the orange sand color). I use a lighter warm orange mix (cadmium orange, cadmium red light, and cadmium yellow medium with white) for the highlights. Using a small filbert and a bright yellow mix of cadmium yellow medium, a touch of phthalo green, and white, I create green highlights on the surfboard to draw the eye directly to the surfer. This complementary highlight will capture the viewer's eye, much the same way the only two red umbrellas amid hundreds of black umbrellas attract attention. I refine the surfer with a small round brush and a very dark mix of Carbazole violet and phthalo green.

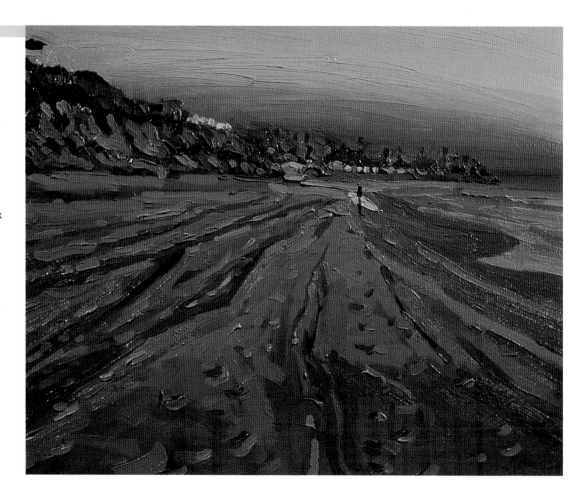

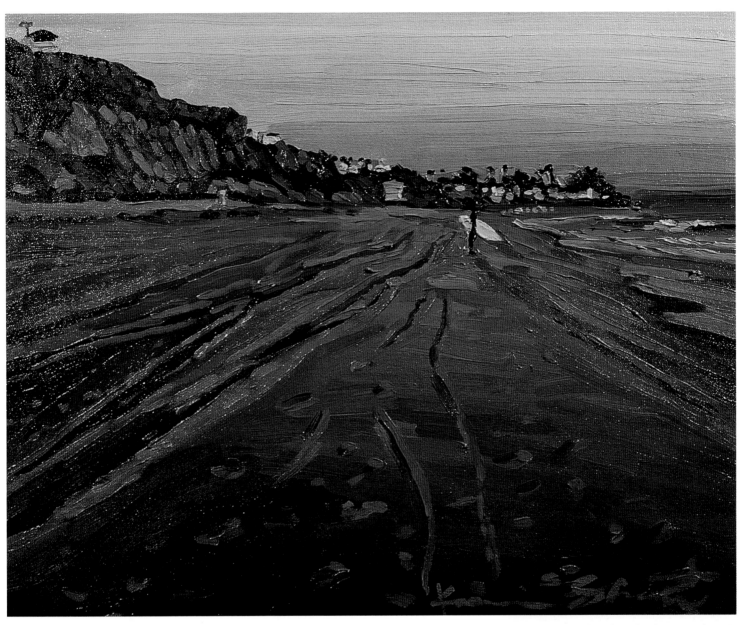

Step Six

After standing back and assessing my work, I decide to make some slight alterations. I lighten up the sky by mixing a light creamy color (white, cadmium orange, cadmium yellow medium, and quinacridone violet) directly into the wet sky color and blending it in evenly with a medium round brush. I think the sand needs to be cooler, so I work some blue into the wet paint with a small filbert. The tire tracks need a slightly darker shadow—I mix a dark purple and dab it on top of the tracks, leaving some of the original color showing through. I also change the shape of the tracks slightly, straightening out a few bumps. Since the foreground highlights in this painting are the center of interest, I've created them with careful and deliberate strokes and left the other elements in the painting loose and less detailed.

Highlighting

For the highlights on the tire tracks, I use a mix of cadmium red light, Carbazole violet, and cadmium yellow medium. I heavily load a round brush and paint short, simple strokes along both sides of the tracks.

Painting Figures

I use just a few simple strokes to create the figure. Notice that even with absolutely no rendered detail, your eye fills in what the brushstrokes only suggest: a surfer walking with a surfboard. Scale is important, so pay attention to the size of the figure in relation to its surroundings.

California Coast

Step One

With a pencil, I draw the horizon line, then the tracks and bushes and the other basic elements, taking care to get the perspective correct. I paint the shadows of the trestle with a mix of Carbazole violet, ultramarine blue, and quinacridone red. As I paint toward the distant part of the trestle, I blend in a mixture of Carbazole violet, ultramarine blue, and white. With a small round brush, I block in the bushes with thick strokes that mimic their growth. As the foliage recedes into the distance, I use less and less blue until I am using a mix of only phthalo green, cadmium yellow medium, Carbazole violet, and white. This color change creates a color pathway that leads the viewer's eye through the painting, creating extra movement and interest.

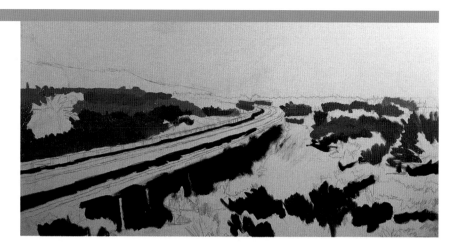

Step Two

I add a little of the trestle shadow color to the darker mix I used for the bushes and place a few strong shadows in the foreground and near the trestle. I paint in the ocean on the right with a small flat brush and a mixture of ultramarine blue, phthalo green, and white. It looks bright now, but later I'll add some sky color to tone it down. I stroke in a mix of ultramarine blue, Carbazole violet, quinacridone red, and white onto the track with the same small flat brush. I also add more white and ultramarine blue to cool the mixture as the tracks disappear into the distance. Sometimes I mix colors together directly on my canvas; I find that the new colors that often appear in the blend help the overall color harmony of the painting.

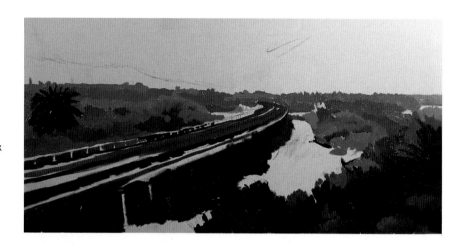

Step Three

I block in the mountain and then create a pale yellow mixture for the sky with white, cadmium yellow medium, and ultramarine blue. I mix a lot of this sky color; I'll save some to blend it into the other color elements later to give the illusion of a very hazy atmosphere. And if an element of the painting "pops" forward too much, I simply add a little sky color to it. I start by first painting the mountain in the distance and then thickly laying on the sky colors with a medium round brush.

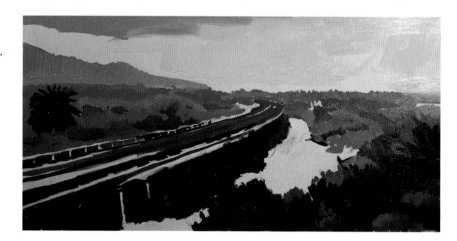

Step Four

I blend some of the sky color into the mountain until it starts to disappear, alternating between the two colors. Then I scrub in the sand and add yellow to the edges of the path for variation. I add thick highlights to the bushes with various mixtures of ultramarine blue, cadmium yellow medium, white, and phthalo green. I save the brightest highlights for the foreground; I dab in flowers and highlights with a mix of cadmium yellow medium and a little cadmium orange, white, and phthalo green.

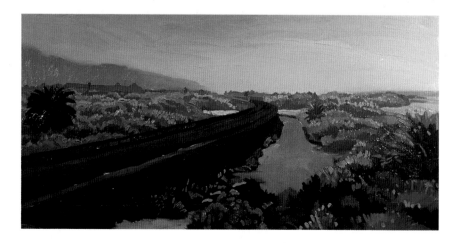

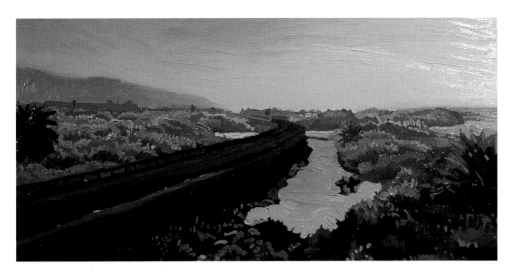

STEP FIVE

Next I add the final sand color. Then I darken the palm tree on the left to bring it forward with a mix of Carbazole violet, ultramarine blue, and phthalo green. I place the two figures with a small round brush and a dark mix of Carbazole violet, quinacridone red, and ultramarine blue. Where the sandy path recedes, I add some sky color to my sand mix near the horizon.

STEP SIX

I add some bright red flowers to the bushes in the foreground with a mix of quinacridone red and white. I also paint in the structure on the right with a few quick strokes. Then I refine the figures by painting their clothes and surfboards and decide I'd like to add one more directional element. I quickly add a surfer going the other direction, and that does the trick.

Sand

Carbazole violet, quinacridone red, cadmium orange, cadmium yellow medium, and white

Sand Shadows

Carbazole violet, ultramarine blue, quinacridone red, cadmium orange, cadmium yellow medium, and white

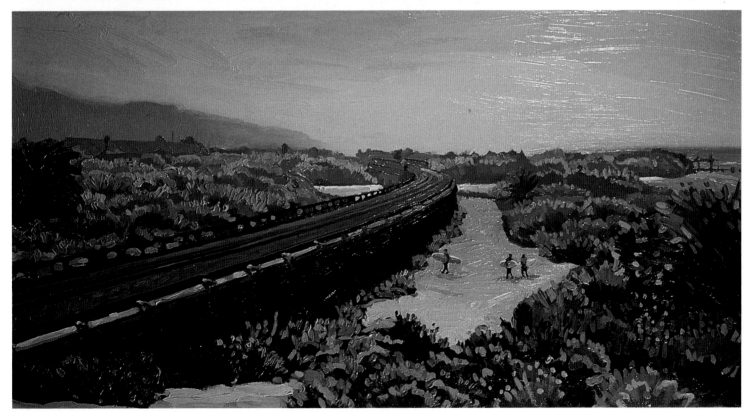

STEP SEVEN

I finalize the tracks by painting highlights on the gravel. Starting with the track colors I used in step five, I add more quinacridone red and white. I highlight the tracks with more ultramarine blue and white and add a few last bright highlights to the foreground bushes.

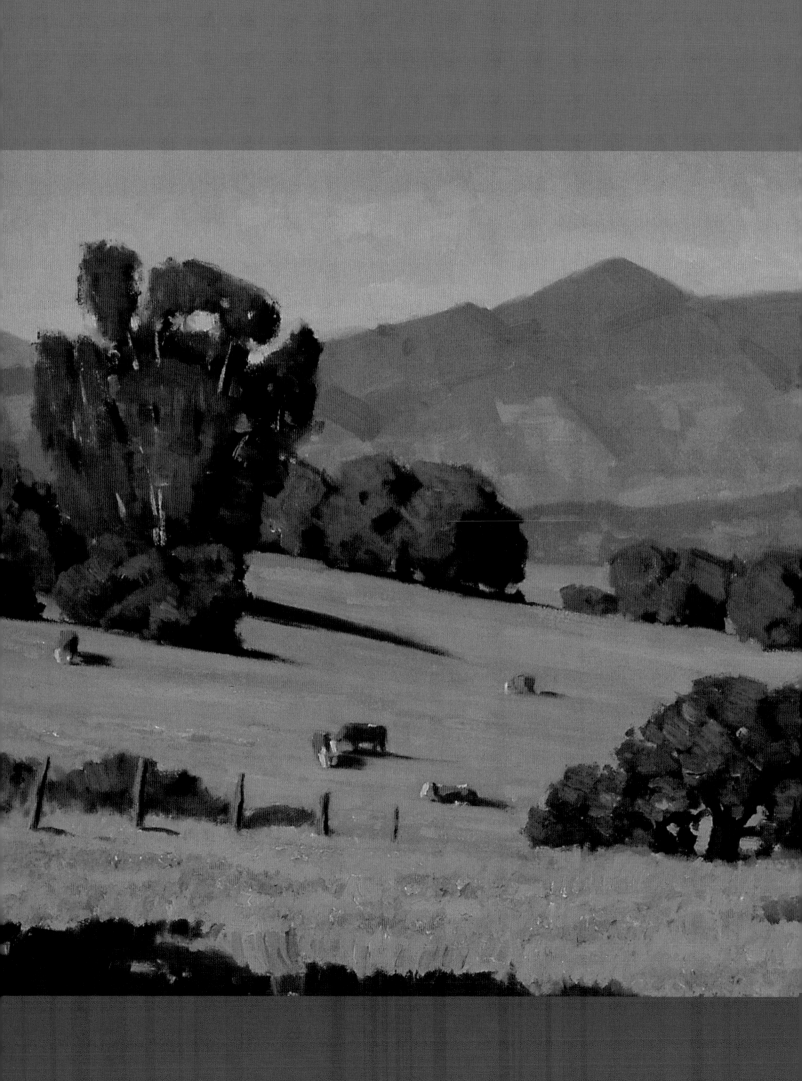

PLEIN AIR PAINTING WITH FRANK SERRANO

A California native, Frank Serrano was a successful commercial artist before deciding to pursue his passion for fine art painting in the early 1990s. Since then, he has participated in numerous exhibitions, including the California Art Club Gold Medal Exhibit. He also conducts workshops on location and in his studio. Frank travels throughout the western states, painting scenes that range from the desert southwest to the beautiful high country vistas of the Sierras. Although the majority of Frank's work is done on location, he also paints in his studio, creating larger pieces from his finished on-site sketches. Frank is a member of the California Art Club and currently resides in southern California.

WHAT IS PLEIN AIR PAINTING?

The plein air (French for "open air") painting style evolved in the late 19th century on the heels of the Realist and Impressionist movements. Tired of rendering nature from indoors, artists from the Barbizon school in France started bringing their easels outdoors in the hopes of finding the "truth" of a landscape. Around the same time, the plein air style received a further boost when collapsible tin paint tubes and portable easels were invented. Although these new plein air artists were criticized at first for their loose, "unfinished" style, painting outdoors soon became a well-respected venture. Today plein air painting is still highly regarded; many believe it allows the artist to experience a natural landscape and translate it directly to the canvas. There's an almost contagious excitement in capturing a moment on canvas that continues to intrigue landscape artists and art lovers alike. Most plein air artists' intent is not to re-create nature exactly but to truthfully express their impression of it. As you learn the art of painting "en plein air," you'll find that content becomes more important than technique. You'll learn to restrict your paintings to only those elements that help you tell a story or convey a mood. Generally, your style will become looser as you're forced to work quickly to capture the constantly changing light and weather conditions. The amount of subject matter outdoors is endless! You may find a fantastic subject at an exotic location, at a favorite nature spot, or even in your own backyard. The key is to stay flexible and have fun—then painting outdoors can be a truly enlightening experience!

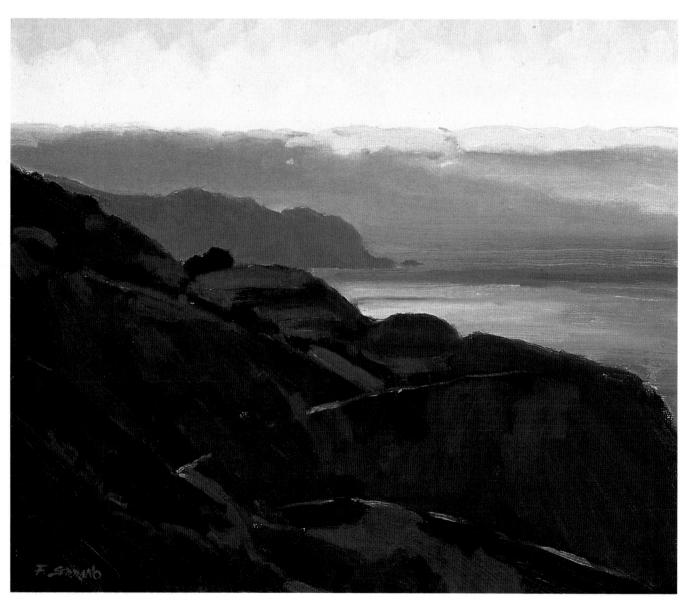

PLEIN AIR SUPPLIES

ADDITIVES

When painting outdoors, I take mineral spirits to clean my brushes. I also bring linseed oil to thin the consistency of my paints, making them easier to apply and blend. I use a commercially made metal container for my thinner. It has a leak-proof, rubber-sealed lid that locks shut so the mineral spirits won't spill.

PALETTES

My palette is wooden and it is built right into my pochade. After painting for a couple of hours, my palette gets crowded with mixed colors; I scrape it off once in a while with my palette knife. You may want to cover your palette with plastic wrap before you start mixing, for easy disposal when you're ready to pack up and go home.

EASELS

Most plein air artists use a wooden easel called a "pochade" (French for "quick sketch"). A pochade is a combination portable easel and paint box that sits on top of a tripod. These easels come in different sizes and configurations, with various compartments. The best ones are made of hardwood and are well-crafted, so they should last a lifetime. They are available in art supply stores or through art supply catalogs. Choose one that is compact and light enough to carry but has enough room for you to set up all your supplies.

WORK SPACE

The way in which you set up your supplies will depend on whether you are right- or left-handed and what feels most comfortable for you. I usually place my easel in the shade, facing away from the sun. You can also attach an umbrella to your easel for shade—but stay away from brightly colored or white umbrellas; they can reflect their own color or allow too much light onto your painting. It's also smart to wear darker clothing that won't reflect light onto your canvas. Finally tie a plastic bag to your easel for easy disposal of trash and used rags—and you might want to spray some bug repellent around your work area.

OTHER NECESSITIES

Although you should keep your supplies light and portable, there are a few other items you might need. Don't hike out too far without enough food and water to sustain you for the day. A hat and sunscreen are essential, even on cloudy days. A small, plastic poncho is inexpensive and invaluable on rainy days, and don't forget a jacket, hand warmers, and a thermos of your favorite warm beverage on cold days. You may also want a flashlight, masking tape, and cord or twine to secure your setup in case it's windy.

Brushes and Knives
I use only three brushes when painting outdoors: flat bristles in sizes 6, 4, and 2 (I paint on small canvases). I also have a long, flat, rectangular knife for mixing colors and a small triangular-shaped painting knife.

Canvas Boards
For plein air painting, I recommend using commercially prepared canvas boards in small standard sizes, such as 8" x 10", 9" x 12", and 11" x 14". These ready-to-use, lightweight panels have pre-rimed canvas glued onto cardboard.

Sketchpad
A sketchpad comes in handy for working out a composition before beginning a painting. I sometimes use a marker to draw because it forces me to simplify my drawing.

Canvas Carriers
Some art stores sell wooden cases with built-in dividers for transporting your paintings. They come in various sizes, and some are even adjustable. Carriers are great because they keep wet paintings separated so the color doesn't smear.

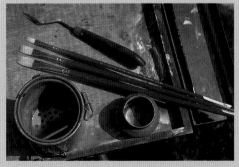

Setting up My Tools
Before I begin to paint, I always arrange my tools in the same place on my easel. I also place the colors on my palette in the same place every time. This way, I can paint quickly, without having to think about where everything is.

Preparing to Go
I use a small backpack to transport anything that doesn't fit in my pochade. I suggest that you pack up your supplies ahead of time and keep them separate from your studio supplies. That way you'll always be ready to go!

Cloudy Skies

Step One

For this bright sky, I use a small brush and sketch in the general shape of the cumulus clouds. Next, using my large brush, I paint the sky around the clouds with a generous mixture of titanium white, ultramarine blue, and a dab of phthalo green.

Step Two

Here, using a thin lavender mixture of ultramarine blue, alizarin crimson, and titanium white, I paint in the shadows beneath the clouds with quick, horizontal brushstrokes. As with any other object, where the clouds recede, their color is less intense.

Step Three

For the final step, I paint in the remaining cloud color using a thick mixture of titanium white and dabs of cadmium yellow pale and alizarin crimson. Then I soften some edges using my finger and a paper towel.

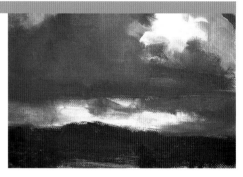

Step One

To create the ominous mood of a dark, stormy sky, I first scrub in a dark bluish base color of ultramarine blue, alizarin crimson, and a touch of burnt sienna, avoiding the area where I want to suggest lighter clouds. Then I go back in with a paper towel to rub out areas of paint here and there, creating varying values of the base color. These contrasts in value create a bit of depth in the storm clouds.

Step Two

Next, using the same base color, I add some patches of sky breaking through the clouds in the distance (closest to the horizon line). Then I start shaping some of the sunlit patches above and below the main storm cloud, using titanium white mixed with a dab of cadmium yellow pale. Next I darken up the base color with a little burnt sienna and apply a suggestion of land at the bottom of the scene. The land mass creates a reference point for the dramatic sky.

Step Three

In this final step, I continue to create depth in the sky by further darkening the underside of the storm cloud and bringing out some highlights in the sunlit areas with thicker paint. The dark, ominous shadows create a nice contrast to the few wisps of puffy white clouds.

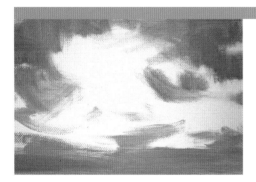

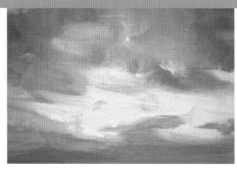

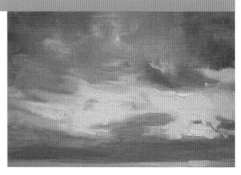

Step One

I rendered this sky just after the sun disappeared behind the horizon. When I re-create such specific times of day (when the light changes swiftly), I work very quickly with a large brush on a small canvas. First I lay in the dark areas of the sky with a thin lavender mixture of titanium white, ultramarine blue, and alizarin crimson. I work around the cloud areas, making bold strokes in different directions to suggest the wispy, irregular shapes of the clouds.

Step Two

Using a combination of vertical and horizontal brushstrokes, I carefully paint into the lavender with a light orange mix of cadmium yellow pale and alizarin crimson. (I don't use cadmium orange yet because it's a little too intense for this stage.) Next I work in the bright clouds, using a mixture of titanium white with a dab of cadmium yellow pale. I add a little more yellow to the mix as I work closer to the horizon (where the sun was).

Step Three

Finally I paint in the horizon using horizontal brushstrokes and a mix of cadmium orange, cadmium yellow pale, and a little titanium white. I use more brilliant hues as I get closer to the horizon because that is what I see.

TREES

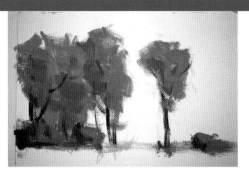

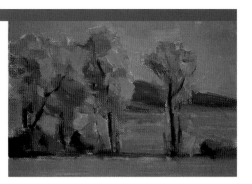

STEP ONE

The canopies of cottonwood trees are large, oval-shaped masses, and their trunks are tall and thin with just a few narrow branches growing upward. After sketching in the basic shapes, I lay in the shadow areas with broad strokes of yellow ochre mixed with a little ultramarine blue and titanium white. Then I rub out a few spots with my finger to create some warmer shadows.

STEP TWO

Next I use a warm golden yellow mix (I add more white to the shadow color) and my largest brush to fill in the foliage. Again I don't try to paint each leaf; instead I vary the angle of my strokes and work around and over the shadow colors. I add the tree trunks and a few branches using a corner of the same brush and a mixture of burnt sienna and a little ultramarine blue.

STEP THREE

I continue to build up depth in the trees with different values of my golden mixture. I carefully dab on the very lightest highlights last. Notice that the variety of lights and darks makes the foliage appear thicker and more lifelike and that the short, angled brushstrokes create the illusion of leaves.

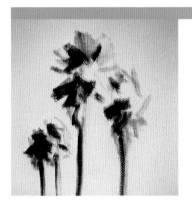

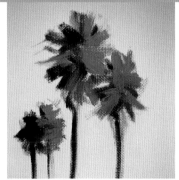

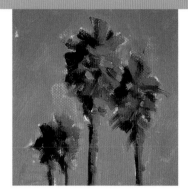

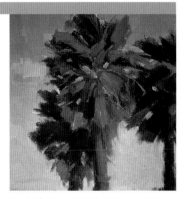

STEP ONE

For palms, I start with the shadowed fronds, using a mix of ultramarine blue, cad. yellow pale, and alizarin crimson. For the trunks, I mix ultramarine blue and burnt sienna and make one vertical swipe with the side of my brush.

STEP TWO

I block in the rest with a mix of cad. yellow pale, ultramarine blue, and titanium white. I make sure my brushstrokes follow the direction in which the palm fronds grow—starting at the center and brushing out.

STEP THREE

I use some bright greens to add depth and then highlight the trunks with a thick mix of titanium white, burnt sienna, and cad. yellow pale. I soften the edges and add patches of sky color among the fronds.

VARIATION

In a large studio painting like this one, greater detail is necessary to add a sense of realism. Here I added tiny flecks of bright color to the trunks and built up the fronds with thicker strokes of paint to add depth.

STEP ONE

To paint a stand of pine trees, I sketch in the shapes, varying the heights. Then I apply the shadows with a dark green mix of ultramarine blue, cadmium yellow pale, and alizarin crimson.

STEP TWO

I block in the rest with a lighter mixture of ultramarine blue, cad. yellow pale, and a little alizarin crimson. In the distance, I add a little more white and ultramarine blue to the green to push them back.

STEP THREE

Now I add a thick mixture of warmer green (yellow ochre mixed with ultramarine blue) to the tree in the foreground.

WATER AND ROCKS

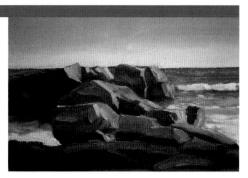

THE OCEAN

As the water approaches the shore, it becomes brighter in color and lighter in value. In this painting, the water is in the distance, so there's less emphasis on the motion of the waves. Instead the movement is just suggested with a few sweeping strokes of thick white paint.

A RIVER

When the water is in the immediate foreground, as in this example, the action of the current is important to emphasize. Short, choppy strokes of white help convey a sense of the speed of the water rushing over the granite rocks.

A ROCKY SHORELINE

In this painting, I wanted to capture the dramatic light created by the setting sun so I painted the highlights on the rocks with sharp edges. Notice that there are more shadowed areas than highlights—this shows the various planes of these craggy rocks and creates a more dramatic impact.

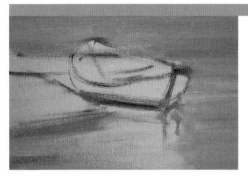

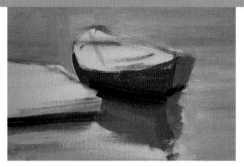

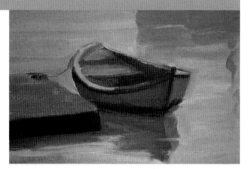

STEP ONE

Water reflects anything above its surface—including the clouds and the sky. After sketching the outlines of the boat and dock, I use light, horizontal strokes to block in the water with a thin mix of ultramarine blue, cad. yellow pale, and alizarin crimson.

STEP TWO

Next I paint the boat and its reflection in the water with a green mixture of ultramarine blue, alizarin crimson, cadmium yellow pale, and titanium white.

STEP THREE

In this final step, I show the very slight movement in the water by dragging my brush across the water and into the reflection. Then I also pull some of the reflection color back into the water.

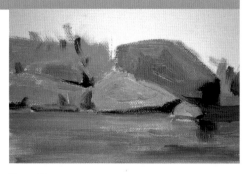

STEP ONE

The large rocks in this example are fairly smooth, with rounded planes. I begin by using thinned burnt sienna and a medium-sized brush to sketch in the general masses of the rocks. Then I establish the darkest shadows, using a thin mix of ultramarine blue, burnt sienna, and a touch of alizarin crimson. I use this color as a reference, so I don't make the overall value of the rocks too dark; in other words, all other values will be lighter than the shadows.

STEP TWO

Next I mix titanium white, burnt sienna, alizarin crimson, and ultramarine blue for the sunlit patches of the rocks. (Rocks are never just one solid color.) Then I add a little more white to the mixture and repaint parts of the rocks with thick, horizontal strokes to give a sense of texture and variation of color.

STEP THREE

Now I apply varying values of the previous mix, making sure that my strokes follow the different planes of the rocks. Notice that the different planes reflect whatever objects are around them—even the sky. So in this last step, I also apply a bit of the sky mixture (ultramarine blue mixed with white) on the top surfaces of the rocks to indicate the sky's reflection.

FIGURES

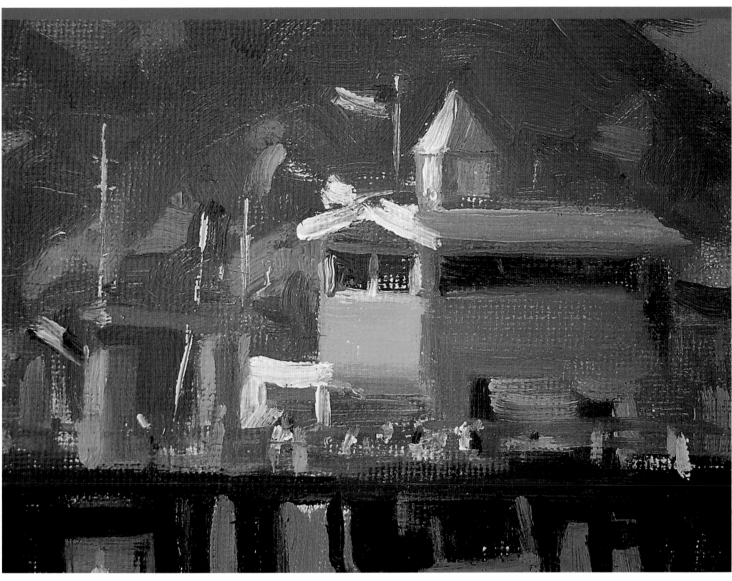

AVALON PIER

This is a 6" x 8" study I painted while on a trip to Catalina Island off the coast of southern California. I was particularly drawn to the scene because of the strong contrast between the bright green hue of the pier and the shadowed hillside. The loose impression of the crowd of tourists and fishermen walking along the pier adds life and interest to the painting.

STEP ONE

Here I painted two people close up to illustrate how easy it is to render them effectively. I start with a small brush and a light wash of paint to make quick, broad lines, merely indicating the couple's general shape and stance. Scale is important, so I'm constantly judging the relationships—both between the two figures and between the figures and their surroundings.

STEP TWO

With a mixture of ultramarine blue, burnt sienna, and titanium white, I build up the overall silhouette of the couple. (I simplify the shape by ignoring the feet.) These few brushstrokes begin to convey the form and dimension of the figures. Notice that even with absolutely no rendered detail, your mind fills in what the brushstrokes only suggest: a man and woman holding hands, walking along the beach.

STEP THREE

Here I use some subtle value and color changes to depict hints of clothing. Then I refine the shapes of the figures by painting the areas around and between them with sky and sand color. Notice that I also suggested another couple on the beach; these figures are much smaller and have even less detail than the main figures, which makes them appear more distant.

Cottage and Garden

Creative Cropping
Cropping into the scene is often the easiest way to simplify a subject. Although I definitely want to capture the brilliance of the flowers in the front, I don't need to depict every single bush. By zooming in on the house, I get a more focused composition. As I start my sketch, I make some other minor changes to the scene: I decide to change the brick wall into a fence and eliminate a large bush in the front.

Step One
Once I've sketched in the basic lines and angles of the house, I create the shadowed façade using a dark bluish mixture of ultramarine blue, alizarin crimson, and white. I block in the shadow under the overhang with a mix of yellow ochre, ultramarine blue, and white; then I block in the darkest greens of the foliage with blue, yellow, and a touch of alizarin crimson.

Step Two
After finishing the shadows, I start blocking in the rest of the cottage and the basic shapes of the plants that surround it. Next I add a light blue mixture of ultramarine blue, alizarin crimson, and white for the sky. For the flowers, I use a mixture of alizarin crimson and titanium white with a dab of cadmium yellow pale. I squint my eyes to determine the most essential values in the flowers; I can't look at every single petal (or even every single plant) if I want to capture this scene before the afternoon light changes and fades away.

Step Three
Next I start building up the forms. I use variations of cadmium yellow pale, ultramarine blue, alizarin crimson, and titanium white for all of the midtone greens in this painting. For the brown fence, I use a mix of burnt sienna and white and vertical brushstrokes, following the direction of the wooden planks. Then I add lighter mixtures of alizarin crimson, white, and cadmium yellow pale to the flowers. I'm constantly judging the relationship between the light areas and the shadows here—these contrasts are what make this scene so interesting. I block in the rest of the foliage with more mixtures of green, keeping my lightest values in the sunlit areas.

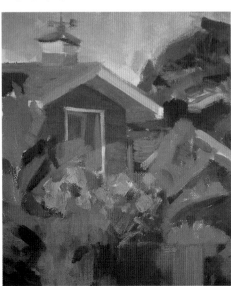

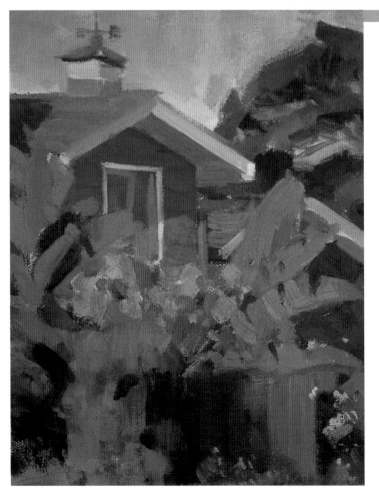

Step Four
I add some bright yellow and orange flowers in the foreground, applying little dabs of paint with my small brush. I also start refining some of the foreground foliage, using thicker brushstrokes of my green mixtures. I want to make sure the right side of the house doesn't get lost in the foliage, so I work in a darker shade of the blue house mixture to define the area but also push it further into the background.

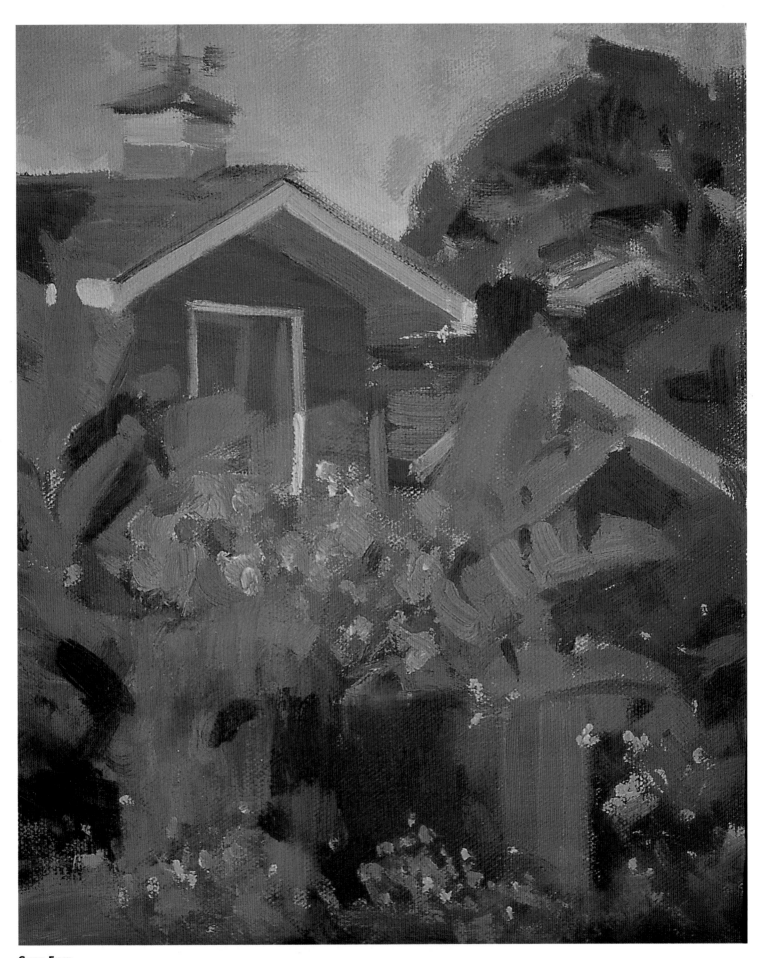

STEP FIVE

Since the center of interest is the house and the flowers in front of it, I use thicker, brighter paint and sharper edges to draw the eye to this area. I step back from my painting frequently to make sure the whole painting is balanced. The advantage in starting out simply is that I can always add more detail in the final stages if I need to. In this case, I go back over the whole canvas, adding small but necessary details and adjusting the colors and values.

FOREST

STEP ONE

I start by laying in the dark, cool shadow areas of the foreground and tree trunks, using a mix of burnt sienna and ultramarine blue. Then I paint in some sunlit patches of green and yellow in the grass and foliage. This contrast helps me judge the shadow values, making sure they are dark enough compared to the sunlit areas.

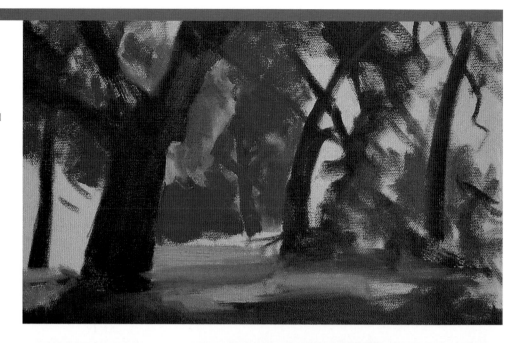

STEP TWO

Next I begin to define the shapes of the dark branches with lighter values of blue and burnt sienna. To depict the tree leaves, I use varied values of a warm yellow-green mixture to distinguish the sunlit areas from the shadows. I paint the shadow areas thinly to keep the paint from mixing with the thicker highlights of the sunny spots.

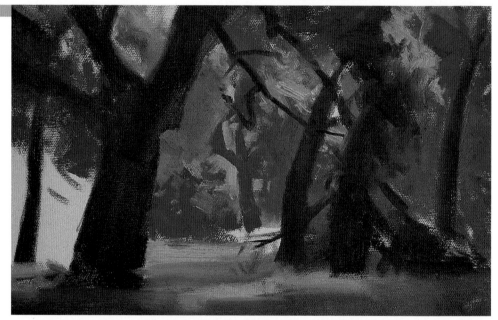

STEP THREE

To highlight the brightest patches, I dab a thick, yellowish mixture on the edges of the leaves. In the foreground, I use a warm green mix of cadmium yellow pale, phthalo green, alizarin crimson, and white to add touches of sunlight to the grass. Finally I add a mixture of blue and white between the branches to give glimpses of the sky breaking through.

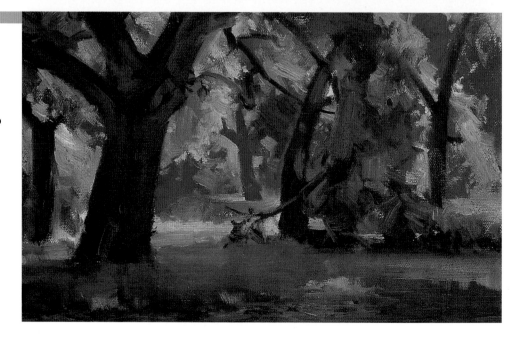

Beach at Dusk

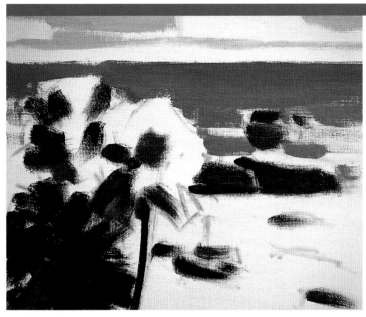

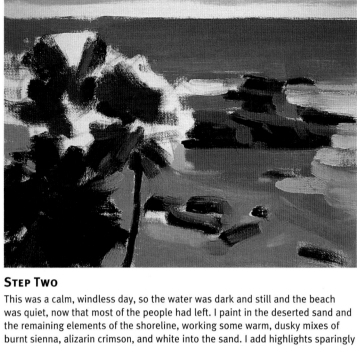

Step One

When I paint, I don't rely solely on the sky colors to show the time of day—instead all the elements in a scene work together to impart a sense of time. For example, a sunset sky may establish the tone of the scene, but warm colors, long, cool shadows, and calm waters can all contribute to the feeling of a quiet beach at dusk. With confident, quick strokes, I begin sketching in the rocks and trees. Next I block in the sky and the water with mixes of ultramarine blue and white. I want the drama of the fading afternoon light to be evident, so I paint in the shadow areas a little darker at the beginning—I can always adjust them later if they turn out to be too dark.

Step Two

This was a calm, windless day, so the water was dark and still and the beach was quiet, now that most of the people had left. I paint in the deserted sand and the remaining elements of the shoreline, working some warm, dusky mixes of burnt sienna, alizarin crimson, and white into the sand. I add highlights sparingly to the simple rocks in the foreground to contrast with the long, cool shadows beneath them. The highlights are mixes of burnt sienna, alizarin crimson, and white, and the shadows are mixes of ultramarine blue and burnt sienna.

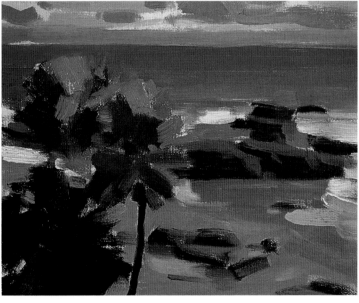

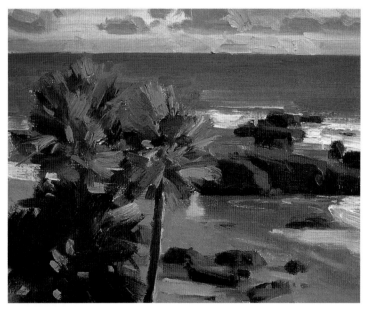

Step Three

Once I fill in the remaining color of the palm trees (cadmium yellow pale, ultramarine blue, and a touch of phthalo green), you can see the effects of the waning sunlight and how the mood of the whole painting begins to take shape. I quickly paint in the distant clouds with the rich pinks and violets of late afternoon, using mixes of alizarin crimson, cadmium orange, ultramarine blue, and titanium white. These cool colors contribute to a sense of peaceful serenity.

Step Four

To finish the palm fronds convincingly, I use thick brushstrokes and paint them the direction in which the leaves grow. (See page 117 for more on palm trees.) I add hints of green algae to the rocks and sharpen their edges with more thick highlights. Last I use loose, horizontal brushstrokes to refine the waves and soften the edges of the distant sunset clouds.

Foggy Harbor

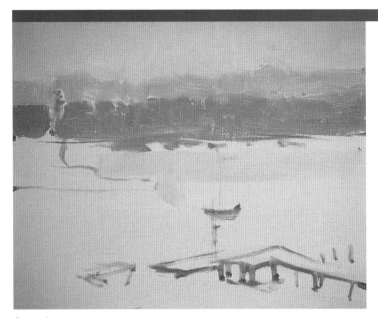

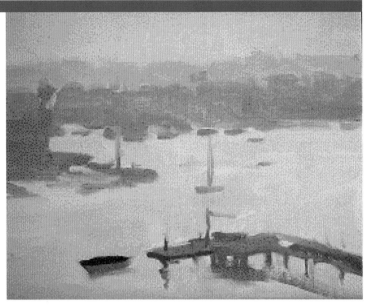

Step One

Subtle gray shapes are all that are visible in the thick haze, so I approached this painting a little differently than I usually do—once my sketch was in place, I blocked in the midtones first, creating the overall gray tone. Notice that all the values are just slight variations of each other; each is a mixture of ultramarine blue, alizarin crimson, and titanium white.

Step Two

I block in the basic shapes of the dock and boats and paint in a thin wash of titanium white, cadmium yellow pale, and a touch of phthalo green over the water. After most of the color is laid in, I start to build up the forms a little to suggest distant buildings and trees. I paint in the dock using a mixture of blue, burnt sienna, and white. Then I add a darker mix of those colors for the darkest shadows to the foreground boat and dock. Here I keep the objects in the foreground the darkest and gradually progress through the midtones in the middle ground to the lightest values in the background.

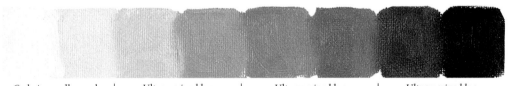

| Cadmium yellow pale and white | Ultramarine blue, cadmium yellow pale, burnt sienna, and white | Ultramarine blue, alizarin crimson, burnt sienna, and white | Ultramarine blue, alizarin crimson, and burnt sienna |

Step Three

Now I add thicker paint to the water with horizontal strokes to create some subtle movement. Although the water is mostly white, I add some blue to the mixture where it ripples. I refine the shapes in the middle ground and background with lighter values to make them appear as if they're fading into the hazy distance. Because I've kept my use of color to a minimum, the peaceful mood of this hazy, uninhabited harbor is more apparent.

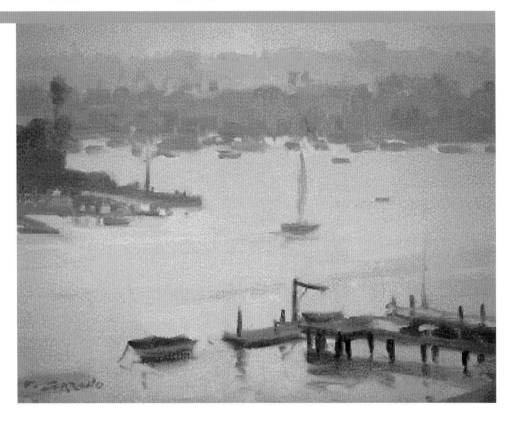

EUCALYPTUS TREES

STEP ONE

Once my sketch is complete, I quickly block in my colors. To make these trees look realistic, I need to leave some negative space between the branches, so I squint my eyes to get a simplified view of the negative space and the values in the trees. I completely ignore the details at this point—establishing the right shapes, colors, and values is more important.

STEP TWO

At this stage, I start to tighten up the positive shapes by adding quick, random strokes of green midtones to the leaves. I also lighten up the tree trunk with thick highlights in mixes of burnt sienna, yellow ochre, and white. Then I strengthen the shadow of the tree on the right, and add a house in the distance to lead the viewer's eye into the painting.

STEP THREE

Next I add more detail to the distant mountain and middle ground foliage. Finally I focus completely on the negative space, adding patches of blue sky in between the leaves and branches of the eucalyptus tree. Notice that I don't paint any individual leaves at all, yet the varying values and brush techniques used create the illusion that there are thousands!

Creating Quick Sketches

Quick sketches made on site are a good way to work out a composition before starting to paint. When drawing trees, looking for and drawing the negative spaces among the branches and leaves can help you achieve a more accurate drawing. This is because you are forced to draw what you see rather than what you think you see. Observe the negative space created by the branches and leaves—do the negative shapes help to break up the positive shapes and make the tree more visually interesting? If so, then your painting will be successful.

COUNTRYSIDE

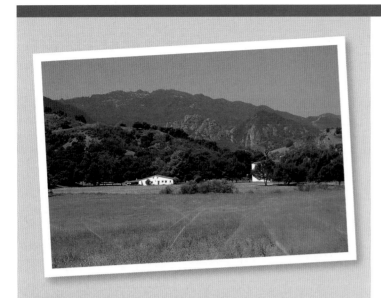

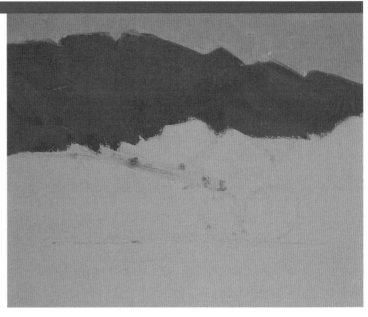

Choosing a Scene

Most artists agree that successful landscape paintings have a distinctive foreground, middle ground, and background that work together to create a beautifully balanced painting. As I drove through the countryside, I discovered a perfect example in this hillside scene. The mountain is the background, the lush green hill and the house are in the middle ground, and the field is the foreground. For my painting, though, I cropped out part of the foreground to create a better overall composition.

STEP ONE

I want to emphasize the scale of the mountain, so I compose the scene with a low horizon line. First I lay in the sky. Then I block in the mountain, using a light blue-green mix of ultramarine blue, cadmium yellow pale, alizarin crimson, and white. I pay close attention to its silhouette, being sure not to soften the top edge too much—the mountain is in the background, but it's not a long distance away.

STEP TWO

Now I block in the middle ground and foreground, squinting to see the most important shapes and values. I paint the house using titanium white with a slight touch of ultramarine blue and cadmium yellow. The mountain is commanding, but the house is the focal point in the painting. I placed it slightly off-center to make the composition more dynamic.

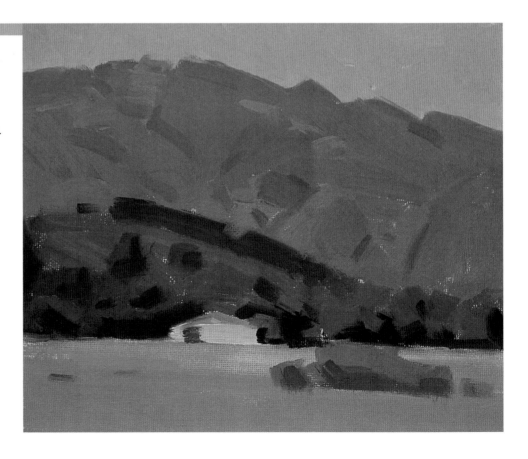

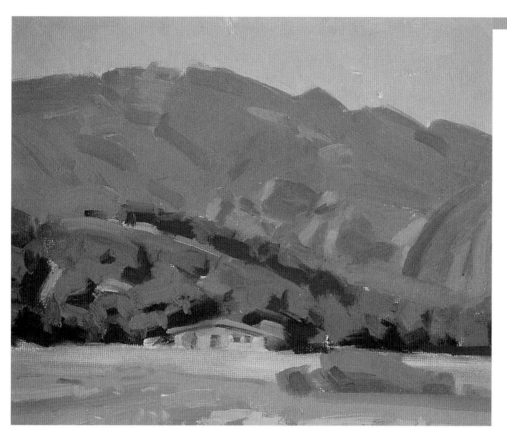

STEP THREE

Next, before I add the remaining details, I adjust all my values in the distant mountain and hillsides to make sure I'm conveying the illusion of depth, or atmospheric perspective. Then I sharpen the details in the immediate foreground and on the house to make them "pop" forward.

Placing the Shadows
Notice that the shadows of the trees frame the house and help keep it from looking "pasted" onto the hillside. I vary the shapes I paint into the foliage for added interest, and I use a very loose, impressionistic style. This detail of the foliage looks much different up close than it would if you were to stand back from the painting and let your eye fill in the details.

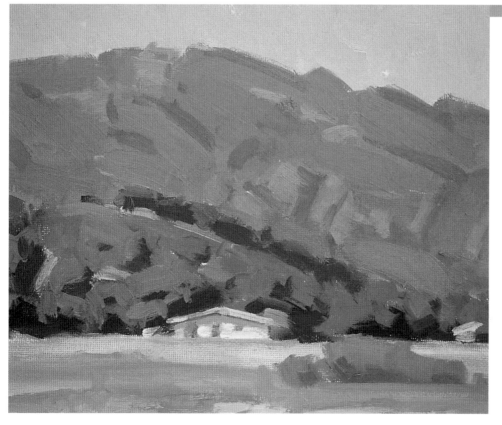

STEP FOUR

Finally, I add a few more highlights and details, including the hint of another house and some blooms in the foreground for added color. To make the wildflowers seem scattered, I randomly dab a mixture of cadmium orange, cadmium yellow pale, and white sparingly across the field. This simplification keeps the foreground from drawing undue attention.

Seeing the Whites
Even though the house may appear to be pure white from a distance, up close you can see that I've added shadows of ultramarine blue and white under the roof, as well as minimal details that suggest doors and windows with a darker gray mixture.

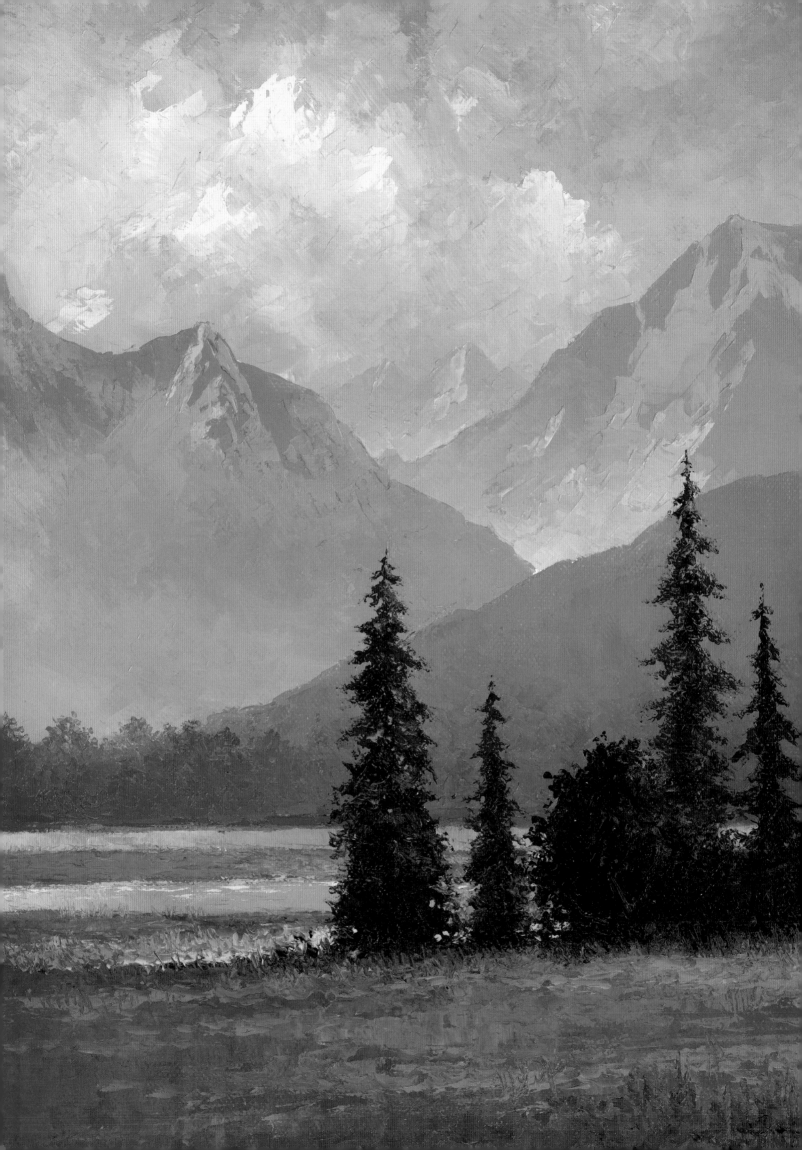

KNIFE PAINTING WITH WILLIAM F. POWELL

William F. Powell is an internationally recognized artist and one of America's foremost colorists. A native of Huntington, West Virginia, Bill studied at the Art Student's Career School in New York; Harrow Technical College in Harrow, England; and the Louvre Free School of Art in Paris, France. He has been professionally involved in fine art, commercial art, and technical illustrating for more than 35 years. His experience as an art instructor includes oil, watercolor, acrylic, colored pencil, and pastel—with subjects ranging from landscapes and seascapes to portraits and wildlife. Much of his work has been reproduced as prints and collector's plates, and he has produced numerous contract paintings and illustrations for a variety of publishers. Additionally Bill conducts painting workshops and produces instructional videos that employ unique methods of in-depth presentation and demonstration.

KNIFE PAINTING TOOLS

PALETTE KNIVES

Palette knives are used for mixing paint. They are available in several styles and materials, often of a wood/metal combination or plastic. The two most common styles are shown below. Palette knives should be used with a smooth, gentle, kneading stroke rather than a heavy stirring motion. If paint colors are overmixed, they tend to lose their freshness.

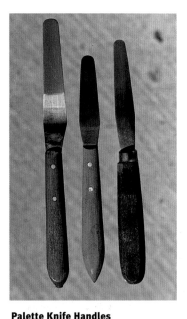

Palette Knife Handles
The traditional long, straight, flat-bladed knives are clumsier than those with elevated handles. The elevated handle (extreme left) allows for control of the mixture while keeping hands out of the paint.

PAINTING KNIVES

Painting knives can be used to create extremely fine works of art. They come in many shapes, styles, and sizes. Some artists even grind and alter the blades to create a "custom-made" knife. A good painting knife must be thin, flexible, and sensitive to the touch. Made of hand-tempered steel, these knives are usually one solid piece; some knives, however, are soldered or welded.

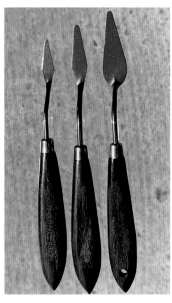

Painting Knives
I think the most versatile style of painting knife is tear-shaped with a small, rounded tip (shown above). This knife has no sharp angles to accidentally dig into the canvas. I occasionally use the knife in the middle for larger detail.

SELECTING KNIVES

Knife selection is important. All knives will spread paint onto the canvas in some manner. However each knife has a slightly different shape and, therefore, performs differently. One of the most important things to look for is "spring" in the blade. A painting knife should not be stiff; it should be very flexible, especially at the tip. When pushing the tip upward with your finger, it should curve easily. Curving should take place toward the tip and within at least one-fourth of the blade. Also keep in mind that knives become more flexible with use.

The Blade
Looking across the blade, one can see a variation of thickness from the handle to the tip. The thickest part of the blade is at the hilt, or handle, and the thinnest is at the tip. This thin blade allows for delicate application and manipulation of paint. A sharply pointed knife tip will not carry as much paint as one that is slightly rounded. The rounded tip can create delicate detail even though the tip appears to be slightly blunt.

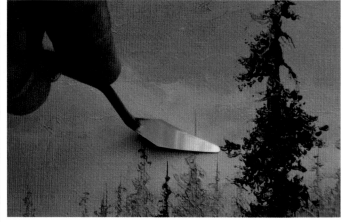

Flexible Knives
Select a knife with good flexibility and spring memory. Pressing too hard with a stiff knife can damage the canvas. With a gentle push, a flexible knife will curve and apply paint in either a thick or thin manner. Textures to suggest plastered walls, tree trunks, ocean waves, mountain faces, and so on, can be created.

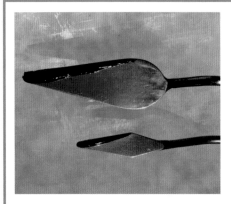

Knife Working Areas
The shape of the side of each knife dictates the required working area for spreading and blending colors. At left are two illustrations showing the working areas for those knife shapes. Throughout this book, close-up illustrations are shown of various knife-working surfaces and edges for applying paint, blending color, and creating detail.

Dulling the Edge
Remember: As a knife becomes more flexible, the edges become sharper with use. Be careful; they can cut! To dull the edge, buff with a very fine file—but do not over do it. The edge is an important part of the painting tool. Polish any rough areas with fine steel wool.

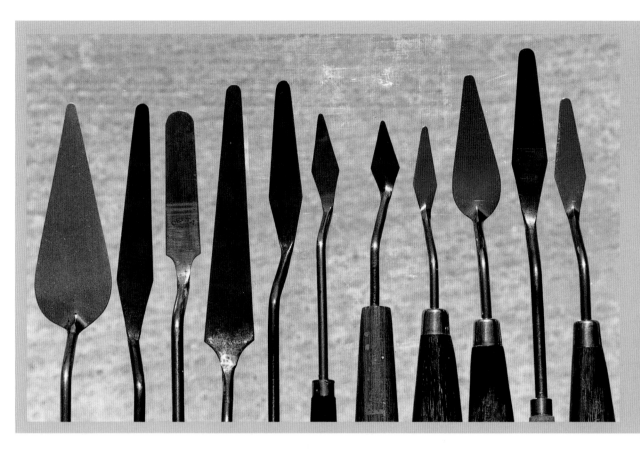

Knife Shapes and Sizes

Many different knife shapes and sizes are available (pictured at left). Each knife has its own characteristics. Very long knives are great for blending large areas of color, while short knives are good for textures, details, and smaller blends. Knife tips vary as well. Finer, smaller, rounded tips can create more detail than the larger, rounded tips. A sharp-pointed tip, however, carries very little paint. Experiment with different styles and sizes to see the effects you can create.

HANDLING THE KNIFE

I have several tips regarding ways to and not to hold a painting knife: If the forefinger is placed on the top, as shown at right, it makes the tool seem very stiff and less mobile. With this position, movement is limited to the wrist.

Controlling the Knife

Holding the knife handle lightly in the fingers and moving it with the wrist and fingers enables control and movement in all directions. The knife can also be rolled between the fingers while applying paint. This aids paint manipulation and, because you can easily sense slight knife movements and pressure changes, there is less chance of pushing too hard.

Pushing and Pulling

It doesn't matter if you are left handed or right handed, the knife works the same. When a left hander pushes, a right hander pulls, and vice versa. It's that simple. Often students say my knife works differently because I am left handed. They soon find out that this is not true. Also I occasionally change hands when knife painting. Experiment using your other hand. Notice how easy it is to change hands with a knife.

Drawing

When drawing with the tip, hold the knife gently in the fingers as shown. Change pressure by squeezing the handle firmly or lightly. Press as needed while moving the knife to allow the paint to be pulled from the tip. Change the angle to apply more or less paint. Also twirling the knife between the fingers can alter the flow of color.

131

Techniques

Mixing
Painting knives are used with gentle kneading strokes to mix colors. Loosely mixed colors appear more lively than overmixed ones. Caution: Do not scrape a paper palette too hard or little furry "roll ups" will mix with the paint and destroy the mix.

Loading
First make a thin spread of color. This makes it easier for the knife to pick up an even load of pigment. Then raise the leading knife edge and drag the trailing edge to load paint on one edge. Paint is then applied from the trailing edge of the knife.

Leading Edge
Raise the leading edge of the knife slightly. This allows the paint to roll off the underside smoothly. If it is raised too much, the trailing edge will dig in, removing color already applied. Hold the knife with your fingers, and use a gentle touch.

Coverage Strokes
This requires a good load of paint, which can be drawn out to cover a large area. Strokes can be made in any direction, but for maximum coverage, use the side of the knife and make the stroke smooth and continuous.

Dot Strokes
Using the smaller knife, or the tip of the larger one, paint can be applied in small dot-like masses. This technique can be used to add color, life, and texture to an uninteresting area without making major changes. Because uniformity will attract the eye, it is best to avoid creating a monotonous or uniform pattern when using these dots.

Side Strokes
This photo shows many of the strokes you can make by drawing the knife sideways. Some strokes are straight, others are curved. You can even smear the paint, as if you are mixing it. Practice these strokes on a painting pad or extra scraps of canvas. This is a great way to become accustomed to the feel of the knife. On the next page you'll learn about "pulling" strokes and double loading the knife with two colors.

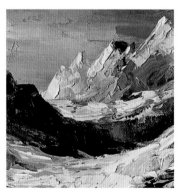

Thick Paint
With a gentle touch, several layers of thick color can be applied over other layers of wet paint. Here is an example of thick paint layered over two other wet layers. Use this method where color buildup and texture are desired without blends. Note: The viscosity of paint on the knife should be a bit thinner than the wet paint on the canvas. If the paint on the knife is too stiff, it removes or digs into the previous layer.

Thin Paint
Paint can be applied thinly to create a very smooth surface, sometimes allowing the grain of the canvas to show. Fine blending of colors is also possible. However blending can become difficult if the colors are too thin because there is not enough body in the paint to apply or manipulate. Feel the consistency of your paint, and always apply enough to accomplish the desired blends.

Changing Directions
By moving the wrist and elbow, you can make strokes in different directions. This creates interest in an area that may not contain any dramatic subject anatomy. By overlapping strokes, many patterns, textures, and blends are created. Notice how these overlapping, blended colors create a rich and interesting color mood.

Combined Strokes
By changing directions (as shown above) and combining long and short strokes with those made using different length knives, interesting textures and blends can be created. The possibilities are endless and, when using a good fresh color scheme, the results can be dramatic. This illustration shows combined strokes using fairly thick paint.

Blending Colors

Very long knives such as the one pictured above are perfect for blending large areas of color. To blend, pull sideways through two roughly applied colors. Raise the leading edge of the knife slightly.

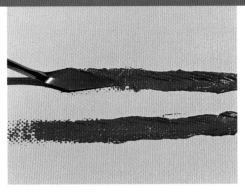

Pulling

Load the knife fully with paint. Place it flatly on the canvas surface and pull. Use the handle as a guide for making a straight pull. The paint is dragged from the knife in a completely different manner than with the side stroke. This can be used to change the monotony of a stroke within an area of a painting or for general color application. All strokes can be made with any size knife.

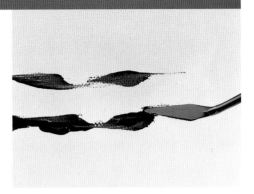

Rolling

Load the knife again and place one edge on the canvas. Start the stroke by pulling the knife and rolling it slightly between the fingers. This will create a broken pattern that can be used to enliven an otherwise flat area. It can also be used to build color in an interesting way. Use it in combination with other strokes.

Double Loading

This is another important technique. This means loading the knife with two colors at once. A double load creates an automatic blending of the two colors as they are applied to the canvas. Here are two knives loaded differently: one with colors side by side and the other with colors loaded top and bottom. Blends can be made by stroking in a straight, curved, or wavy manner.

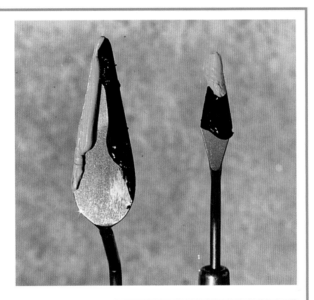

Loading for Lines

To paint thin lines, load the paint onto the very edge of the knife. To do this, make a thin smear of color on your palette, and then drag the trailing edge of a clean knife through it until the right amount has built up on the edge.

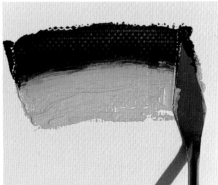

Loading Top and Bottom

With this technique, the paint is loaded top and bottom and blended as it is applied using a slightly curving stroke. This application could be used when painting rounded objects, such as vases, rocks, and tree trunks. Try different colors and combinations.

Loading Side by Side

Here the paint is loaded side by side, and the double-loaded knife creates a loose impression of textured leaves or foliage. By changing direction and slightly tapping the knife, a rough blend is created that suggests a textured surface on the leaf forms.

Drawing Lines

Now place the loaded edge onto the canvas and make lines by either drawing the knife upward or downward or by stamping or tapping it against the surface. Hold the knife at more of an angle to make the lines thinner and less for thicker lines. It takes a little practice, but it is worth the effort.

Rocks

Step One

The following steps are an easy way to begin painting rocks using a knife. First paint a light background by mixing white, permanent blue, and burnt sienna. Then block in the rock mass using burnt sienna, burnt umber, and the gray mix. Keep the mixture a little on the burnt sienna side for a warmer looking rock.

Step Two

With a small knife, begin building the shape of the rocks using a mix of white, yellow ochre, and cadmium orange. Build from dark to light, using a side stroke to develop the face of the rock. This also begins texture. When painting rocks, always follow the angles of the planes. Notice how the rock begins to appear solid.

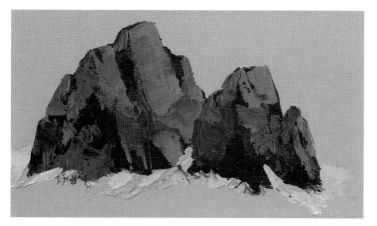

Step Three

Next use the small knife with white, permanent blue, and alizarin crimson to begin blocking in color within the shadow areas. Vary the value and warmth of the purple to make the shadows more lively. Purple is an extremely important color within shadows; however try not to make it too bright. Use a small knife to develop these shadows and make shorter strokes than you did in the last step. Short strokes give the illusion of texture within the shadows. Mix a lighter blue and establish foam at the base of the rocks.

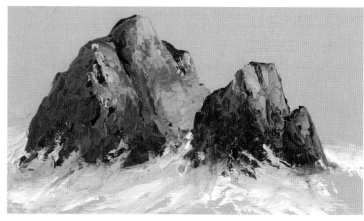

Step Four

Use the small knife again to paint in the last highlights. Do not use pure white; it will appear chalky. Instead use mixtures of white and a speck of cadmium orange in combination with just a speck of yellow ochre. Paint the lightest highlights with the tip of the knife to create a sparkle effect. Last, to set the rocks, add light to the water and foam at the bottom.

Step One

Begin painting these granite rocks by establishing the basic shape and size with a mixture of white, burnt umber, and permanent blue. This produces either a warm or cool gray depending upon how much blue is added. The more blue, the cooler the color. Paint the overall shape of these two rocks.

Step Two

Next begin modeling the form of the rocks by adding white and yellow ochre to the basic rock gray. Make small, flat tapping strokes as if patting or sculpting the rock. Your brushstrokes should follow the shape of the rock.

Step Three

Once the forms are established, paint the highlights using a lighter mix with a speck of cadmium orange for warmth. Use dot strokes to add to the texture, and paint rock cavities by dragging the tip of a small knife through the wet paint. This allows the dark underpaint to show through. Then place a few highlights next to the cracks and holes for depth with a mix of white and a speck of permanent blue.

TREES

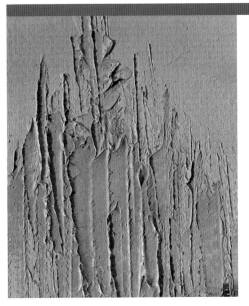

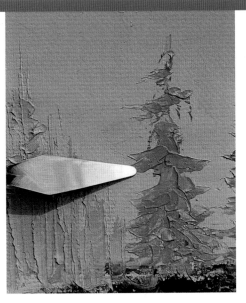

STEP ONE

It is easy to paint both broadleaf and coniferous trees with the knife. Begin with distant pine trees. Apply a mix of permanent blue and white for a sky background. Next mix equal parts of permanent blue and yellow ochre to a soft green. This is the basic mix for distant pine trees. Next mix a little sky blue into the tree mix to make them recede. Then load the side of a small knife and paint vertical strokes to indicate distant pine trees.

STEP TWO

Blend the distant trees slightly into the wet sky base. The more sky color you add, the more distant they appear. Use the tip of the knife to add horizontal strokes to suggest branches. Add detail as you move forward. Make tree masses darker and greener as they come forward. Paint a few closer trees adding some boughs to indicate detail. Next mix two parts burnt umber to one part phthalo blue for a blackish green.

STEP THREE

Paint in a small foreground tree using the tip of the knife. For highlights, add a bit of cadmium yellow light to the basic tree mix, and use the knife tip to paint a suggestion of light on the left side of a few trees. Place a mix of white, phthalo blue, and alizarin crimson on the shadowed side of the trees (not all of the trees!). Finally spot a little burnt umber and cadmium orange in the foliage to indicate trunks showing through here and there. Draw branches using the small knife tip.

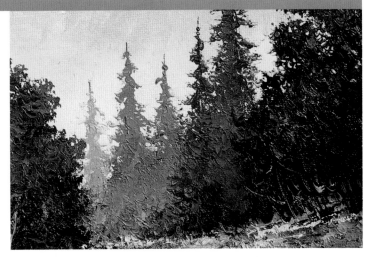

Foliage

Broadleaf trees are less rigid in their form than pine trees, but each type of tree has its own shape. Above I painted loosely to indicate the foliage of broadleaf trees. It's best to use mostly the tip of the knife with this technique. Change colors often and attack the canvas at different angles to create the abundance of foliage. Notice the introduction of warm colors to create color interest within the foliage.

Branch

To draw branches use the tip of the knife. Make long strokes, stopping and changing direction to give a natural look to the branches. Twigs are made with a small-pointed tip. Make lighter twigs by scraping out color. Use the point and edge of a small knife to create highlights within the branches and twigs.

Stand of Trees

Above a combination of broadleaf and coniferous trees are shown in the same setting. Light background color was mixed into the distant trees to create some perspective. Notice how dark the color is on the right foreground tree.

Seascape

Step One

To begin this exercise, paint a simple sky using a mixture of white and ultramarine blue to the value shown. Use a medium-sized knife and keep the texture fairly smooth. This blue is warm, making it excellent for an afternoon sky. Paint a horizon haze using white and a speck of alizarin crimson. Use a sawtooth stroke to blend. For the backwater, mix a combination of equal parts of ultramarine and cerulean blues. This combination creates a cobalt blue hue that is rich and controllable. For a warmer blue, add more ultramarine. This makes the mix deeper and more purplish because of the red in ultramarine blue. For a cooler blue, add cerulean. Cerulean is a greenish blue and does not contain the red that ultramarine does. Lighten this blue with white to change value. Paint a thin layer of this color over the entire area. Keep the horizon line straight and parallel to the top and bottom of the picture plane and blend the hard edge slightly. Wave forms will be painted into this wet backwater area. Use the same color and paint in the basic form of the headlands. Use a scrap of canvas to practice these strokes.

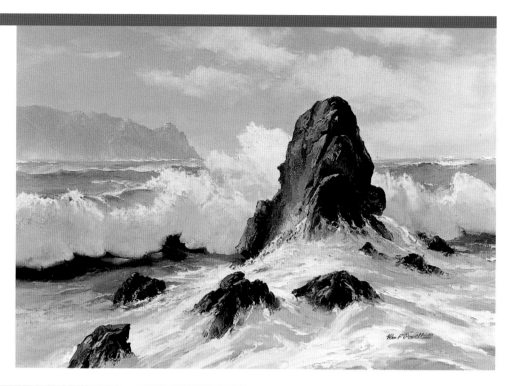

Step Two

Next, mix white with Naples yellow and white with a speck of alizarin crimson. Use the small knife and add detail to the headland mass. Make long curving "pulling" strokes (as shown) to create the waves in the backwater. Blend this color along the top of these strokes leaving a hard edge at the bottom. This builds form in the waves. Notice how this color is also used to build the form of the major wave.

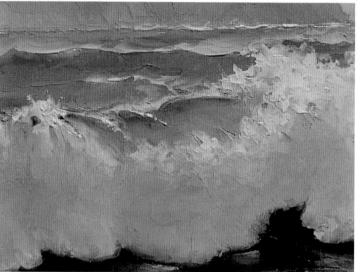

Step Three

Add yellow ochre to the blue backwater mix. Paint in the lights and darks of the wave and foreground water. Add more blue to darken. Add ochre and white to lighten. To block in the crashing foam mass use white, ultramarine blue, and a speck of alizarin crimson. Paint the shadow areas, and then place the lighter highlight colors (mixes of white, Naples yellow, and alizarin crimson) over them. Add white with a speck of cerulean to the bottom of the foam.

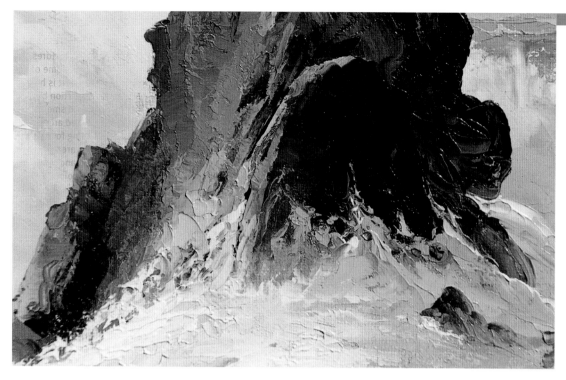

ROCKS

Paint the dark rock base using a mix of burnt umber and alizarin crimson. Then overlay the lighter colors for shape and form. Gray is white with burnt umber, orange is Naples yellow with a speck of alizarin, and yellows are pure Naples yellow and Naples yellow with white. Begin the foam using white with cerulean blue and white with backwater blue.

FOAM

Make sure the foam around the rock is painted to your satisfaction. It can be accomplished later, but is much easier to complete before painting the rock over it. Notice the loose application of the gray mix in the top area and how it is applied to suggest openings and cracks in the rock face. Try not to blend these lighter colors, otherwise the rock will become smooth and appear out of place. Notice the foam and waves on the right.

BRUSHSTROKES

This close-up shows the wave detail and small rocks that are in the shadow on the right side. A great variety of strokes are used to accomplish this area. Pulling strokes are combined with side strokes. Long and short strokes are combined with straight and curved strokes. Stroke variation adds excitement and reality to the scene.

WAVES

Here the detail of the rocks in the left front are shown. Paint in the foam patterns first. Then place the basic rock forms using burnt umber and a speck of alizarin crimson. Next paint the rock features with the same lighter mixes used previously. Finally paint in the highlights, shadows, and details to bring the scene to completion.

Mountain Lake

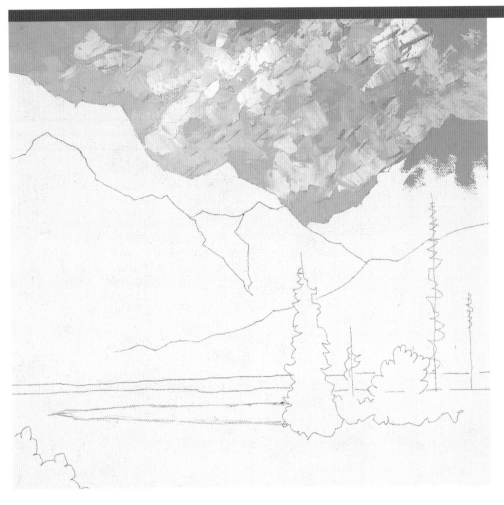

STEP ONE

For this painting, smooth out the paint textures to the desired degree, but remember that some of the charm of a knife painting is the texture. It is best to smooth and blend each area to satisfaction before continuing; it is difficult to go back and smooth colors after another area has been painted around or over it. Refer to the completed painting for depth of final texture. I prefer texture in some areas and less in others. Texture helps form shapes and makes the painting interesting to view. Use the color mixes at left and block in the atmosphere of the sky. In this sky, keep the final blends loose for color and mood.

White + ultramarine blue,
a speck of burnt umber
and cerulean blue

Mix above + white and
a speck of cerulean blue

Mix above + white and
a speck of cadmium orange

White + a speck of
phthalo red rose

White + a speck of
cadmium orange

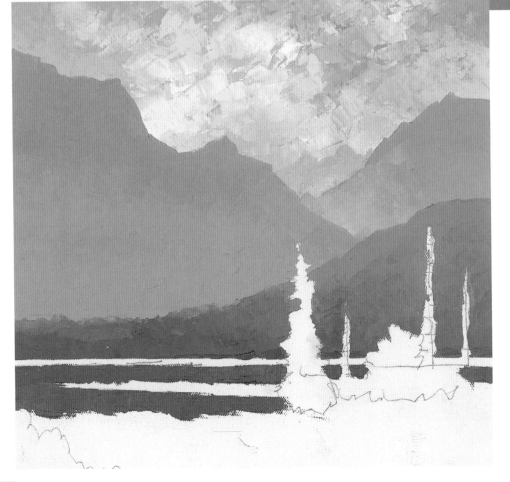

STEP TWO

Before using the colors below to develop the mountain range, refer to the final painting and blend your sky to a desired smoothness. The texture of the sky should be a bit smoother than the mountains. This texture creates depth and atmosphere. Mix more sky colors into the distant mountains and less as they move forward in the scene. Paint in haze at the base of each mountain to add to the aerial perspective. Establish the dark green land and then refer to page 139 to finish your mountains while the underpaint is wet; otherwise blends are impossible. Use the sky colors to develop the structure of the mountains, working from dark to light. Try not to over-blend the strokes that make up the mountain face and texture.

White + ultramarine blue,
specks of burnt umber and
phthalo red rose

Mix above + white and
specks of ultramarine blue
and phthalo red rose

White + ultramarine blue
and specks of burnt umber
and cerulean blue

Ultramarine blue +
yellow ochre and
a speck of white

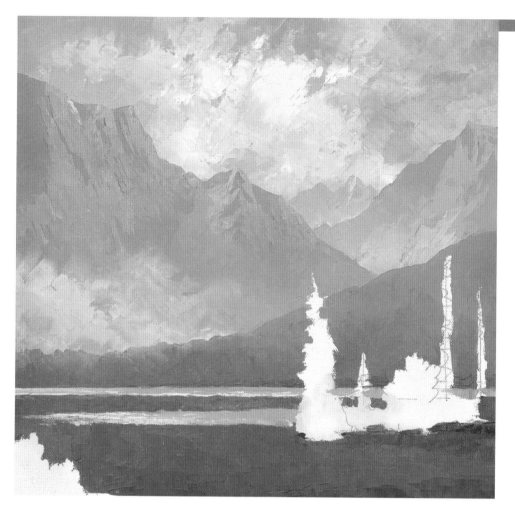

Step Three

Use the color mixes below to finish the foreground and trees. Work from dark to light when building these tree forms. Paint in the grass using the light yellow-green, and enhance the glow area with a touch of pure cadmium yellow light here and there. Paint the mist at the base of the mountains stronger than desired; it will fade a bit during the blending and smoothing stage. Establish and blend all of the haze areas first, then pull the snow and mountain face colors down into them. Block in all of the foreground undercolors, making them appear a little darker in the very front and a bit lighter toward the back. Paint in the water with white and ultramarine blue, and then apply the lightest sky colors into them as reflections. Notice how the snow masses fade as they move down into the mists and haze. Develop the outline of the distant trees, then blend all areas to desired satisfaction.

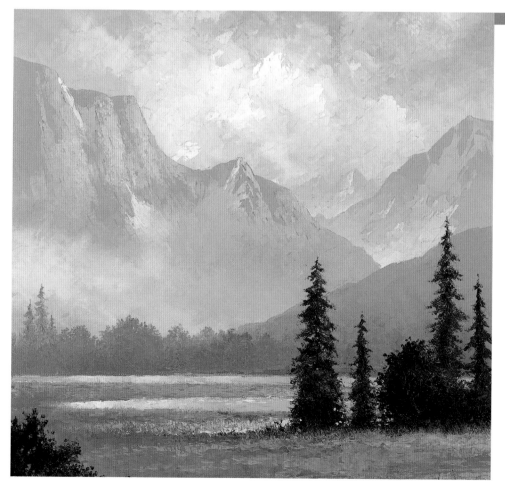

Step Four

Mix burnt umber and phthalo red rose for the fall colors on the bushes. Highlight with white and a little cadmium orange. Draw the suggestion of branches using the tip of the knife and a lighter mix. Use the second color for the dark base of the trees, then highlight with cadmium yellow light and a little ultramarine and cerulean blue. Spot some of the bush colors into the trees to tie everything together, using the tip of the knife for small details. Keep the colors a bit grayed, as seen in the color samples below, so they are not too harsh.

White + ultramarine blue and specks of burnt umber, phthalo red rose, and cerulean blue

Ultramarine blue + cadmium orange

Mix above + cadmium yellow light

\White + cerulean blue and a speck of cadmium yellow light

FOREST GLADE

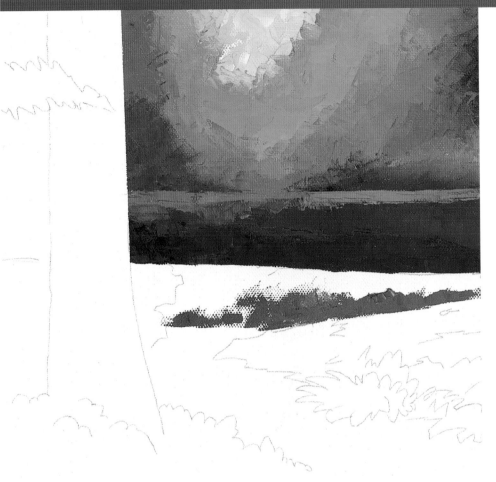

STEP ONE

Mix the colors below, and use them to block in this portion of this scene. There is a rich feeling of green in this painting; it adds to the flavor of lush forest growth. Begin by lightly sketching the subject on the canvas. Then use the color mixtures to lay in the undertones. As before, always refer to the finished painting to bring each area up to a satisfactory final before going on to the next portion. Once the painting surface has dried, it is difficult to apply any smooth color layers, and blending into the under-color is impossible. If this should happen, simply rewet the undercolor and proceed from there.

White + cadmium yellow light and a speck of phthalo blue

Cadmium yellow light + a speck of phthalo blue

Two parts yellow ochre + one part ultramarine blue

Two parts burnt umber + one part phthalo blue

STEP TWO

Continue using the color mixtures from the last step, and block in more of the undercolors. Use pure yellow ochre for the warm spot of undercolor. A small pond will be painted in this area, which requires a warm undercolor to support it. When knife painting, you do not know if the paint will remain smooth when applied, so you need to make sure there is a sufficient foundation of color before adding any final color. Using the mixtures below, begin forming the shape of the fallen tree trunks. Add some of the green colors to create a feeling of harmony throughout the entire painting. Add a little more green to the log colors and establish the fore-ground. Adding more yellow and warm brownish colors gives the feeling of ground.

Burnt umber + a speck of white

Mix above + white

Mix above + light yellow-green

White + Naples yellow

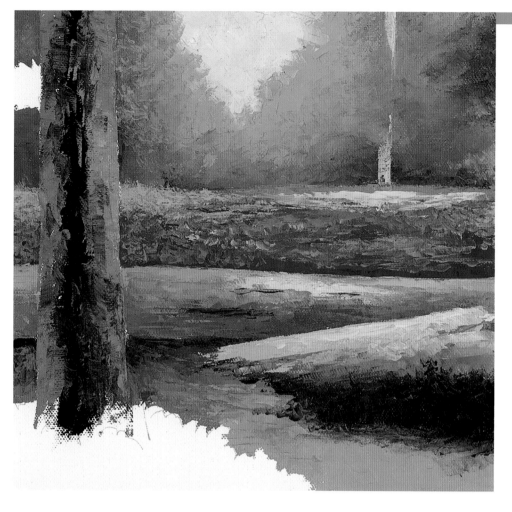

STEP THREE

Begin establishing more detailed textures, such as grass and tree trunks. Use the final painting as a guide, and create the textures while the under-paint is still wet. Use the small knife and make flat, upward strokes to create the illusion of grass. For the logs and bark textures, make more controlled strokes to create a pattern that follows the length of the trunk. Apply the cooler blue-green color over the warmer undertones. Use the top mixture for the bright sunlit glow in the distant middle ground. For a harmonious blend, add the purple to the basic log colors for the shadow side of the tree.

White + cadmium yellow light

Mix above + phthalo blue

Burnt umber

Burnt umber + Naples yellow

*White + ultramarine blue
and alizarin crimson*

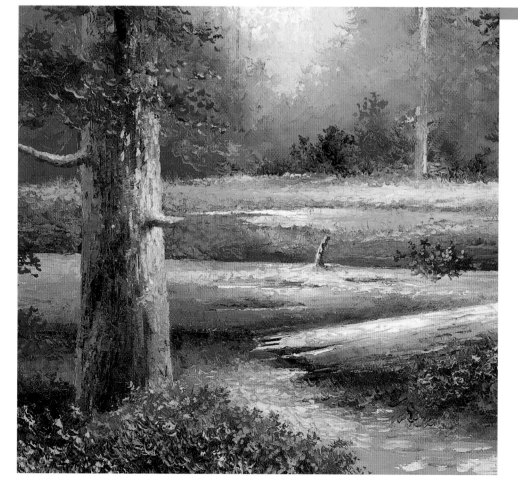

STEP FOUR

Now it is time to place the final details. Most of these have been created as the painting developed; it is now a matter of bringing them to a complete painting. Individual preference dictates how much detail to put into this painting. Some artists like a lot of detail, while others prefer little detail. All areas have been left semi-rough to show the methods used to develop the work. A much softer final can be created by simply blending the colors a little more thoroughly than shown here. Add the pond by using white and a speck of phthalo blue. Develop the reflection on the left side using the lighter yellow colors and, finally, a touch of white on the very thin, left side. Add a little yellow for the green in the middle, and keep the mix pure light blue on the right. White and Naples yellow in varying degrees of mixes are used for the final texture on the tree trunk, fallen logs, and foreground. Dark leaf, bough, and grass masses are painted in with the dark burnt umber and phthalo blue mix, and then they are highlighted with lighter greens. Use the knife tip for this task. Add cadmium red light to the burnt umber mixes, and block in the final colors and shapes on the bushes using the knife tip. These little bushes add color, contrast, and warmth.

INDEX